# A History
# of British Design
# 1830–1970

*Fiona MacCarthy*

LONDON    BOSTON    SYDNEY
GEORGE ALLEN & UNWIN LTD

First published in 1972 as
*All Things Bright and Beautiful.*
This revised edition published as
*A History of British Design 1830–1970* in 1979.

GEORGE ALLEN & UNWIN LTD
40 Museum Street, London WC1A 1LU

© George Allen & Unwin Ltd 1972
*(All Things Bright and Beautiful).*

© George Allen & Unwin (Publishers) Ltd 1979
*(A History of British Design 1830–1970)*

**British Library Cataloguing in Publication Data**

MacCarthy, Fiona
  A history of British design, 1830–1970. –
  Revised ed.
  1. Design – Great Britain – History
  I. Title    II. All things bright and beautiful
745.4′49′41        NK928

ISBN 0-04-745007-X

This book has been designed by
Walter Bloor DFA(Lond)

Typeset in 10 on 12 point Baskerville by
Trade Linotype Ltd
and printed in Great Britain by
Hollen Street Press Ltd, Slough

# Contents

CHAPTER 1  PAGE 7
The Cole Group 1830–1860

CHAPTER 2  PAGE 21
The Arts and Crafts 1860–1915

CHAPTER 3  PAGE 39
The D.I.A. 1915–1928

CHAPTER 4  PAGE 53
The Architects 1928–1940

CHAPTER 5  PAGE 69
The Council of Industrial Design 1940–1951

CHAPTER 6  PAGE 85
The Industrial Designers 1951–1960

CHAPTER 7  PAGE 100
The Engineers 1960–1970

CHRONOLOGICAL TABLE  PAGE 113
SOURCES OF ILLUSTRATIONS  PAGE 133
INDEX  PAGE 134

# The Cole Group
# 1830–1860

HENRY Cole, an early Victorian civil servant of adequate talent and exceptional zeal, decided to design a teaset. This decision turned out to be a great deal more important than it sounds. It grew into a movement for reform, a great campaign for improved design in industry, which continues even now.

Cole had a motto: 'Whatsoever thy hand findeth to do, do it with all thy might'. And since his hand was forever occupied with innumerable projects for improvements—from reorganizing the Public Record Office, introducing Penny Postage and reforming Patent Laws to unifying railway gauges and constructing Grimsby docks—Cole was a busy and influential man. He was really a professional reformer. But, when young, he found time to take a course in water-colour painting under David Cox; his sketches were shown at the Royal Academy; and, as a result, he was always sympathetic, through his other enterprises, to the cause of the art. In 1839, he commissioned William Wyon, a painter, to design the Penny Black; and in 1845, he asked Horsley to produce an illustration for a Christmas card. The Christmas card itself was a Henry Cole invention; and so, for that matter, was the adhesive stamp. His excursions into the reform of children's books, resulting in *Felix Summerly's Home Treasury*, gave him more chances to commission illustrations: Redgrave and Townsend and Mulready were employed. It is not at all surprising, with this artistic background and his contacts with the influential painters of the time, that Henry Cole decided to extend his reforms directly to design.

The Society of Arts was offering prizes for a tea service and for beer jugs designed for common use. Henry Cole decided to compete, and as usual, he put his whole heart and soul into his job. He

7

went to the British Museum and consulted Greek earthenware 'for authority for handles'. He went to Stoke-on-Trent and spent three days at Minton's superintending the throwing, turning, modelling and moulding. He set out to show that 'elegant forms may be made not to cost more than inelegant ones'. His teaset, submitted under his Summerly pseudonym, won a silver medal. It was also a best-seller for Minton's. It gave Henry Cole the idea that 'an alliance between fine art and manufacture would promote public taste'.

Cole's scheme, of course, was easier in theory than in practice. Fine art and manufacture were extremely far apart. The level of design in industry was then appalling, for a number of reasons. Among them was the fact that the industrial revolution had destroyed the old craft traditions of honesty and quality; as factories replaced small individual workshops, products became shoddier and also more pretentious. As stamping replaced chasing, as moulding replaced cutting, as transfer printing took over from hand-painting, as weaving became mechanized, there was no concurrent advance in design: though mechanical weaving was welcomed (and quite rightly) as one of the splendid offerings made by genius at the shrine of utility, this was not to say that the end product was inspired. On the whole, machine products merely imitated earlier designs for production by hand. Standards were chaotic. An ally of Cole's looked around him sadly in 1847 and commented on the confusion of the scene. He said 'There is no general agreement in principles of tastes. Every one elects his own style of art . . . Some few take refuge in a liking for "pure Greek", and are rigidly "classical", others find safety in the "antique", others believe only in "Pugin", others lean upon imitations of modern Germans and some extol the Renaissance. We all agree only in being imitators'.

Cole and his friends were not the first to realize the shamingly low level of design for mass-production. As early as 1832, Sir Robert Peel (who made his own fortune with the spinning jenny) had blamed falling exports on incompetent designs: he told the House of Commons that although British products were technically excellent, pictorial designs were 'unfortunately not equally successful'. The fact of the matter was they did not sell. The remedy, according to Sir Robert Peel, was simple: build the National Gallery to instil a sense of design in the manufacturer and

to elevate the public taste. He urged the Government to grant £30,000 to finance an art collection. Lord Ashley supported the motion with the comment that artists and mechanics and the industrious classes in general would thereby be enabled to spend their leisure hours in an atmosphere of beauty 'instead of resorting to alehouses, as at present'. Mr Hume, perhaps more pertinently, contrasted the efficiency of the school at Lyons, which trained specialist designers for the textile trade, with the fact that in the whole of Coventry 'only one man was at all proficient in forming designs for silks'.

In 1835, eleven years before Henry Cole's Minton teaset won its prize, Mr Ewart's Select Committee had been formed 'to inquire into the best means of extending a knowledge of the arts and principles of design among the people (especially the manufacturing population) of the country'. It was mainly concerned with the inferiority of English products compared with French, and the extent to which industry in England depended on plagiarized foreign designs; it also considered the comparative states of art education in England and abroad. For almost a year, the Committee collected the opinions of artists, industrialists and spectators, including James Nasmyth, inventor of the steam hammer (who insisted incidentally on 'the entire reconcileability of elegance of form with bare utility'). The views of the experts were collected together into a depressing 350-page report which concluded that 'from the highest branches of poetical design down to the lowest connexion between design and manufactures, the Arts have received little encouragement in this country'. The witnesses stressed 'the want of instruction in design among our industrious population'. The result was that a Normal School of Design was set up by the Board of Trade in London straight away, and by 1846, when Cole began campaigning, eleven outer Branch Schools received Government support.

In spite of this activity—committees, national galleries, a dozen far-flung schools intent on training in design—nothing much had happened to convince the manufacturers that industry in Britain had any need of art. This was Cole's first object : a practical alliance between the fine artist and the manufacturer. In 1847, he announced the formation of 'Summerly's Art Manufactures'. His principal idea was to revive 'the good old practice of connecting the best Art with familiar objects in daily use'. He was evidently

9

thinking of the time, about a century before, when George Adams, the King's architect, designed pottery for Josiah Wedgwood, and John Flaxman, the sculptor, and other British artists were employed from time to time by the potteries in Staffordshire. With great enthusiasm, Cole rounded up a number of well-known painters and sculptors, Dyce and Herbert, John Bell, Richard Redgrave, Sir Richard Westmacott, and other academicians, to co-operate with the 'most eminent British manufacturers' to produce such things as vases, decanter stoppers, christening mugs, mustard pots, bread platters; bread knives with handles in the shape of Indian corn; a hall stand for hats, cloaks and umbrellas, with a looking-glass; a lamp; a letter-box and brush-box and an inkstand all combined.

In practice Henry Cole was not a revolutionary: the works of Felix Summerly were hardly epoch-making; to a very large extent, they were true products of their time with their craze for ingenuity, their urge to tell a story. Cole is less important as a visual innovator than as the first great propagandist for design. Long before Frank Pick and Gordon Russell, far in front of any government-supported Council of Industrial Design, Cole was infiltrating his artists into industry and trying very fervently to raise the public taste.

Summerly's Art Manufactures were apparently commercially successful. Although the project ended in 1850, when Cole became preoccupied with plans for the Great Exhibition, his collaborators in this practical attempt to promote design in industry stayed round him many years. The Cole group, which grew increasingly substantial, carried on the movement for reform in other ways, constantly aiming to provide 'the enjoyment of taste to the enormous and now all-powerful bourgeois class'. They themselves belonged to it. They were the establishment: the art teachers and art critics, the more worldly of the painters and the sculptors, inveterate committee members, earnest clubmen. The Etching Club, for instance, with its friendly monthly meetings, was a Cole group social centre and recruiting ground as well.

This was the essential Cole group: John Bell, sculptor and designer for Summerly; William Dyce, painter and friend of the Nazarenes, for five years head of the School of Design; George Wallis, artist and pupil of Dyce, principal of schools at Manchester and Birmingham; John Callcott Horsley, a painter specializing in

domestic and countryside scenes, designer of Cole's first Christmas card and teacher at the School of Design; Richard Redgrave, painter, Summerly designer and, once again, a teacher at the School of Design; Gottfried Semper, German architect, writer and educationalist, who first came to England for the Great Exhibition; Owen Jones, Welsh architect, lecturer and theorist; Matthew Digby Wyatt, writer and designer, Secretary to the Exhibition executive. This active and articulate and more or less creative body of reformers was later to include Ralph Nicholson Wornum, critic and journalist, whose outbursts against Cole were pacified completely by the diplomatic offer of a job as Cole's librarian. After taking office, his views were well in line.

Cole's group was very worthy, level-headed and efficient; moderate in outlook and methodical in practice. Reform of design entailed a sequence of committees, a series of reports and pressures on the Government. But curiously close to these well-disciplined endeavours loomed the unconventional figure of Augustus Welby Northmore Pugin, architect, Gothic revivalist, author, pamphleteer. Before he died of madness at the age of 40, Pugin had established his own art workshops, anticipating Morris and all the Arts and Crafts. He had also propounded theories which quite obviously basically influenced Henry Cole and friends: in *True Principles of Pointed or Christian Architecture*, published in 1841, he maintains that 'all beautiful forms in architecture are based on the soundest principles of utility'. And although his ideals were more extreme than Cole's, springing from his passionate Catholic conviction that mediaeval Gothic was the godliest of styles, the two were in basic agreement on the point that 'the great test of architectural beauty is the fitness of the design to the purpose for which it is intended'. So much so that Pugin, who was not a born committee man, sat on the judging panel to select exhibits from the 1851 display for Cole's new Museum of Ornamental Art.

The rational side of Pugin, his 'soundest principles', his emphasis on fitness for purpose and good sense, are evident in all the Cole group writings of the period. They dominate Cole's *Journal of Design and Manufactures*. For Cole, like many subsequent reformers, had decided that to publicize his movement he must have a magazine. The first volume was issued in March 1849. There were 'Forty-Four Fabric Patterns inserted and upwards of two hundred engravings'. There were contributions from Dyce and

Owen Jones, Matthew Digby Wyatt and John Bell and a paper from the German Gottfried Semper, all urging the reform of design in British industry. Wrote the critics of 1849: 'The more we see of this subject the more satisfied we become that every one concerned with it—the public, manufacturers, designers, art workmen, and ourselves—have all very much indeed to learn.' (One has only to turn to critics writing in 1949, the year in which *Design* magazine was first produced, to see that this view of things survived almost unaltered, in spite of all attempts at reformation of design.)

*The Journal*, like Henry Cole himself, was multi-purpose. It was published ostensibly for British manufacturers: in fact it purported, at one time, to be their spokesman. It was, simultaneously, Henry Cole's weapon in a running battle with the Schools of Design and with the *Art Union Journal*; it publicized (and even sometimes criticized) Summerly's Art. It had the general function of disseminating principles of ornament, of laying down the law that decoration should consist of appropriate motifs drawn from nature, strictly related to the object's use. In general, it advertised the stylized, flat patterns which in the view of Cole—and Pugin long before him—had more moral validity than freer natural styles. Criticism of new products, always frank and often rude, help throughout the *Journal* to put Cole's ideas across. A trowel with amorini decoration is detested: 'we think it ought to be unmistakeably a trowel'.

The first of the Journals was dedicated to Prince Albert, President of the Society of Arts: 'In respectful acknowledgement of the uniform and successful endeavours of His Royal Highness to aid the progress of the arts and manufactures of His adopted country.' This grateful dedication was more than surface politeness. Henry Cole and Prince Albert were by then devoted allies. In fact, the Cole group's slogan, 'art applied to industry', was said to have originated with the Prince. For Prince Albert was deeply interested in design, both in theory and in practice. His theories derived from the virtuous criteria of his fellow-countrymen, the Nazarenes, with their near-religious sense of vocation and their emphasis on honest, earnest craftsmanship, of which the work of Semper is a perfect, dull example. The practice of Prince Albert—who designed a small variety of trophies and adornments, a royal billiard table and the Balmoral tartan (grey, black, lavender and

red)—was not perhaps distinguished, but endearingly wholehearted. The details of all palace decorations much concerned him; in 1845, for instance, he was busy with samples of new wallpapers for Osborne House.

The Prince had a natural interest in promoting art in industry. From 1843, as President of the Society of Arts, he stressed the great need to encourage 'more efficiently the application of the Fine Arts to our manufactures' in order 'to wed high art with mechanical skill'. He encouraged the Society to organize a series of selective industrial design exhibitions, with medals for outstanding examples of the marriage of art and technique. It was one of these medals, in 1846, which Cole's 'Felix Summerly' teaset had won.

The Prince and Henry Cole had a great amount in common : a moral sense of beauty, an obsession for detail. Between them they tried hard to resurrect the Society of Arts which had been founded in 1754 'for the encouragement of arts, manufactures and commerce', but which from the day of its foundation had proved fairly ineffective : it was almost moribund. The Prince and Cole agreed that strictly-chosen exhibitions of industrial design would raise the public taste and prove to manufacturers how art might be applied. The scheme was quite successful : attendance figures rose from 20,000 in 1847 to 100,000 in 1849. But Cole came under fire for the preponderance of Summerly Art Manufactures in the displays at the Society of Arts. Cole's autocratic methods were apparently resented; inevitably, maybe, he was known as 'Old King Cole'.

These small exhibitions gave way to an immense one : the Great Exhibition of 1851. Who was the progenitor, Prince Albert or King Cole? Both were so involved in it that this is not quite clear. But Cole is on record as proposing to Prince Albert, in January 1848, a series of national industrial design exhibitions; Prince Albert sounded out some members of the cabinet and though, at this juncture, they were unenthusiastic, Cole's original suggestion no doubt paved the way for the Great Exhibition when, after long negotiations, it finally appeared.

Cole was on the planning committee, and was later granted leave of absence from the Public Record Office to serve on the Exhibition executive. He and his friends from the Art Manufactures and the *Journal of Design* were fully occupied with the Great Exhibition, making plans and making comments. They were full

of jubilation. The *Journal of Design* rejoiced at the impending improvement in the standards of industrial products. Matthew Digby Wyatt expected Paxton's building to exercise a powerful influence on national tastes. They seem to have imagined that the Exhibition would be a turning-point in the campaign for good design : in the words of a Cole spokesman, 'Since the period of the Reformation we believe the prospects of Design have never been so good as at the present time in England.' Prince Albert's prophecies were still more optimistic : praising 'the great principle of division of labour' and 'the stimulus of competition and capital', he came to a crescendo, 'So man is approaching a more complete fulfilment of that great and sacred mission he has to perform in this world.'

After this, the Exhibition was a fearful anti-climax. Queen Victoria, of course, made appreciative comments : '*Such* efforts have been made, and our people have shown *such* taste in their manufactures.' But Cole and his colleagues were not nearly so impressed. The Queen 'felt so grateful to the great God', but the critics hit out at the tasteless manufacturers, condemning all objects offending against the principle of appropriate ornament. There were thousands : from blatant absurdities like the notorious Town Mansion House for bees to humbler iniquities like carpets filled with holes, wallpapers showing landscape in perspective, slabs of glass made to imitate marble, pieces of metal textured as chain-mail, creations in grass and dyed flowers and chocolate, meaningless contraptions of extreme complexity, in general— according to an irate spectator—'startling novelty or meretricious decoration leading, in most cases, to an extreme redundancy of ornament'. Past styles, in all directions, underwent most gross revivals; Owen Jones, irritated and astounded, deprecated 'the vain and foolish attempt to make the art which faithfully represents the wants, the faculties and the feelings of one people, represent those of another people under totally different conditions'.

Owen Jones found the Great Exhibition most dispiriting : it proved that we were far behind our European neighbours; it showed that we were plunged in 'chaos and disorder in art'; it revealed the manufacturers' incredible stupidity : 'We are amazed at the shortsightedness of the manufacturers, who do not see how much it would be in their interest to begin by having a real and proper design from the hands of an artist.' Shortsighted manufac-

turers : this charge was to be levelled again and again by reformers of design. The artistic vicious circle which Jones described so forcefully recurs, of course, in every subsequent design campaign: 'No improvement can take place in the art of the present generation until all classes, artists, manufacturers, and the public are better educated in art, and the existence of general principles is more generally recognized.' Jones' plans for education involved the installation of an art museum in every town and a drawing-school in every village. Education by example was a basic Cole group creed.

For they speak with one voice, Cole and Jones, Semper and Wyatt, self-confident and reasonable, intelligent and crisp. Redgrave's *Supplementary Report on Design in the Great Exhibition* is typically sensible. As well as pointing out what was wrong with British industry, complaining of a constant lack of fitness in its products, he included a good lecture on ideal design principles: for china and glass 'the purest forms should be sought, allied to the greatest convenience and capaciousness; and the requisite means of lifting, holding, supporting—of filling, emptying and cleansing, should engage the attention of the designer, before the subject of their ornamentation is at all entered upon'. He argues for the technical education of the designer, insisting that schools should contain workshops 'where the specialities of design may be fully explained'. He also recommends the employment of designers on an executive level in the firm. This long before the Bauhaus, a century ahead of the drive for Design Management : surprisingly perceptive for its time.

In fact the aesthetic criteria of the Cole group were those of the *Architectural Review* circa 1930. The objects which they tolerated are the products with no claim to beauty whatsoever : the functional machinery, the humble cooking stove, the invalid chair with its unpretentious structure. Gottfried Semper commented that, in the Exhibition, only 'objects in which the seriousness of their use does not allow for anything unnecessary, e.g. coaches, weapons, musical instruments and the like, sometimes showed a higher degree of soundness in decoration and in the methods by which the value of functionally defined forms is enhanced'. Wyatt, in the *Journal of Design*, wrote most ecstatically on the wonders of the Menai and the Conway iron bridges.

When the Exhibition ended, the Cole group was constructive.

They had obviously decided to salvage what they could and to channel the £186,000 profit from the Exhibition towards 'the promotion of science and art and their applications in productive industry', trying to ensure that the 6 million people who contentedly thronged the Crystal Palace could be made to change their tastes. On Prince Albert's advice, and no doubt with Cole's approval, the Commissioners bought 87 acres at South Kensington for building an educational complex of museums and colleges. Wyatt finally judged the Exhibition an 'extraordinary stimulant', which could awaken all their energies : 'men's minds', he announced 'are now earnestly directed to the subject of restoring to symmetry all that had fallen into disorder.'

Henry Cole, who was of course the most symmetrical of men, was busily spending £5,000 on the most instructive exhibits he could purchase from the Crystal Palace for his own Museum of Manufactures. Agreeing with Semper that 'Public monuments and collections are the true teachers of a free people', a committee consisting of Cole, Herbert, Redgrave, Owen Jones and Pugin selected Elkington electrotypes, china from Minton and Sèvres, oriental arms and armour, Belgian gold and silver, and other striking objects, including—perhaps from politeness—a few of Pugin's chalices. To this well-intentioned collection were added all the samples which had been kept in lamentable disarray at the Schools of Design, and objects which were bought from the 1844 Exhibition in Paris. Cole sifted them all through and set up his Museum of Manufactures in Marlborough House.

It was mainly for the benefit of students; but the public keenly attended the museum exhibitions. Prince Albert liked the scheme and gave Henry Cole permission to search the Palace cupboards for examples of Sèvres china. The British manufacturers were less enthusiastic when Cole set up a Chamber of Horrors in design, naming the producers. Charles Dickens, to whom Cole was anathema, makes use of the Museum for the scene in *Household Words* in which Mr Crumpet of Clump Lodge in Brixton returns home discontented with his own design for living and is terribly haunted 'by horrible shapes'. Needless to say, such was the outcry that Cole's display of horrors was very soon dispersed. The Museum, renamed more grandly the Museum of Ornamental Art, later moved to South Kensington and later still became the Victoria and Albert. It is more of a monument, in fact, to Henry Cole.

Alongside the Museum, Cole was now in charge of the School of Design. It seems that he had had his mind on it for years. For Cole could not resist the call for reformation, and the School of Design had been an out-and-out fiasco. Already, two government committees had examined the failure of the institution, concluding wanly that 'there has been an immensity of time consumed in disputations on modes of instruction and management, that might have been far more beneficially devoted to the practical business of the School'. Already Henry Cole, requested to write an official report on improvements for the school, had untiringly produced not one report but three, recording the growing dissatisfaction of manufacturers. Cole sympathized, of course, with the industrialists' view.

The trouble was that no one, in the main school or the Branch schools, knew how to set about a training for design. They could not decide whether students should be given a broad training in art, including life drawing, or whether the course should be commercial and technical, with industrial machinery instead of human figures. The argument for practical, commercial design training was forcefully expressed by Gabriel Tinto who claimed that
'The moment the artisan student is taught to be an artist instead of a draughtsman, his mind becomes unsettled and aspirations arise in his bosom calculated to lead him out of the sure and solid path of commerce into the thorny and devious tract which leads to Fine Art.'

Characteristically, Cole was well set on the sure and solid path of commerce. He believed that students should be trained to be of immediate use to industry : none of this high art, but a practical course in geometry and ornamental copying. 'This is the beginning of the end,' said the *Art Journal* at the news of his appointment. But Cole was quite impervious to rudeness. He was, luckily for him, utterly self-confident. Installed as Superintendent of the Department of Practical Art, with Richard Redgrave as Art-Superintendent in charge of the London School, he sat back and pronounced, with benign smugness,
'We cannot hope to escape from mistakes, but we trust that vigilance, firmness, prudence and conciliation, will reduce the number and afford a fair trial in this new attempt to afford practical art instruction.'

Systematically, Cole set off on a tour of Europe : Berlin, Dresden

B

and Vienna. Systematically, he aimed to reorganize entirely national art training, to strengthen the school in London in its role as provider of designers for industry and teachers for the board schools, to establish a network of practical, and self-supporting, art schools in the provinces. He emphasized the need for national drawing classes, for he believed that 'the improvement of manufactures is altogether dependent upon the public sense of the necessity of it, and the public ability to judge between what is good and bad in art'. By 1864, at the time of another Select Committee, Cole's achievements were impressive : 90 art schools with 16,000 students; art teachers teaching 70,000 schoolchildren. On paper, Cole was excellent at making systems work.

But in practice his success was limited. His products, the Summerly Art Manufactures, made no lasting impact. His promotional activities got him almost nowhere : by 1874, a series of industrial design exhibitions had to be curtailed for lack of support. What is more, his friends and pupils, in terms of actual products, made little contribution to the progress of design. George Moore maintained : 'The schools were primarily intended as schools of design where the sons and the daughters of the people would be taught how to design wallpapers.' The attack is very waspish, but pretty nearly true.

The only designer of Cole's generation to work with manufacturers consistently and practically was Alfred Stevens, a sculptor outside Cole's group, with reactionary Italianate-academic views. The only designer of successive generations to work industrially with any genius was Dresser : Christopher Dresser, Doctor of Botany and lecturer on principles of ornamentation. Dresser was a very original designer, who worked with several manufacturers of pottery and glass and metalware and also opened his own shop in New Bond Street. At Dresser's Art Furniture Alliance the attendants were 'robed in many aesthetic costumes of the period in demure art colours'. This 'added a certain air to the place' : an air which, one suspects, Cole could not tolerate.

For this was 1880 or so. By then, John Ruskin had spent a quarter-century attacking Henry Cole. Ruskin's swarthy Christianity, his love of natural nature and his overall idealism cried out against Cole's pompous and bleak commercial outlook, the Cole group's flat, prim patterns, Cole's systematic training for designers at South Kensington. 'Try first to manufacture a Raphael,'

thundered Ruskin, 'then let Raphael direct your manufacture.' And in fellowship with Ruskin, and quite opposed to Cole, a new reforming movement, both gentler and more rugged, more romantic, more humanitarian, had begun. Cole's tight neat attempt to promote 'an alliance between fine art and manufacture' was swept away completely by the larger proposition, more practical and also a good deal more fantastic, that 'the beginning of art is in getting our country clean and our people beautiful'.

BOOK LIST

Adburgham, Alison  *Liberty's. A Biography of a Shop* (George Allen & Unwin, 1976)
Ames, Winslow  *Prince Albert and Victorian Taste* (Chapman & Hall, 1967)
Aslin, Elizabeth  *The Aesthetic Movement* (Elek, 1969)
    *19th Century English Furniture* (Faber, 1962)
Bell, Quentin  *The Schools of Design* (Routledge & Kegan Paul, 1963)
Cole, Sir Henry  *Fifty Years of Public Work* (G. Bell & Sons, 1884)
Dresser, Christopher  *Principles of Art* (London, 1881)
    *Principles of Decorative Design* (Cassell, Petter & Galpin, 1873)
    *Studies in Design* (London, 1876)
Edwards, Ralph and Ramsey, L. G. G.  *Early Victorian Furniture, 1830–1860* (Connoisseur Guides, 1958)
Gibbs-Smith, C.  *The Great Exhibition of 1851* (Victoria & Albert Museum, 1950)
Girouard, Mark  *Sweetness and Light: The Queen Anne Movement* (Oxford, 1976)
Gloag, John  *Victorian Taste* (George Allen & Unwin, 1962)
Jervis, Simon  *Victorian Furniture* (Ward, Lock, 1968)
Jones, Owen  *Grammar of Ornament* (Day & Son, 1856)
Pevsner, Nikolaus  *Academies of Art* (Cambridge, 1940)
    *High Victorian Design* (Architectural Press, 1951)
Pugin, A. W. N.  *The Principles of Pointed or Christian Architecture* (London, 1841)
Redgrave, Richard  *Manual of Design* (Chapman & Hall, 1876)
Rolt, L. T. C.  *Victorian Engineering* (Allen Lane, 1970)
Spencer, Robin  *The Aesthetic Movement* (Studio Vista, 1972)
Stanton, Phoebe  *Pugin* (Thames & Hudson, 1971)
Stewart, Cecil  *Art in Adversity: A Short History of the Regional College of Art, Manchester* (Royal Manchester Institution, 1954)
Wornum, Ralph  *Analysis of Ornament* (Chapman & Hall, 1856)

EXHIBITION CATALOGUES

*The Aesthetic Movement and the Cult of Japan* (London, Fine Art
Society, 1972)
*Great Exhibition of 1851*. Illustrated catalogues, 1851; Reports by the
Juries, 1852.
*International Exhibition of 1862*. Centenary booklet issued for 'London
1862' exhibition. (London, Victoria & Albert Museum, 1962)

PERIODICALS

*Art Journal*, 1839–1912
*Journal of Design and Manufacture*, 1849–52
*Royal Society of Arts Proceedings*

# The Arts and Crafts
# 1860–1915

WILLIAM Holman Hunt, long before he painted 'Little Nell and her Grandfather', 'The Light of the World' or 'Isabella and the Pot of Basil', had down-to-earth experience of industrial design. He had worked as a juvenile pattern designer, from the age of fourteen, in Richard Cobden's London office, producing commercial designs for cotton prints. This monotonous apprenticeship influenced his attitude for ever; it gave him a passion for reform. He explained : 'My past experience in pattern designing and my criticisms upon the base and vulgar forms and incoherent forms in contemporary furniture, to which I drew Rossetti's attention on his first visit to me, encouraged visions of reform in these particulars, and we speculated on improvement in all household objects, furniture, fabrics and other interior decorations.'

Holman Hunt could find no furniture to buy, so he designed some. He started work, it seems, in about 1855. When he showed his 'small group of household joys' to his brother Pre-Raphaelites, 'the contagion spread', and soon they were designing and painting, sometimes making, new artistic furniture for themselves and friends. For instance : Ford Madox Brown designed a chair inspired by the Egyptians and a series of countrified ladder-backs, rush-seated and stained green; Burne-Jones painted a piano with a 'chant d'amour', surmounting a picture of female musicians and death; Rossetti painted stories from Dante, and Sir Galahad, on a high-back settle for the rooms in Red Lion Square which Burne-Jones and Morris had taken over from him in 1856. At this stage their design work was all quite dilettante, a high-flown kind of hobby, done in camaraderie. A letter from Rossetti, on the move to Red Lion Square, stresses the high spirits : 'Morris is rather doing the

magnificent there and is having some intensely mediaeval furniture made—tables and chairs like incubi and succubi. He and I have painted the back of a chair with figures and inscriptions in gules and vert and azure, and we are all three going to cover a cabinet with pictures.' He describes the large round table, 'as firm, and as heavy, as a rock'.

One may ask what this impulsive, very individual feeling for reforming household objects has to do with the improvement of design for British industry. The answer is, directly, very little. Unlike Cole, who from the first was concerned with British trade and the economic consequences of inept design, the Pre-Raphaelites and Morris and the Arts and Crafts designers on the whole were rather ignorant of commerce. Some were even hostile to it. Most of them cared more for the quality of life, for a 'standard of goodness', than for national trade figures. In one sense, their reforms were much less practical than Cole's. In another sense, of course, their reforms were ten times more so. It does seem fairly obvious that without William Morris and Lethaby and Gimson and others of their kind, setting a tradition of designers in small workshops, establishing a cult of straightforwardness and soundness, truth to materials, attention to detail, that British industrial design, as we now know it, could never have developed as it has. There is a direct link from the whole Arts and Crafts movement, through the Design and Industries Association (which was in fact an offshoot of the Arts and Crafts societies), right on to the Council of Industrial Design.

In the Arts and Crafts movement, Morris is the central figure. It is almost true to say that he was the originator. Once Morris was married and had moved from Red Lion Square to his new Red House at Bexley Heath in Kent, the idea came to him of beginning 'a manufactory of all things necessary for the decoration of a house'. Philip Webb, his friend and architect, had already designed stained-glass windows for churches; and so, wrote Burne-Jones, 'the idea grew of putting our experiences together for the service of the public'. In 1861, Morris, Marshall, Faulkner & Co. brought out its first prospectus, stressing the need for 'artists of reputation' to devote their time to decorative art. The early results were on view the next year, at the 1862 International Exhibition; the Morris firm showed, among other things, a sofa by Rossetti, an iron bedstead, sideboard and washstand by Webb, a

collection of tiles painted by Rossetti, Burne-Jones, Webb and Morris, a pair of copper candlesticks too heavy to carry (according to Rossetti) and a substantial range of furniture designed in the mediaeval idiom, 'of solid construction and joiner made'.

Morris, Marshall, Faulkner, Fine Art Workmen, were publicly protesting against the prevailing style of decoration : the ponderous and complex, bogus Second Empire fashion. Walter Crane, a Morris ally, maintained in retrospect that this practical protest 'represented in the main a revival of the mediaeval spirit (though not the letter) in design; a return to simplicity, to sincerity, to good materials and sound workmanship; to rich and suggestive surface decoration, and simple constructive forms'. It meant the simple black-framed old English Buckinghamshire elbow-chair instead of wavy-backed and curly-legged stuffed seating, French-polished and often unreliably constructed; it meant bordered Eastern rugs and fringed Axminster carpets on plain or stained boards or India matting instead of 'the stuffy planned carpets'. It recommended slender black wood or light brass curtain rods; plain white or green paint for interior woodwork; canopied settles, plain oaken boards and trestles and blue-and-white Nankin, Delft or Grès de Flandres to brighten the dresser. From Morris' workshops in Queen Square developed a sophisticated cult of everyday simplicity, intended to offset *objets d'art* of lustrous splendour, and unique palatial pieces of ornately-painted furniture. This became a powerful fashion among the cultured people. 'Soon,' says Crane, 'no home with any claim to decorative charm was felt to be complete without its vine and fig tree so to speak—from Queen Square.' Though Walter Crane was biased, this was partly true.

But there was more to Morris, of course, than vines and fig leaves, more than a new rarified rich style of decoration. For Morris had already, at Oxford with Burne-Jones, embarked upon a 'holy crusade against the age', the crusade against the tyranny of factory production which John Ruskin, the writer and critic, had begun. As an undergraduate, Morris had been highly influenced by Ruskin and, in particular, by Ruskin's *Stones of Venice*, published 1851–53; the chapter on 'The Nature of Gothic,' Morris said, would 'be considered as one of the very few necessary and inevitable utterances of the century.' When he and his friends first read it, 'it seemed to point out a new road on which the world should travel' : away from competitive capitalistic commerce to

23

groups of men and maids working happily together, away from massive factories to individual workshops, from mechanized banalities to skilful craft and truth. Away from Academic convention in the arts to warmth and sincerity and Gothic spontaneity. Respect and affection for materials was essential to Ruskin's reformation, and to Morris's as well. Ruskin wrote, in *Stones of Venice*,

'The workman has not done his duty, and is not working on safe principles, unless he so far honours the materials in which he is working as to set himself to bring out their beauty, and to recommend and exalt, as far as he can, their peculiar qualities.'

Taking his doctrines to their logical conclusion—that designers should master practical techniques—Ruskin, in charge of the Oxford Museum, insisted on building a column himself. It had to be rebuilt by a professional bricklayer : Ruskin's experiment had not been a success. Morris, as technician, was a good deal more efficient. He was no doubt encouraged by the architect George Edmund Street whose office he joined briefly, first in Oxford, then in London, in the Pre-Raphaelite days at Red Lion Square. Street, a full-blown Gothicist, believing that an architect should also be conversant with the crafts, learned realistic ironwork, joinery and building; for one of his first houses, he even made the staircase. His ideal of the multi-skilled architect, and his practical energy in carrying it out, clearly affected Philip Webb and Morris who met in Street's office, and there made friends for ever. It was partly due to Street that Morris would be found with his arms dyed blue up to the elbows, in his vats; that before he began printing, he made a sheet of paper himself, out of fine white linen rags. Probably Street influenced his endless curiosity. Morris was always needing to do more. In a letter to Wardle of Leek, the printers of many of his chintzes, he admits this restlessness :

'I mean that I can never be contented with getting anything short of the best, and that I should always go on trying to improve our goods in all ways, and should consider anything that was only tolerable as a ladder to mount up to the next stage—that is, in fact, my life.'

A disciple, C. R. Ashbee, attributed the Arts and Crafts movement to the earnestness of the Pre-Raphaelite painters, the prophetic enthusiasm of Ruskin and the titanic energy of Morris. What he did not add, though it was in fact important, was that Morris' titanic energy was tempered by considerable realism. He could

compromise. On the whole, his own designs were not produced by merry groups of men and maids showing pleasure in their work; nor were they available for all the world to buy them. Morris' productions were never for the poor. Failing an ideal society, he seemed able to make friends with, and take work from, the people he opposed, the advocates of commerce; designing the Green Dining Room for Henry Cole's Museum, acting as examiner in Henry Cole's new art school, and making the most of the South Kensington exhibits, which profoundly influenced the course of his design. Perhaps this was his strength. He was not a lone reformer, shouting out against the world; he was in the thick of it, and his influence was large.

This was a period of incredible activity in the decorative arts (as the friends of Morris termed them). It was a two-fold movement, with a lot of overlapping : the tendencies, on one hand, were the airy and symbolic, with Burne-Jones and Japonaiserie and Liberty and Beardsley; the urge was, on the other, for the soundly-made and practical. This trend was very well exemplified by Philip Webb, the architect. It was the Philip Webb school, the less fanciful designers, more anxious to avoid than to create a great sensation, who had profoundest influence on subsequent developments and indirectly much improved design in British industry.

'I never begin to be satisfied until my work looks commonplace', said Philip Webb, developing Ruskin's rule of sound construction and honest work into a plea for a certain anonymity of style in the design and decoration of buildings. Philip Webb and William Morris, Norman Shaw and John D. Sedding, all at one time in Street's office, spread the principle of 'comely and workmanlike' building, the concept of pleasant modest living : in short, the decent home. Their concern took them backwards to form the Society for the Protection of Ancient Buildings, and forward to advocate the garden city. Ironically enough, the 'Anti-Scrape' Society, founded to conserve the best buildings of the past, became in fact the focus for 'a school of rational builders and modern building', as a member once described it. William Morris was the Secretary. Charles Eastlake's influential *Hints on Household Tastes*, published in 1868, encouraged a simple, clean and forthright style of living, with furniture in sturdy rustic style, hand-made by honest carpenters. For the next forty years these ideas, with variations, were carried through in practice by Mackmurdo, Frank

Brangwyn, C. F. A. Voysey; by Ashbee, Baillie Scott, Wickham Jarvis, Walter Cave, Edgar Wood, and Lethaby and Gimson and the Barnsleys; and, almost more important, by a manufacturer and seller of furniture for bedrooms, Ambrose Heal.

In 1882, the Century Guild was founded by Arthur Heygate Mackmurdo, pupil of and traveller with Ruskin, devotee of Italy, a worldly and flamboyant personality, unlike the rather dogged figures of the mainstream Arts and Crafts. In some ways he was closer to the 1880s aesthetes. But his scale of operations was similar to Morris's. Like Morris's workshops and Pugin's even earlier, the Century Guild was established to design and produce household objects of a kind which were unobtainable elsewhere; it intended to restore building, decorations, glass-painting, pottery, wood-carving and metal to their right place beside painting and sculpture: in other words, to make them no longer trades but arts. Involved with the Century Guild from the first were Herbert Horne and Selwyn Image, the poet and designer. Other members and associates included Clement Heaton, specialist in cloisonné enamel; George Heywood Sumner, master of 'sgraffito', with which he decorated many churches, and stained glass; and William De Morgan, the potter and perfecter of lustre techniques and Persian blue-green glazes. The work of the Guild, Mackmurdo's in particular, shows brilliance, a great originality, almost eccentricity, both in use of pattern and in structural design. It seems to reach maturity in the much serener, more fastidious work of C. F. A. Voysey, a younger designer, not officially a member of the Century Guild, but an adherent of its gentle, quirky style.

In 1888, the Guild of Handicraft was founded by C. R. Ashbee, a highly educated architect with socialist ideals, who put many of Morris's ideas into practice. The Guild had its origins in the Ruskin Class which Ashbee organized at Toynbee Hall for the working men of Whitechapel. This developed into the School of Handicraft and, from there, the Guild. The aim was to draw in young journeymen and train them in design for their specific craft: for cabinet-making, iron and coppersmithing, lithography, draughtsmanship, printing, house-painting, sign-writing and patternmaking. Meanwhile, workshops, run by guildsmen, would produce and sell professional handicrafts and help support the school. The system of co-partnership of craftsmen was evolved to counteract 'the unintelligent ocean of competitive industry'; it challenged 'a vast output

of rotten, useless, sweated, cheap industries, and a vast growth of nerveless, characterless, under-fed cheap men and women'. It aimed to establish a standard of goodness : goodness in work and goodness in life. In 1890, the Guild occupied a large, handsome building, Essex House in Mile End Road. In 1902, at the height of its idealism, family by family, the Guild moved in a body to a kind of promised land in Chipping Campden, Gloucestershire, where 150 men, women and children settled in cottages, kept their own pigs and dug their own allotments, acted comedies in winter, held swimming sports in summer, played in the band, led by the foreman of the woodshop, chased, engraved, enamelled, constructed honest furniture, carved wood, forged iron, and printed and bound books.

In 1890, Kenton & Co., a furniture workshop in Theobald's Road, was set up by Macartney and Blomfield, Colonel Mallet (a friend of Macartney's who 'had taste and knew people'), Gimson and Sidney Barnsley and Lethaby. Each of them contributed £100. Inspired, so they said, by what they had seen in Morris's shop window, they set to work producing their own designs in their own workshops with materials they had bought themselves. They were friends, as well as rivals, of Morris and Webb; Philip Webb was our 'particular prophet', said Lethaby. The fairness and the squareness of Webb's buildings and his furniture influenced the Kenton designers, then and later. For Kenton, which was never a very serious business, ended very amicably after two years. They enjoyed themselves greatly, Lethaby explains, 'making many pieces of furniture, selling some at little over cost price—nothing being included for design or for time expended by the proprietors' : they finally drew lots for the remaining furniture, and went their separate and influential ways. Gimson and the Barnsleys went to workshops in the Cotswolds, developing a simple finely-detailed country style. Lethaby, in London, as the leading design teacher, and later as the father-figure of the DIA, promoted the same qualities : the measured and the modest, the soundly-made, the gentlemanly and the sociable.

Where there is a movement for reform, there are committees: even the Arts and Crafts meant many meetings. The St. George's Art Society, a small discussion group formed by pupils and former pupils of Norman Shaw, enlarged its membership to make The Art

Workers' Guild in 1884. Meanwhile, a group of decorative designers, caught in a hurricane one January Tuesday in Lewis F. Day's house, had formed another group for discussion, meeting in rotation at members' homes or studios. This group, The Fifteen, under Lewis F. Day, included John D. Sedding and Walter Crane, who describes its 'happy if obscure life' over several years until it was absorbed by the Art Workers' Guild and the Arts and Crafts Exhibition Society in 1888. Crane points out that the craftsmen members came from very different backgrounds and used very different methods; but each aimed at 'a renaissance of the decorative arts which should act through and towards more humanized conditions for the workmen and employers' and, in this concern for society, 'there were few if any among them who would not readily have acknowledged Morris as their master'.

The Arts and Crafts Exhibition Society made a great impression with its first six exhibitions, in 1888, 1889, 1890, 1893, 1896 and 1899. The opening of the 1896 Exhibition was clouded, of course, by William Morris' death; but, said his admirers, 'it was a splendid moment for a hero to die.' The exhibition showed work of extraordinary quality and individuality. Craftsmen were making a name for themselves : for furniture, Barnsley, Lethaby, Cave; for textiles, Walter Crane, Lewis Day and Arthur Silver; for metalwork, Benson and Rathbone; for silver and jewellery, Ashbee, Henry Wilson, Nelson Dawson; for bookbinding, Cobden-Sanderson; for printing, Emery Walker; for glass, J. H. Powell of Whitefriars; for musical instruments, Arnold Dolmetsch; for a variety of wall papers and carpets and furniture, a mantelpiece, a clock-case and a lamp-post, Charles Annesley Voysey. His constructions were considered 'at once the most restrained and the most novel in the Exhibition'. *The Studio* magazine wrote perceptively of Voysey : 'His vivid personality is one of the chief factors in modern design—one that cannot fail to have immense influence on the design of the coming century'. And, as it happened, *The Studio* was right.

In Arts and Crafts catalogues, and in *The Studio*, there is a strong sense of the spirit of the movement : its deeply-held convictions and its almost courtly tolerance, its strong romantic outlook and its heartiness of manner. 'I want us all to be friends', said William Morris 'all to be gentlemen, working for the common good, sharing duly the common stock of pleasure and refinement.'

Perhaps it was not difficult. Many of these craftsmen were gentle-men already : they had been to public schools and on to university. Most of them were naturally friendly and gregarious : they liked long country walks, and discussions by the fireside with a great stone jar of ale, and suppers out at Gatti's where the old Italian waiter, whom they always called Tricino, was perpetually smiling. A typical enterprise, high-principled and jolly, was *Beauty's Awakening*, an Art Workers' Guild Masque, presented at the Guildhall to the Lord Mayor and Aldermen. The craftsmen had worked hard : Walter Crane designed the Dragon, Lethaby the Throne, Nelson Dawson (metalworker) the Sword for Trueheart, A. S. Haynes the Dress for Bogus. R. Rathbone, the lightmaker, of course produced the Lamp. Selwyn Image, once a curate, intoned a formal prologue. The *mis-en-scene*, one hopes, was rather better than the verse.

'The fullness of communal life' was the whole purpose. It led Ashbee to sing catches with his guildsmen after supper; it caused Gimson, in his village, to direct the merrymaking, personally leading the 29th of May. These genial impulses were very much connected with the new enlightened Socialistic movement in the country : with the Fabians, Sidney Webb and Bernard Shaw and Granville Barker, Bishops Ingram and Gore, with their ideas for Church reform, the foundation of new schools like Abbotsholme and Bedales with an open-air philosophy and brother-loving motto 'Work of each for weal of all'. The Arts and Crafts were fighting for humanized conditions; Walter Crane describes 'the movement in art represented by William Morris and his colleagues as really part of a great movement of protest—a crusade against the purely commercial, industrial, and material tendencies of the day'. If this crusade appears a little ineffective, perhaps it was because the protestors were perfectionists. When Morris left the Socialist League to form the Hammersmith Socialist Society, Walter Crane designed the banner and Morris' daughter settled down to work it. This is not the attitude which wins the revolution.

What the Arts and Crafts achieved was less a total reformation than a new and much more serious attitude to building, a fresh and simple style, a new appreciation of the objects round the house, and a sudden quite fanatical respect for craftsmen's hand-work. Faithfully or more or less erratically following the guidance of Ashbee, Guilds of Handicraft rose up in Birmingham and

29

Newlyn and places far afield : Bromsgrove, for instance, had its Guild of Metalworkers and Keswick its School of Industrial Art. The Guild up in Scotland moved its guildsmen out to Stirling, seeking (like Ashbee) the pure country life. The Guild down in Bristol opened a showroom for 30 craft members to sell their work collectively. Even in Manchester where, said *The Studio*, 'discouragements beset the pursuit of handicrafts', Walter Crane, after two years' propaganda, established a substantial Northern Art Workers' Guild.

The Royal School of Needlework, founded in 1872, commissioning designs from Morris, Burne-Jones, Crane, Selwyn Image and Alexander Fisher, stimulated the practice of embroidery. The Home Arts & Industries Association, founded in 1885 by Mrs Jebb, encouraged by Mackmurdo, propagated the idea of everyman a craftsman, and a vision of fair women all with needles in their hands. The romance of cottage craftsmanship was to a large extent responsible for numerous small craft groups, some professional, some wholly unprofessional, which quickly came to life : The Leek Embroidery Society, directed by Mrs Thomas Wardle, which issued sewing patterns; the School of Art Woodcarving in Pelham Place in London; the Haslemere Peasant Industries, founded by Geoffrey Blount, a Wykehamist, in 1896; St. Edmundsbury Weavers from 1901 in Haslemere; the Women's Guild of Arts; and many dozens more. The range and the enthusiasm of these peripheral arts and crafts revivals can be gathered from accounts of displays by the Home Art & Industries Association which annually managed to fill the Albert Hall. Exhibits included, in 1894, the brass and copper repoussé work, perfected by the parishioners of Compton Greenfield, Bristol, 'under the able guidance' of the Rector. The next year, pride of place was given to arts and industries from the royal home at Sandringham : a log-stand wrought in iron by the Princess of Wales, a little heart-shaped table with polished pokerwork which H.R.H. Duchess of York had executed.

On a more commercial level, art potteries were thriving : the Martin Brothers, Southall; Doulton's of Lambeth; Della Robbia at Birkenhead (directed by Harold Rathbone, a painter and pupil of Ford Madox Brown). Howson Taylor, Bernard Moore, Moorcroft and Pilkington's Lancastrian Pottery were all experimenting with artistic lustrous glazes. When Pilkington's exhibited in 1904 in London, showing new opalescent and crystalline effects, curdled,

mottled, flocculent and clouded texture glazes, a critic reported with a tone of ecstasy :

'In a great room draped with white were vases, bowls, dishes and trays, resplendent in all the colour of the rainbow and glittering like precious stones.'

Beyond the shining lustres, home-made silver, palace poker-work, the fluttering enthusiasms of the arts and crafts, a solider, more lasting side-effect was now emerging : the reform of official teaching of design. In 1894, William Richard Lethaby, architect and very much one of Morris's disciples, became an adviser on art to the Technical Education Board of the London County Council. George Frampton, the sculptor, was appointed co-adviser, and when in 1896 the Central School was founded 'to encourage the industrial application of decorative art', Lethaby and Frampton were made joint principals. Frampton never put in an appearance. So Lethaby himself was in fact in full control, concentrating all his energies into propagating the level-headed 'doing is designing' school of thought. Sweeping aside the method of training pursued at South Kensington since Henry Cole was there—a method which reminded Lethaby of learning to swim in a thousand lessons without water—the Central School developed a practical curriculum of craft techniques and training in the right use of materials. 'Art, construction, architecture,' exclaimed Lethaby to Central School pupils 'they are all one. You must go upstairs and see how stained glass windows are made and books are bound and gilding done.' The staff he employed were highly-skilled craftsmen : for example, Douglas Cockerell for bookbinding, Catterson Smith for wallpaper and textiles. Even a reputable plumber was brought in. Lethaby himself taught leadwork, and encouraged the practical approach. (A student described him kneeling on the carpet to admire the workmanship of a metal coat of arms.) He needed to keep up morale; for at first the Central School was very badly housed in Morley Hall, a building abandoned by the YWCA. The roof in the conservatory leaked, on rainy days, so fearfully that students had to put umbrellas up to listen to Halsey Ricardo's lectures on architecture. But they struggled through, and *The Studio* reported that the first exhibition of work by Central School students fully justified the expectations raised by the staff.

With Lethaby installed at the Central School, another very vocal Arts and Crafts protagonist was appointed to South

Kensington. In 1898, much to his amazement, Walter Crane was offered the job of Principal of the Royal College of Art. Crane, who had already been Director of Design at the Manchester School of Art, accepted reluctantly. When he arrived, he found that 'The School was in rather a chaotic state. It had been chiefly run as a sort of mill in which to prepare art teachers and masters'. He much disliked the system of working for certificates : to Crane's admittedly unacademic mind, the curriculum seemed terribly mechanical and lifeless. He seems to have tried quite hard to put it right, to make the methods flexible and to improve equipment. But he found, as others have found before and since, that 'One could not order a flower or a bit of drapery, or obtain any ordinary immediate studio requirement without a proper form duly signed and countersigned in the right red-tape department.' It was all too much for Crane. He got on badly with the staff; a fierce attack of 'flu 'left depressing effects'; the job, which had been offered on a part-time basis turned out to be full-time, and Walter Crane was longing to finish the scenes in the Masque he was writing for the Guildhall performance by the Art Workers' Guild. Besides, his own design practice was suffering. He resigned at the end of the year.

But the influence of Arts and Crafts philosophies on the training at the Royal College of Art was not to end with Walter Crane's resignation. In 1900, Lethaby himself became the First Professor of Design at the Royal College of Art, doubling the influence of his theories that 'Designing is not the abstract power exercised by a genius. It is simply the arranging how work shall be done.' Until 1911, Lethaby divided his time between the Central School and RCA; then he retired from the Central to concentrate on his South Kensington professorship. Beresford Pite, the Professor of Architecture, watched Lethaby's reforms with admiration, describing him 'disintegrating the creepers and parasites of form, weeds which had planted themselves at South Kensington and taken root . . . and supplanting them with the healthy seed of truth and directness of expression'.

It is very interesting, although not at all surprising, that the influence of Arts and Crafts ideas was strong in Europe long before it got to Kensington. The Arts and Crafts, as usual, were more honoured on the continent than they were in Britain, and better understood. Early in the 1880s, Crane was pointing out that 'In

Belgium particularly, the work of the newer School of English designers has awakened the greatest interest.' The Belgian, Van de Velde, exclaimed that 'it was spring' when the first of the Arts and Crafts arrived from England. By 1895, when Bing's shop L'Art Nouveau opened in Paris, England was acknowledged as the source of a whole new visual style : 'When English creations began to appear, a cry of delight sounded throughout Europe. Its echo can still be heard in every country.' For Art Nouveau in France, Jugendstil in Germany, Secessionstil in Austria, Stile Liberty in Italy and all the variations in Holland, Scandinavia and even Spain and Russia can to some extent be traced right back to Britain, back to Ruskin and to Morris, to their new intense perception, to their love of handicraft. At the end of the century, to Loos in Vienna, the centre of civilization was London.

Morris and Crane, Ashbee and Voysey, Baillie Scott and Mackintosh, the Glasgow architect, were the best-known, most-admired of the designers on the Continent. Their work was illustrated in the magazine *The Studio* which had a reverential foreign circulation; Peter Altenberg describes the arrival of a new issue in a cultivated household in Vienna as 'a kind of silently aesthetic celebration. The British designers were shown in the flesh in the small avant-garde continental exhibitions : La Libre Esthétique in Brussels, for instance, showed Morris and Ashbee and Voysey and Beardsley. They later exhibited in the larger international displays which multiplied and prospered at the turn of the century : Paris 1900, Glasgow 1901, Turin 1902. British designers even worked abroad. Mackintosh decorated a music room for Fritz Warndörfer in Vienna. Baillie Scott, with six other artists —the elite of the continental movement—was asked to design the Grand Duke of Hesse's Palace at Darmstadt, the centre of a whole community of artists in which every object in every house was to be designed, in every detail, by the owner. This enthusiastic project, so immaculate in principle, was attributed to the influence of 'The English art of furniture making, the theories of Morris, the actions of men like Ashbee and Baillie Scott, of the Belgian, H. van de Velde, the Japanizing tendency introduced by the house of L'Art Nouveau (S. Bing) of Paris' : not forgetting the contribution of the Germans, who by then had developed ideas of their own.

The Germans sent Hermann Muthesius to England. From 1896 to 1903, Muthesius, an architect, was attached to the German

embassy in London, for official research into English housing. Sir Robert Lorimer later described how Muthesius 'showed the greatest interest and keenness in the British Arts and Crafts Movement. He travelled all over the country, interviewed everyone, got the loan of designs and of photographs of work and every kind of information he could lay his hands on'. He reported back to Germany. In 1898, he gave first-hand impressions of Ashbee's Guild and School of Handicraft in the German magazine *Dekorative Kunst*, stressing Ashbee's preference for functional forms. In 1901, Muthesius published a book on English contemporary architecture; in 1904 and 1905, he brought out three illustrated volumes on modern English houses, emphasizing sanity and sound use of materials, the fundamental principles of English Arts and Crafts. Simultaneously, encouraged by Muthesius, large folios of drawings by Baillie Scott and Mackintosh were published in Germany. Already, the Germans' design appreciation, with determined application, was a step or two ahead. In 1901, *The Studio* had noted in German government circles and manufacturers 'a far-sighted alertness to the practical value of good design'; the German manufacturers seemed to be determined 'to wrest from British craftsmen and designers their initiative supremacy in the applied art campaign'.

Following on from Muthesius' researches, the authorities in Germany began to take design education very seriously. Lorimer reported rather bitterly that in Germany 'every help and encouragement was given to the teaching of design for technical purposes. The immediate result was that a great amount of "New Art" design was produced, worse than anything of the kind produced here. But—and this is the remarkable and interesting part—a few years before the war, the Germans had worked through this phase, and arrived at the production of simple straightforward designs'. It was in fact in 1905 in Dresden that the Deutsche Werkstätten exhibited Richard Riemerschmid's mass-production furniture, a style of furniture specifically developed 'from the spirit of the machine'. And it was 1907 when, urged on by Muthesius (then Superintendent of the Prussian Board of Trade for Schools of Arts and Crafts), German manufacturers, architects and artists and interested laymen formed the Deutscher Werkbund, which aimed at 'combining all efforts towards high quality in industrial work'.

Meanwhile, back in England, the Arts and Crafts proceeded straightforwardly and calmly. They went their own sweet way. The Arts and Crafts Exhibitions of 1903 and 1906 showed the usual fine selection of expensive hand-made furniture, a sound display of admirable craftsmanship in oak, an English walnut cabinet inlaid with pearl, a pulpit inlaid with ebony, a decorative carving in silver, gilt-bronze and gold, forming a Gothic overmantel, intended 'for a room in which armour is hung'. Walter Crane designed a mace; May Morris had embroidered 'a truly beautiful cushion'; Mr and Mrs Arthur Gaskin showed 'a dainty little group of hat-pins and lace-pins', some of them with precious stones at the head. *The Studio*, which felt that it had all been seen before, was moved in 1906 to complain : 'The arts and crafts in this exhibition, almost failing to contend for improvements in the practical necessities of domestic comfort, have taken very seriously the covers of the books we shall read, and jewellery that will be worn in the evening.'

The Arts and Crafts, one must remember, were never open-minded. They were insular. They kept to their familiar ideals of wholesomeness. They disliked the new and foreign; they distrusted the extremes. Early on, they had detested the room which Edward Godwin designed for Oscar Wilde; according to May Morris, it was 'needlessly spartan—there was a hair-shirt vigour about it, opposed to all geniality or prandial humours'. With much the same suspicion, designers from Glasgow—Mackintosh, McNair and the Macdonalds—were disparaged, underestimated and labelled 'Spooky School'. Art nouveau was called 'the squirm'. When 'the squirm' arrived in Britain, when exhibits from Paris 1900 were displayed at the Victoria and Albert Museum, Lewis F. Day and Walter Crane were outraged. In a letter to *The Times*, three very reputable architects maintained that 'This work is neither right in principle nor does it evince a proper regard for the material employed.' It was this same spirit, the Arts and Crafts resistance to what was regarded as excessive novelty, which underlay the almost total apathy in Britain towards the design developments in Germany.

This is not to say that the English Arts and Crafts men opposed design for industry in principle. In fact, most of them designed for machine production regularly : Morris, Crane, Mackmurdo, Lewis Day and Voysey; Benson and Silver exclusively so. But,

one way or another, design for mass-production was not what they believed in; it was nowhere near their heart. The Society they formed in 1888 for promoting art in industry was never very earnest. This National Association for the Advancement of Art and its Application to Industry—'a somewhat large order', said Crane—held congresses in Liverpool, Edinburgh and Birmingham. Some of the ideas expressed by individual speakers were potentially constructive. But, as a body, the Association achieved nothing and was very soon abandoned. Perhaps it was doomed from the first, from the moment at the inaugural meeting when Edmund Gosse brought in statistics of trade and the cotton industry—' "Things," as Oscar Wilde, who followed him, insisted, "which we do not want to hear about at all." '

BOOK LIST

Amaya, Mario   *Art Nouveau* (Studio Vista, 1966)

Arts and Crafts Exhibition Society   *Arts and Crafts Essays*, from 1888

Ashbee, C. R.   *Craftsmanship in Competitive Industry* (Grant & Co. for Essex House Press, 1908)

   *An Endeavour towards the Teachings of John Ruskin and William Morris* (Essex House Press, 1901)

   *A Few Chapters in Workshop Reconstruction and Citizenship* (Guild and School of Handicraft, 1894)

   *Modern English Silverwork* (facsimile edition, B. Weinreb, 1974)

Banham, Rayner   *Theory and Design in the First Machine Age* (Architectural Press, 1960)

Boe, Alf   *From Gothic Revival to Functional Form* (Basil Blackwell, 1957)

Bradshaw, A. E.   *Handmade Woodwork of the Twentieth Century* (John Murray, 1962)

Briggs, Asa   *William Morris: Selected Writings and Designs* (Penguin, 1962)

Crane, Walter   *An Artist's Reminiscences* (Methuen, 1907)

   *William Morris to Whistler* (G. Bell & Sons, 1911)

Day, Lewis F.   *Everyday Art: Short Essays on the Arts Not-Fine* (London, 1882)

Franklin, Colin   *The Private Presses* (Studio Vista, 1969)

Heal's Catalogues 1853–1934 (David & Charles, 1972)

Henderson, Philip   *William Morris* (Thames & Hudson, 1967)

Howarth, Thomas   *Charles Rennie Mackintosh* (Routledge & Kegan Paul, 1952; revised edition, 1976)

Kornwolf, James D.   *M. H. Baillie Scott and the Arts and Crafts Movement* (Johns Hopkins Press, 1972)

Lethaby, W. R. *Architecture* (Oxford University Press, 1955)
 *Form in Civilization* (Oxford University Press, 1922)
 *Philip Webb and His Work* (Oxford University Press, 1935)
Lethaby, W. R. (ed), *Ernest Gimson, His Life and Work* (Ernest Benn, 1924)
Mackail, J. W. *The Life of William Morris* (Longmans, Green, 1899)
Macleod, Robert *Charles Rennie Mackintosh* (Country Life, 1968)
Madsen, S. Tschudi *Art Nouveau* (Weidenfeld & Nicolson, 1967)
Massé, H. L. J. *The Art-Workers' Guild* (Shakespeare Head Press, 1935)
Morris, May *William Morris, Artist Writer Socialist* (Basil Blackwell, 1936)
Morris, William *Collected Works* (Longmans, Green, 1910–15)
Morton, Jocelyn *Three Generations in a Family Textile Firm* (Routledge & Kegan Paul, 1971)
Naylor, Gillian *The Arts and Crafts Movement* (Studio Vista, 1971)
Nuttgens, Patrick 'A full life and an honest place', chapter 7 in *Spirit of the Age* (BBC Publications, 1975)
Pevsner, Nikolaus *Pioneers of Modern Movement* 1936; revised edition *Pioneers of Modern Design* (Penguin, 1960)
 *The Sources of Modern Architecture and Design* (Thames & Hudson, 1968)
 *Studies in Art, Architecture and Design,* vol. 2 (Thames & Hudson, 1968)
Pevsner, Nikolaus and Richards, J. M. *The Anti-Rationalists* (Architectural Press, 1973)
Ruskin, John *Seven Lamps of Architecture* (Smith, Elder, 1849)
 *Stones of Venice* (London, 1851–3)
Saint, Andrew *Richard Norman Shaw* (Yale University Press, 1976)
Schmutzler, Robert *Art Nouveau* (New York, Harry N. Abrams, 1962)
Sedding, John D. *Art and Handicraft* (Kegan Paul, Trench, Trübner, 1893)
Selz, Peter and Constantine, Mildred (eds) *Art Nouveau* (New York Museum of Modern Art, 1959)
Service, Alastair *Edwardian Architecture* (Thames & Hudson, 1977)
Service, Alastair (ed) *Edwardian Architecture and Its Origins* (Architectural Press, 1975)
Taylor, John Russell *The Art Nouveau Book in Britain* (Methuen, 1966)
Watkinson, Roy *William Morris as Designer* (Studio Vista, 1967)
 *Pre-Raphaelite Art and Design* (Studio Vista, 1970)

### EXHIBITION CATALOGUES

Arts and Crafts Exhibition Society catalogues (Chiswick Press, from 1888)
*The Arts and Crafts Movement* (London, Fine Art Society, 1973)
*C. F. A. Voysey* (Brighton Art Gallery, 1978)
*Charles Rennie Mackintosh* (London, Victoria & Albert Museum, 1968)

*Ernest and Sidney Barnsley: Good Citizens' Furniture* (Cheltenham Art Gallery and Museum, 1976)
*Ernest Gimson* (Leicester Museums and Art Gallery, 1969)
*Morris & Company 1861–1940* (London, Arts Council, 1961)
*Victorian and Edwardian Decorative Art* (London, Victoria & Albert Museum, 1952)

PERIODICALS

*Architectural Review*, from 1897
*The Studio*, from 1893

# The D.I.A.
# 1915–1928

ONE Sunday morning in 1914, late in the summer, two men sat talking, sanely and convivially, in a garden on Chiswick Mall. One was Harold Stabler, the silversmith : the other, the owner of the garden, was the artist Ernest Jackson. It could have been an Arts and Crafts discussion. As it happened, this was the beginning of the DIA.

The Design and Industries Association, which intended 'to instil a new spirit of design into British industry', was almost an extension, the phoenix from the ashes, of the English Arts and Crafts. By 1912, the Arts and Crafts triennial exhibition had become not only aesthetically timid but, at the same time, a financial disaster, and a group of younger craftsmen urged the elders to take action, suggesting that the Arts and Crafts should rent a shop in Bond Street. This suggestion was rejected. But the discontent continued : of the rebels, Harold Stabler was the most energetic and persuasive.

The question had been raised repeatedly for decades : what future for the Arts and Crafts? What use to modern man? Nearly twenty years before, in 1895, *The Studio* had rather sacriligeously commented that 'Mr Benson's lamps could be more influential on public taste than Mr. Morris' : meaning that the metalwork mass-produced by Benson was in a sense more valuable than the precious handwork, the tapestries, the bindings, the mosaic overmantels, which crowded exhibitions of the Arts and Crafts. Two years later, the campaign in *The Studio* was shriller : 'Is it,' they asked 'beyond the power of a body which numbers nearly every prominent architect, designer or craftsman to face the problem of beautiful yet economic furniture? Can they not institute a section devoted

to designs with estimates of their cost attached? Is it unreasonable to suggest that they should offer diplomas of honour to those manufacturers who would submit cheap and comely furniture, well-decorated pottery for household use, dinner and tea services and the like, artistic but inexpensive table glass, low priced but satisfactory wall papers, cretonnes and carpets?'

Although this urgent challenge was never taken up—there were never any estimates of costs, still less diplomas for inexpensive tableware—there always were some members of the Arts and Crafts quite conscious of the need for a much broader-based improvement in design. In 1898, Ambrose Heal's first catalogue of Plain Oak Furniture appeared; in 1901, Lethaby, in Birmingham, urged sceptical industrialists to upgrade their design, insisting that 'A *quality* department in a *quality* business must bring reputation'—and usually profit. At this stage, much the strongest and most direct effect of Arts and Crafts on industry was obvious in printing: the private presses, Kelmscott, Doves, Pear Tree, Chiswick, Ashendene, and others, helped to transform standards in the printing trade in general. (Their influence on Germany, of course, was greater still.) J. H. Mason's Imprint type, introduced in 1912 by the Monotype Corporation, was celebrated next year with the issue of the magazine *The Imprint*, in which Lethaby attributes the British renaissance in printing to Morris' and Walker's and Hornby's good example.

All this goes to show that within the Arts and Crafts there were people who could see a little further than their noses. Stabler and his colleagues objected to the fact that so much skill and energy was so much misdirected: everyday industrial products were appalling, while high-minded artist-craftsmen found it hard to sell their work. Stabler, Ambrose Heal and Cecil Brewer, Harry Peach, and other keen dissenters, made the journey to Cologne where the Werkbund Exhibition of 1914 showed what had been achieved by Muthesius' cajoling, by Government support for design, by the German campaign for public education 'by means of lectures, exhibitions, lantern slide displays, and other devices by which the attention of people of all classes could be arrested'. This had resulted in what then seemed to the British a modern spirit 'full of vitality and hope for the future', an absolute acceptance of mechanization with its mass-production disciplines and anonymity. This spirit was summed up, in Cologne, by two exhibits, the model

modern factory designed by Walter Gropius; the revolutionary glass house designed by Bruno Taut. The DIA forefathers travelled back with great excitement, exchanging notes and samples and proposals through the summer. Cologne 1914 had given them great visions : here, up to a point, lay Britain's future in design.

It was with these visions that Stabler and Jackson sat roughing out their campaign to begin the DIA, a British equivalent of the Deutscher Werkbund which had by then been active seven years. A provisional committee of seven was appointed. First meetings were held, not entirely inappropriately, close to William Morris' old workshop in Queen Square. The August declaration of war meant added urgency : for imports from Germany and Austria had ceased, and the Board of Trade, in order to drum up British substitutes, promoted exhibitions of 'enemy products' notable for cheapness and shoddiness, quite obviously untouched by the hand —or the machine—of Deutscher Werkbund.

The DIA, fast-acting in all the best traditions of Henry Cole's reform group, wrote a memorandum to Sir Hubert Llewellyn Smith, Permanent Secretary to the Board of Trade, telling him the German exhibitions were one-sided : would he give the Werkbund a good showing? This he did. He lent several members of staff to the committee of the DIA, who had by then collected a small body of supporters, 'like-minded men and women'. They combed the shops of London, and ransacked their own homes, for well-designed German and Austrian products. Harry Peach, a stalwart member who always had his pockets and his rucksacks stuffed with samples, lent a number of exhibits, including a collection of finely-printed German books and pamphlets. The exhibits were amassed at Goldsmiths' Hall in London in March 1915. The exhibition acted, of course, as a recruiting ground for British DIA. A public meeting in the Great Eastern Hotel was followed, in May, by a more formal inaugural meeting in the Abercorn Rooms, with Lord Aberconway in the chair. At the first count, DIA members numbered 199. At least half of them were drawn from the Arts and Crafts societies : men like Selwyn Image, Anning Bell and Benson. Others were architects well indoctrinated with the ideas of Morris and Philip Webb and Street.

The executive committee met weekly, through the bombing and the anti-aircraft guns, far into the night, in Cecil Brewer's office in Queen Square. It was a period of strenuous activity and great

good-fellowship. The shaping of the DIA, formation of branches in Edinburgh and Manchester (with more to follow), the drafting of the rules and agreement on a creed—consistent but 'not too inelastic'—all took time. Hamilton Temple Smith, the designer of furniture and member of this very first committee, later listed his eight colleagues. His comments in themselves, with their sense of camaraderie, exactly show the spirit of the early DIA.

John Marshall, a Marshall and Snelgrove director, was 'a man of deep religious and artistic sensibility—a "spoiled priest" or perhaps a "spoiled artist". He it was who introduced (among other innovations) the bold pen-lettering for showcards, price tickets and advertisements, which soon ceased to be exclusive to Marshall's. But although he made his influence felt in the business world it was certainly not his spiritual home. When he volunteered for war I felt that he did so with a sense of escape; the news of his death in battle in September 1917 came as a bereavement but, somehow, hardly as a surprise'.

Cecil Brewer, the architect and cousin of Heal, 'combined an austere intellectual scepticism with a puckish sense of humour and a fastidious devotion to beauty. Already an ailing man when the DIA was first mooted, and while bearing his full share of work in a busy architectural practice, he yet found time to throw himself unstintingly into the task of forming and guiding the new Association. In so far as it can be said to have been built to any one man's design I would say it was his . . . by August 1918 he had worn himself out, leaving the DIA in his lasting debt'.

W. R. Lethaby, architect, designer, ex-Principal of the Central School, Professor of Design at the Royal College of Art, seemed 'the elder statesman—or, more aptly, perhaps the godfather of the DIA. He had been preaching the essence of its gospel for years, and had become an almost legendary figure during his own lifetime. He took little part in committee work, but his advice and pen were always at our service, and looking back, it seems to me that his philosophy of life was the touchstone by which we continually tested the soundness of our own ideas'.

'Fred Burridge had succeeded Lethaby as Principal of the Central School of Arts and Crafts, and this fact threw into sharper emphasis the difference in their temperaments. Burridge was of the planning type, admirable at framing unambiguous rules, writing reports of meetings and drafting memoranda; and he had strong

views about reforming the system of art education which were not shared by all his colleagues, least of all by Lethaby, who distrusted all systems, reformed or unreformed. But the DIA got the best that each man had to offer, and not the least of Burridge's contributions was a sort of Rabelaisian gusto.'

'Harold Stabler was not only a consummate artist and craftsman; he was also a man of wide vision and imaginative common sense. He came of Westmorland and yeoman stock and remained a countryman all his life; perhaps it was an inherited instinct for doing things in their right season that gave him his flair for producing the idea for a new activity at the psychological moment when it could be most effectively undertaken . . . it is only now that I find myself wondering, in retrospect, how many of our best ideas were *not* born in Stabler's fertile brain.'

'His friend Ernest Jackson was an artist first and last—observant, witty and detached: he brought a certain astringency into our discussions, which was invaluable in keeping enthusiasm within the bounds of what was practicable. How right he was! (and how I wished that he could sometimes have been wrong, bless him!).'

'If ever there was a man with fire in his belly that man was Harry Peach. His watchword was "quality work", and it governed all his varied activities. It was expressed in his "Dryad" products and in the numerous pamphlets he published upon handicrafts of all kinds. His first love had been printing, and I think it was never supplanted in his affections. He was an insatiable reader, and in spite of troublesome eyesight he seemed to find it possible to read every book on art and design, both English and foreign, as well as every magazine and pamphlet on those subjects. He travelled widely and kept himself abreast of all Continental developments in handicraft and industrial design. A sort of latter-day "Mr Valiant-for-Truth" he spent his life hitting out lustily and impersonally on all sides, and exchanging blow for blow without a trace of rancour. It might be said that Peach was the incarnation of the DIA militant, and certainly nobody influenced its course more strongly than he.'

And lastly there was Heal, shopkeeper par excellence, workshop-trained cabinet maker, the main link between the public and the artist-craftsmen, leading figure in improvements in design of furniture 'and of all that belongs to the furnishings of houses'. Ambrose Heal and his associates in Tottenham Court Road had

made 'unswerving efforts to carry into everyday practice the DIA principles of Right Design and Right Making'. Incidentally, the DIA symbol was an Ambrose Heal design.

As Hamilton Temple Smith had pointed out, Lethaby's philosophy of life was the touchstone for DIA ideas : Lethaby's soundness and attention to detail, Lethaby's insistence that design has no mystique. It is 'simply the arranging how work shall be done'; it is 'just the appropriate shaping and finishing for the thing required'; it is nothing but 'well doing what needs doing' : a work of art is 'first of all a well-made thing'. Lethaby's articles in *Imprint*'s first issue expressed this in forthright culinary terms : 'Art is not a special sauce applied to ordinary cooking; it is the cooking itself if it is good.' He chose his image nicely; it made its proper impact; for DIA members were modest *bon viveurs*.

'The products of industrial design have their own excellence.' wrote Lethaby for *Imprint*, in his essay *Art and Workmanship*; this excellence is 'good in a secondary order, shapely, smooth, strong, well-fitting, useful; in fact like a machine itself.' His view of industrial design as lesser craftsmanship—plain, without much character, but none the worse for that—was not the German view: there, machine-made products were whole-heartedly accepted, judged on their own merits. But it summed up very fairly the attitudes in Britain, the ideals of the DIA reformers, by and large. These were moderate ideals : is it sound and is it sober? Is it measured, is it modest; is it common sense? Are sideboards appropriate to our belongings? Are drawers and cupboards of a convenient size? Do washstands permit reasonable ablutions? In short, has the product good reason-for-being? Stamp out serendipity : 'For us,' cried the reformers, 'there is no content or peace of mind till the community of plain honest folk may buy at moderate prices commodities suited to their needs, and satisfying their sense of beauty.' At DIA meetings, the members were incited to clear the decks for action, for (mixing metaphors in the excitement of the moment) 'the tucket is sounding and somehow we must go into action or strike our colours.'

The question remained : how? The DIA was friendless : the dyed-in-the-wool craftsmen accused it of desertion; industry was hostile, and the public mainly ignorant. How was it to propagate the fairly novel theory of fitness for purpose in design for industry, the 'essential prerequisite without which any design for an article

of common use was just silly?' How on earth was it to realize its
ideal of the DIA-indoctrinated business man in his pleasant office,
seeing to the proper housing of his workpeople in dignified factories,
pleasantly equipped canteens and recreation rooms? For, as they
remarked in 1916, the work on which the DIA reformers had
embarked was ambitious and far-reaching : they took in the total
environment; they realized that few national industries were outside
their scope.

Practical as always, the DIA did not attempt to move heaven and
earth immediately. It started fairly humbly, requesting loans or
gifts of lantern slides 'illustrating good or (for contrast) bad design'.
Members got together pamphlets, organized discussion meetings,
lectured round the country, pushed and argued and persuaded,
brandishing the *DIA Journal* and preaching 'fitness for purpose'
at every end and turn. Hoping that the public would eventually
help the campaign by refusing to buy domestic articles which
they could see to be sub-standard, the reformers set about exhibiting
exemplary design. In 1915, the first DIA exhibition, 'Design and
Workmanship in Printing', was held in the Whitechapel Gallery,
and later toured round Leicester, Leeds and Liverpool and Dublin,
even travelling to South Africa. It showed great energy. The next
year, in the Arts and Crafts Exhibition at Burlington House, the
DIA—allocated one small room—showed pottery and textiles.
Fabrics for West Africans, coloured very brightly to satisfy the
natives, were acclaimed by all the *cognescenti*. On the other hand,
the trade thought the exhibition dreadful : off-the-point and pretty
tasteless. What right had these reformers to dictate to British
industry, and anyway what *was* the DIA.

Stoke-on-Trent was in an uproar (an uproar which, in fact,
lasted half-a-century and even now reverberates) because an outside
body, and still worse a group from London, had dared to pass a
verdict on the products of the potters. In Manchester, the textile
manufacturers resisted the idea of selective exhibitions of design
by totally ignoring the DIA's request for samples for display in the
Manchester Art Gallery. The DIA had written to 60 textile firms,
and only three replied. There was nothing for it, but for DIA
contingents to travel round the factories to find their own exhibits.
This was one of their great virtues : they were dogged and resilient.
They recovered from all setbacks and continued with their pro-
gramme : lecturing the Drapers Chamber of Trade on design and

quality; confronting the potters on their own home ground in Stoke, a group 230 strong, to tell them that frankly, 'Expert craftsmanship does not go hand in hand with good design'. In 1919, the DIA intrepidly formed committees to persuade the manufacturers to produce articles in compliance with DIA aims. At the same time, a register of approved designs, 'efficiency-style' products, was brought into being. An earnest Exhibition of Household Things, designed of course 'primarily to serve their purpose', was held in 1920. Furniture and fittings, pottery and glass, hardware, brooms and brushes—the main preoccupations of the early DIA— were arrayed in eight neat rooms. A critique of every product, in the style of Henry Cole's *Journal of Design* of 1849, interspersed its praises with suggestions for improvement. Efficiency was everywhere apparent, and discretion.

'Art is indispensible in life, and therefore in education and work': this worthy pronouncement, so sweeping yet so moderate, sounds quite unmistakeably authentic DIA. In fact it occurs in a Ministry of Reconstruction pamphlet, *Art and Industry*. For once the war was over, there were signs that the campaign for improved design in industry was beginning to be taken slightly seriously by the government and even by industry itself. The Federation of British Industries formed its Industrial Art Committee in 1920: the Chairman was Charles Tennyson; the aim, which was well-meaning if vague, was 'to consider the question of industrial art in this country'. In effect, this at first meant attempting to bring the training at the Royal College of Art into line with industrial requirements. The deficiencies noted by the Commissioners in 1911 —including lack of training in design for mass-production—which led them to contemplate the closure of the College, were nine or ten years later just as bad, or maybe worse.

Again in 1920, another institution for promotion of design, with Treasury support, began a new campaign, full of wishful thinking, to create a market for industrial designers. The British Institute of Industrial Art had, in fact, been in the air since 1914, when the Board of Trade and the Board of Education had combined to consider and approve the scheme. The war had postponed it. But in 1920 the Institute opened in a flurry of activity: a gallery in Knightsbridge was permanently occupied by an exhibition of industrial art and handicrafts, while three temporary displays of modern products were held at the Victoria and Albert Museum. Clough Williams-

Ellis, reviewing an Institute exhibition in *The Spectator*, pointed out how closely its standards and intentions resembled those of the DIA: 'Judging by the usual commercial products of British potteries, a missionary should certainly be sent into "Darkest Staffordshire" with the Institute's little exhibit of well designed and unpretentious chinaware.' The DIA approved of the Institute's Bureau of Information, under Major Longden; for a while they worked together, and perhaps, had all gone well, a national council for design might have emerged. But this is not what happened. With the slump, the public money granted to the Institute was soon withdrawn again, and although private subscriptions financed desultory activities, mainly exhibitions and design tours through the 'twenties, these were not in general a force to be reckoned with. The DIA was virtually on its own again.

It has to be remembered that the DIA was still very small, for all its energy, and acutely short of money. Membership in 1916 was 292; it was only 602 by 1928. The mood of early meetings can be gathered from the General Discussion, reported in the *Journal* for 1918, on 'Memorandum to Ministry of Reconstruction and Proposed Memoranda to Government Departments on The State as Buyer.

'Mr Peach considered the Food posters particularly bad, but Mr Bayes defended the frieze of silhouettes at the recent War Exhibition at Burlington House as decorative and inspiring.'

'Mr. Brewer said that though the things mentioned might be bad, the chief sins were to be found in the Government buildings; the Post Offices were glaring examples of inefficiency and discomfort.'

The chairman seems to have ended the discussion with the typical comment that the DIA must not be too drastic in its condemnation. For although the DIA connections with Morris and the Arts and Crafts were obvious, its methods were now closer to the Cole group: its discretion, its businesslike committees, its lucid memoranda. Instead of jars of ale, it drank tea in the Kardomah; instead of Gatti's suppers, it ate luncheon in the Kenilworth (2s 3d per person, gratuity included). A lot of the romance of the Arts and Crafts was over; the DIA had settled for a life of common sense, urging its designers to talk man-to-man to industry: in the interests of appeasement, never mention Art. Their founders, they insisted, 'were not dreamers in Jaeger sweaters, with blue eyes fixed on supra-mundane peaks'. Not at all: they

47

were ordinary men with ordinary needs and ordinary talents, who practised what they preached.

Little by little, saner and saner, the DIA built up its membership and influence. It did its level best to break the vicious circle (bemoaned by Owen Jones and still as bad as ever) of maker-seller-buyer. The DIA could argue for reform from a position of relative authority; for now, for the first time, the reformers were themselves manufacturers and shopkeepers. They spoke with some experience, and were not shouted down. Manufacturers important in the movement in the 'twenties were Harry Peach, maker of Dryad cane and metalware; John Adams of Carter, Stabler, Adams, the Poole potters; in textiles, Frank Warner, James Morton of Morton Sundour and William Foxton of Foxton's; in printing, Harold Curwen of the Curwen Press and Francis Meynell, founder of the Nonesuch Press in 1923. (Meynell with Stanley Morison and Oliver Simon later formed the Double Crown Club, improving the standards of design in trade publishing, dining and discussing : a club within a club.) In furniture, Gordon Russell of Broadway—as the *DIA Journal* for 1927 commented—was 'carrying on, in both furniture and metalwork, the tradition of the greatest designer and maker of recent times, the late Ernest Gimson, whose modest retiring life in the Cotswolds made him neglected by his contemporaries, but whose influence has been felt on German and Austrian design and is beginning to be felt here'.

The most enterprising shopkeepers were Ambrose Heal in London and Crofton Gane in Bristol, a DIA convert of near-religious ardour. The most vital public servant, without doubt, was good Frank Pick, a DIA enthusiast of quite a different breed, a sober meticulous qualified solicitor who went into the railways and became a chief administrator, first of the London Underground Railway and later the London Passenger Transport Board. Pick, from a conventionally cultured education, with a working knowledge of international art, before the DIA was born, commissioned Ernest Jackson and others to design him some posters for the Underground. He was one of the first 199 DIA members. As he advanced in status, he punctiliously turned the Underground (and later London Transport) into a travelling exhibition of design, commissioning new buildings, new posters and new maps, a new typeface designed by Edward Johnston for Underground publications and notices, a series of wall-tiles for stations from Stabler. In his range of

influence, and his love for detail, Frank Pick was most important : his actions carried weight. Like Henry Cole before him, he was part of the establishment; he belonged to the Reform Club, he was known, he knew the ropes. His great respectability gave prestige, which was much needed, to the DIA campaign for improved standards of design. With support from Raymond Unwin (the town planner), Charles Tennyson (Deputy Director of the FBI), Sir Frank Warner (textile-magnate and Board of Trade Advisor, Vice-Chairman of the Empire Flax-Growing Commission), and Sir Lawrence Weaver (London Press Exchange director, an ebullient protagonist for DIA ideas), Frank Pick gave the DIA considerable substance. And, judging from events before and since, authority seems to be essential for progress in design.

The Cole Group had been statesmanlike and literate. The Arts and Crafts and Morris in particular were speechmakers and writers; the Glasgow School was not (which is probably one reason why Mackintosh and Walton were so badly underrated : they never had their say). The DIA was lucky that its speakers and its writers were professionally lucid, with amazing staying-power. The most vocal propagandists were Clough Williams-Ellis, the architect and author, a very early member; Noel Carrington, the publisher and editor of most of the DIA publications; John Gloag, fiery critic of design, who had been initiated at a DIA meeting in 1924 by designer Alfred Read, and who was preaching only two years later : 'The "something safe to sell" spirit, as dangerously stupid and unconstructive as the red-hot air of communism, is the great enemy of industrial design.'

Efficiency-style had not quite superseded the missionary zeal, the old tub-thumping fervour. They somehow co-existed in the DIA in those days, when meetings, according to Carrington, were 'like a conventicle of some primitive sect'. The heathen manufacturer had still to be converted; the tucket was still sounding, the decks were still being cleared. The DIA was actively persuading its adherents to dedicate their lives to the cause of good design. Among them was John Waterer, designer of luggage, who after the first war adapted the slide-fastener (the 'zipper') from military to civilian use, and developed the whole concept of lightweight bags and cases, in new shapes and new colours. He was an enthusiast for art and woodwork and natural materials; he was also a technician, with practical knowledge of manufacturing. 'About this

D

time,' he wrote, 'I became a member of the Design and Industries Association which I found to be imbued with the same spirit as myself. To my contacts with inspired, far-sighted manufacturers, shopkeepers and idealists, I owe much.'

At this stage, what exactly did the DIA approve of? What did the idealists, then and there, find tolerable? In the *Year Book* 1923–24, Edward Harland & Sons, of North Parade, Bradford, advertised 'Foxton fabrics, Pool pottery, Lygon stools, Dryad cane and metalwork, Rowley wood pictures. Simple furniture, soundly designed and well made of excellent materials'. They knew their readership. For this seems an accurate measure of average DIA taste in the twenties, which glorified plainness and truth to materials and loathed the pretentious, the lush and the sham. DIA idealists liked Heal's straightforward furniture, 'properly planned and thoroughly useful' : his clean cottage cupboards, his bright painted chests, his comely elm dressers, his weathered oak tables. They liked Gordon Russell's sturdy Cotswold-craftsman products; they much admired the hand-block-printed fabrics of Miss Barron. Whitefriars glass and Blue Moorcroft Pottery and Cornish Ware were endlessly in favour, and Wedgwood's 'Honey Buff' underwent a Heal's revival, and was fervently promoted as setting 'standards of good taste'. By way of Crittalls' windows ('art and commerce come together'), Lanchester cars, the Rolls Royce, the Bristol plane, the largest accolade was given to the Underground which was—not surprisingly —'perhaps the outstanding example of Fitness for Purpose on a vast scale'.

DIA approval was virtuous and certain; it had the stamp of Stabler and his yeoman stock from Westmorland, and Peach, the cultured rambler in thick shoes with ruddy face. The DIA in practice was more countrified than mechanized; its standards were consistent and unadventurous. If DIA approval was wholesome and predictable, DIA distaste was equally hard-set. The DIA did not, on the whole, like coon music; 'barbarous patterns'; the ballet from Russia; the Omega workshop where, from 1913, Roger Fry, Duncan Grant and Vanessa Bell tried, not very professionally, to make everyday products in a new and better way. In much the same spirit as the Arts and Crafts resistance to art nouveau, the 'Spooky School' and Continental Werkbunds, the DIA held out against exoticism, strangeness and mechanization carried to extremes. Developments at Weimar, where Gropius had founded the Bauhaus in 1919,

roused scant interest; events in Scandinavia, the pottery and glass in Sweden, and Kaare Klint and his Copenhagen furniture, were noticed and admired but not assimilated; the Paris exhibition of 1925, with its jazziness and cubism, left the DIA quite unimpressed. The DIA reformers were intent upon their target, their British clubman's vision of national improvement : looking straight ahead and preparing for the day 'when not 100 but 1000 members sit down to Dinner in a DIA hall with DIA service and furniture'.

The obvious result was that for about a decade the international modern movement did not come to Britain. In 1927, when the DIA assembled a country-craft display for the Leipzig exhibition, this was all too obvious. Even Harry Peach, who chose it, had a hard job to defend it :
'It is not very exciting as against what the modern schools abroad may offer, but it is something English, and like all English things, sane, good, with fine individual work which will hold its own against anything the others may produce.'
Minnie McLeish, who went to Leipzig, was much sharper :
'Broadly speaking, we do not understand this modern movement in design, and do not like it.'

For the moment, that was that. But here and there designers, Alfred Read for instance, were starting to push forward. Paul Nash designed some fabrics, and Marion Dorn some rugs; a painter, Francis Bacon, designed pseudo-Bauhaus furniture. In the Cotswolds, Gordon Russell, the follower of Gimson and hero of the craftsmen, began to change his thinking. In Oxford Street, a Russian, Serge Chermayeff, was preparing the kind of exhibition which had not been seen before.

BOOK LIST

Arts and Crafts Exhibition Society *Handicrafts and Reconstruction* (John Hogg, 1919)
Battersby, Martin *The Decorative Twenties* (Studio Vista, 1969)
Carrington, Noel *Industrial Design in Britain* (George Allen & Unwin, 1976)
Franklin, Colin *The Private Presses* (Studio Vista, 1969)
Heal's Catalogues 1853–1934. (David & Charles, 1972)
Hillier, Bevis *Art Deco* (Studio Vista, 1968)
Lewis, John *The Twentieth Century Book* (Studio Vista, 1967)
Meynell, Francis *My Lives* (Bodley Head, 1971)

Morton, Jocelyn  *Three Generations in a Family Textile Firm* (Routledge & Kegan Paul, 1971)

Pevsner, Nikolaus  *Studies in Art, Architecture and Design*, vol. 2 (Thames & Hudson, 1968)

Rogers, J .C.  *Modern English Furniture* (London, 1930)

Russell, Gordon  *Designer's Trade* (George Allen & Unwin, 1968)

Simon, Herbert  *Song and Words: A History of the Curwen Press* (George Allen & Unwin, 1973)

Smith, Hubert Llewellyn  *The Economic Laws of Art Production* (Oxford University Press, 1924)

Williams-Ellis, Clough  *Architect Errant* (Constable, 1971)

PERIODICALS

*Architectural Review*
*Commercial Art and Industry*, from 1926
*Design and Industries Association Journal and News Sheet*, from 1918
*The Studio*

# The Architects
# 1928–1940

SERGIUS Ivan Chermayeff, a Harrovian, and a rather impecunious Russian émigré, who had trained in art in Paris, was apparently the person who brought the modern movement, such as it was, to Britain. In 1928, he had, somewhat improbably, married a member of the family which owned Waring and Gillow, the traditional furnishers, and that same December he had been permitted to mount an exhibition of modern French and English furniture in the family's Oxford Street store. There is no record of the reaction of Waring and Gillow's normal customers. But the *Architectural Review*, in those days the harbinger of Britain's modern movement, was ecstatic, exclaiming powerfully (if naïvely in the circumstances), 'it really is inspiring to find great decorating firms like Waring and Gillow, whose roots are firmly founded in tradition, proving their right to be counted amongst the important influences of the twentieth century, by boldly declaring their faith in a modern point of view'. Among the *cognoscenti*, there was general agreement that Mr Chermayeff had excelled himself.

What he had done was to decorate a bathroom in red and black with curtains of American cloth, and to furnish a modern English home without a sign of cosiness or hand-craft or the country-cottage dream. Serge Chermayeff—with his chromium-plated metal-tubing furniture and unit storage systems and rough grey stippled walls—introduced the style the DIA had long resisted. The DIA most valiantly tried to change its attitude. Still upholding sanity, but altering its concept of what constituted sanity and what in fact was madness, the *DIA Journal* praised Chermayeff's 'sane clear outlook unencumbered by ideas and traditions that no longer have any meaning for those who wish to live an honest twentieth-

century existence'. With quite surprising eagerness, the DIA admitted
—or commented, at least, that it could not be denied—that Serge
Chermayeff's interpretation of up-to-date furniture differed very
greatly from the attitudes and methods of those whose creed was
the teaching of Gimson and Barnsley. In the *DIA Journal* John
C. Rogers pleaded for a national conversion, an ultimate rejection
of the Arts and Crafts philosophy, arguing

'. . . it only needs an effort on our part to lay aside insular pre-
judices, to admit that perhaps, after all, our progress is not what
we imagined, and we shall acknowledge that here, in Oxford
Street, is by far the best thing yet done in this country to re-
establish the domestic crafts and to fire English designers with a
new enthusiasm. In many ways, the right note is struck, and given
the support it justly deserves, popular interest will increase, and
in a few years good modern design will sweep the country.'

He was over-optimistic. The reform was not so sudden : good
modern design has yet to sweep the country. And even with such
prodding, the DIA moved slowly : the stalwart old regime to some
extent went on. The LCC report, published 1930, on handicrafts in
elementary schools resounded with the DIA doctrine of Right-
Living and Right-Making and the charitable down-to-earth ideas
of Harry Peach. The DIA kept up its hopeful old activities : its
little exhibitions in Bristol and in Birmingham; its lists of Sensible
Presents for Christmas (from Gordon Russell's showroom, from the
Workshops for the Blind); its advertisements for Jolly Rag Rugs
(hearth size, 3 guineas) and the Legion Book printed by the Curwen
Press; its earnestness and heartiness, its friendliness and cosiness,
its frequent insularity, its members' tours abroad.

And yet, despite the jollity, the DIA had obviously not been to
Waring & Gillow's in vain. The feeling among architects,
Chermayeff and the others, that design was not a 'Honey Buff'
teapot or cane chair but concerned with life itself, with creating
whole environments, made a certain difference to the DIA. This
was the period of the Cautionary Guides to cities—St Albans,
Oxford, Carlisle—for which DIA reporters, out on day-trips with
their Leicas, brought back frightful evidence of national destruc-
tiveness. This was the era of the petrol station outcry, when the
DIA published *The Village Pump: A Guide to Better Garages*, and
even the *Daily Express* was moved to hold a competition for petrol
pump design. The *DIA Year Book* 1929–30 was entirely given over

to 'The Face of the Land'. The campaign had enlarged itself : the movement for reform was becoming more imaginative and more diffuse.

At last, though for the moment in superior circles only, in Hampstead, in the Arts Club, in the architectural schools, the British modern movement, with fervent sweeping statements and socialistic principles, was underway. Unlike the mid-Victorians— Cole and all his works—this movement did not stop at uniting art and industry. Improvements in industrial design, when they occurred, were only the by-products of the wider, more ambitious, architectural activity which aimed to rationalize man's whole environment, with hard-headed large-scale planning and logical use of the most modern industrial techniques. Far away from Ruskin and the cult of heart-felt building, remote from the DIA statement ten years earlier that standardization was the last thing it should father, the modern movement architects, standardizing avidly, with quips about the Arts and Crafts and simple-life rusticity, set about creating a reasonable Britain. To start with, they suggested that men must live in flats.

Young architects, trained at the Architectural Association or under Professor Charles Reilly at Liverpool, stood waiting for commissions. But such were the conditions in Britain then, in slump-time, that commissions rarely came. So instead of waiting idle, a few of these young architects filled up their days with design for household products, embarking on schemes so rash and so unprofitable that they would not otherwise have seen the light of day. For instance, Robert Goodden, in a very idle office behind Blackwell's bookshop in Oxford, decided to break the monotony by designing and marketing some wallpaper, called 'Asterisk'. Another unemployed architect, Keith Murray, filled up time, inspired by the Swedish exhibition in London, designing modern glassware and later on some pottery : Stevens & Williams and Wedgwood took him on. Keith Murray, who was virtually the first freelance designer for industry since Dresser, delighted the converted with his smooth thick useful glassware in smoke violet and green, his sensitive cut crystal, his matt-green Wedgwood bookends and tobacco jars, his plain good modern silver for Mappin & Webb. Pearl Adam wrote an article of praise in *The Observer*; Herbert Read picked out some beer-mugs in matt-straw glaze, by Wedgwood, as 'better than anything else in modern ceramics'.

It was partly economics and partly the new attitude to architecture which prompted Gordon Russell to change his course from craft-made, finely-detailed furniture to plainer mass-production. His younger brother Richard returned from four years training at the Architectural Association with the fashionable concept of bare, functional design for mechanized production and the broader social view of the architect's involvement with the whole environment. He altered the outlook in the Cotswolds quite considerably. Gordon Russell, in his autobiography, acknowledges the definite effect of Dick's return to Broadway : 'it gave us a link with architects and taught us to think in terms of rooms rather than individual pieces'. From then on, the Russells concentrated on lower-price furniture for serial production and evolved some most remarkable designs for Murphy Radio. These cabinets, machine-made, economic, yet presentable, were models of British design for a decade.

For the British were in many ways becoming more receptive. At last, advanced designers had taken to machinery. At last, developments abroad were not so suspect.` Substantial foreign influence was suddenly apparent : influence from Denmark, where from 1927 the architects and craftsmen worked together to produce immaculate furniture, elegant and sensible; influence from Finland, where round 1929 Alvar Aalto designed furniture in laminated plywood (imported by Geoffrey Boumphrey of Finmar and by Findlater in Edinburgh, this was soon much in demand at Fortnum & Mason, where the stools cost 7s.) Most of all, design from Sweden affected Britain strongly, particularly at the time of the Stockholm Exhibition and the London Exhibition of Swedish Art. The *Architectural Review* in 1930 gave over a whole issue to design in Sweden, commenting that if only Swedish standards were more evident in Knightsbridge, 'what a lovely shop Harrods would be'.

Temperamentally, the British and the Scandinavians were—and, by and large, still are—very much in tune : the history of design is one of constant interaction, most evident of all in Britain in the fifties. But contact with the central modern movement in Europe, more extreme and intellectual, was much harder to effect. In 1929, Jack Pritchard made a somewhat unlikely start by commissioning Le Corbusier to design an exhibition stand at the Building Trades Exhibition at Olympia for Venesta. Jack Pritchard, 'Plywood Pritchard', a young Venesta manager, an engineer-

economist from Cambridge with great visions combined with a spirit of practical enterprise, worked hard to build up contacts with Gropius and the Bauhaus, the school which Gropius founded 'to exert a revitalizing influence on design' by providing 'a thorough practical, manual training in workshop activity engaged in production, coupled with'—most important—'a sound theoretical instruction in the laws of design'. In 1931, Jack Pritchard visited the Bauhaus in Dessau with Chermayeff and Wells Coates; though by then Gropius himself had left the Bauhaus, the outlook of the school, with its emphasis on the interaction of technology with art, greatly impressed the visitors from Britain. From then on, the influence of Bauhaus work and attitudes was increasingly in evidence; wrote designer Clive Latimer, 'It was a revelation : here were logic and order, but also adventure'; progressive lighting companies soon turned out Bauhaus fittings; Gropius became a kind of household word. 'So great was our enthusiasm.' Robert Best, of Best & Lloyd and the DIA in Birmingham, wrote with admiration, 'that this name (in the form of GROW PIOUS) was even introduced into a DIA charade.'

These were the elements which somehow came together in a famous exhibition at Dorland Hall in London. It was 1933; the year that Wells Coates founded the MARS Group (for Modern Architectural Research); the year Berthold Lubetkin formed the Tecton Group of architects and built the Highpoint Flats and rehoused the Zoo's gorillas. All this was important. For the Dorland Hall display was designed 'to give expression to a new type of civilization'. It was the result of a Board of Trade Committee on Art and Education under Lord Gorell : the 1932 report concluded (much as Peel had done a century before) that in order to raise national design standards, the citizen must be made design-conscious; he must be shown what constitutes a good design. The Report had strongly emphasized the need for exhibitions ('EXHIBITIONS mania', John Betjeman had called it) and Lord Gorell, the next year, wrote the foreword to the catalogue of the exhibition at Dorland Hall, which was privately sponsored and in which the DIA collaborated. With something of Prince Albert's paternal optimism and Gottfried Semper's theory that seeing is believing, Lord Gorell explained the exhibition was attempting to show the British public the best examples of the new industrial art.

What the public saw was a Minimum Flat, a Unit House, a

large stone wall incised by Eric Gill with a joyful, frank and lustful scene of men and maidens, which the railway hotel in a northern seaside town had recently rejected, but which suited Dorland Hall. The mood there was permissive. The architect in charge, Oliver Hill, had given a free hand, in their individual sections, to Wells Coates, Serge Chermayeff and Raymond McGrath, and even the *Architectural Review* sounded a little overwhelmed by the results: both by the younger architects' talents and by the progress made by manufacturers, by Heal's and Gordon Russell, Carter Stabler Adams, Wedgwood, Dryad, Foxton and the Curwen Press which was showing wallpapers designed by Edward Bawden. The citizen, apparently, was pleasantly surprised. Bearing out the Gorell argument that selective exhibitions would improve the public powers of discrimination, a certain Mr Broadley (who afterwards wrote in to tell the DIA) went straight home to the suburbs to tour his local shops. He was quite surprised to find no Bawden papers there. 'I was saddened to discover,' he reported, 'that in hardly a single article displayed in any shop was there a trace of the Dorland House spirit.'

Remote as it might seem in the suburbs and the provinces, the British modern movement by then had gathered strength. It had reached the Prince of Wales who himself designed a reading lamp for Easiwork, and rather in the manner of Prince Albert, maintained, 'There is always scope for new ideas, provided that the motto "Fitness for purpose" is born in mind, and no wildly exaggerated style is induced merely in order to cause a sensation.' This truly British sentiment was very often quoted. 'Design in Modern Life' had also reached the BBC which, in 1933, devoted programme after programme to the subject: Gordon Russell on 'The Living Room and Furniture', Francis Meynell on 'The Printed Word', A. B. Read on 'Light', Frank Pick on 'The Street', Wells Coates on 'Dwellings', Elizabeth M. Denby on 'The Kitchen'. The list goes on and on.

It was obvious in 1933 and 1934, in small ways and in great, that art and industry were growing gradually closer. Cadbury, for instance, commissioned designs for chocolate boxes from nine quite famous painters, including Laura Knight. Harrods, maybe nettled by comparisons with Sweden, promoted new designs which Foley's China had commissioned from 27 artists. (Laura Knight was there again.) Jack Beddington, at Shell-Mex and BP, in this

new spirit of industrial patronage, chose artists to design a succession of Shell posters. A magazine called 'Shelf Appeal' was founded to publicize activity in packaging; featuring (for instance) the work of Reco Capey at Yardley's and Norbert Dutton at Metal Box. Designing was becoming a kind of a profession. In 1930, after plans and counter-plans, meetings in Chelsea studios, committees in The Cock Tavern in Fleet Street, the Society of Industrial Artists had been founded to serve two purposes which, its manifesto insisted, were of particular importance at the time : 'It is hoped in the first place to establish the profession of the Designer on a sounder basis by forming a controlling authority to advance and protect the interests of all engaged in the production of Design for Industry, Publishing and Advertising. The second purpose is to assemble the resources of Design as a vital factor in British Industry and so to assist the advancement of British Trade, both at home and abroad.' Five years later, a number of designers had collected, with more sophistication than was usual in Britain, to form a design agency, Industrial Design Partnership. The main instigator of both these enterprises was Milner Gray, himself a designer of distinction, the first person to lobby for design as a profession. One of his partners in the new design group was a then unknown young Russian-born designer, Misha Black.

Round this time there was a sudden profusion of modernistic exhibitions : 'Modern Architecture' at the new RIBA, 'Modern Silverware' at Goldsmiths' Hall, 'Modern Living' at Whiteley's, another Dorland Hall which seems to have turned out a comparative fiasco. (Wells Coates, Serge Chermayeff, Ambrose Heal, Maxwell Fry, Jack Pritchard and others wrote complaining of frivolity and far too many fashionable 'amusing' ideas.) Round this time, there was a sudden pile of books about design : Geoffrey Holme's *Industrial Design and the Future*, John Gloag's *Design in Modern Life* and *Industrial Art Explained*. Anthony Bertram, perhaps the most prolific design writer of the period, was working on *Design in Daily Life*. Noel Carrington wrote books on *Design in the Home* and *Design and a Changing Civilization*, and Herbert Read's *Art and Industry* was in its first edition. Milner Gray later wrote respectfully of Read : 'he became the acknowledged leader, mentor and guide of such young designers as myself. This was in many ways the turning point for most of us in the clear understanding of machine art, as we called it then'. Brian Grant, at the

time, was a great deal more impatient, with a tirade in the *Architectural Review* :

'So much chatter and so very little apparent progress.
"Design and Industry", "Art and Industry", "Art in Industry", "Industrial Art", Commercial Art", "Design for Living", "Architectural Design" AND SO ON.'

But as well as all the chatter, there were some true advances. The DIA considered training for designers; the FBI thought hard about industrial art management. In 1934, as a result of the Gorell Report, a Council for Art and Industry was founded, with government support, to educate consumers in design appreciation, to consider design training for industry and commerce, to encourage good design 'especially in relation to manufacturers'. The Chairman of the Council was Frank Pick. Its first remarks were sober : 'a long time will be required to complete the task which the Council has set itself'. And yet despite this caution, and despite the fact that Government support was materially meagre, morale was raised substantially. Pick's Council was official. As they felt in 1850, things were happening at last.

It is not, in fact, far-fetched to compare the atmosphere in the year which led up to the Great Exhibition to the general optimism in 1934, the year before the Royal Society of Arts' exhibition 'British Art in Industry'. This was to be held at Burlington House, and was intended to impress upon the British as well as the foreign public the importance of beauty in the articles they purchased, and to prove to manufacturers that British artists could supply 'original, attractive and technically suitable designs for the production of articles by mechanical means'. What more could people ask? The exhibition sounded exactly what designers had been waiting for for years. If the director John de la Valette, a small and volatile Dutchman with a beard, raised a few small doubts, or the selection committee of high Academicians (even Scott and Lutyens) caused some slight anxiety, this was not admitted, or at least it was not publicized. Everyone, serenely, was hoping for the best.

Of course, 'British Art in Industry', just like the Great Exhibition, was a major disappointment to the British design purists. It was fanciful, extravagant, nothing to do with design for mass-production; it was totally unfunctional, completely inefficient, ladylike, directed towards Mayfair gracious living. Alas for Wells Coates

and his Minimum Flat: the DIA, pride wounded, called it 'a grotesque failure'. With attacks more vitriolic than Owen Jones' or Redgrave's on the fateful Crystal Palace, the critics soon let fly. Herbert Read, with the excuse that the exhibition would do more harm than good unless it was demolished, went on to pour scorn on a bed by Betty Joel: It is made of beautiful Queensland walnut and maple twisted and contorted into a shape which I can only compare to a dislocated hip-bath.' Everywhere, the lack of form and functional efficiency very much distressed him; even Heal's, he said, had become 'modish and Mayfairish'; the elegant design in icing sugar by Mr Rex Whistler reduced him to silence; he was dreadfully unnerved. In the *New Statesman*, Raymond Mortimer insisted the exhibition was worse than none at all: 'the standards it sets are both costly and depraved'. Even Nikolaus Pevsner, a recent refugee from Germany who was treading rather carefully, not hurting people's feelings, admitted that the exhibition was embarrassing for anyone with foreign visitors in London: 'Yet,' he kindly commented, 'what such an exhibition might have been! It might have set up a milestone in the evolution of the Modern Movement in England.'

And, in a way, it did. For as the Crystal Palace had caused the Cole reformers to pause, take stock and start on a new constructive phase, this latest grotesque failure, which sent shudders down the spine of the supporters of the British modern movement, was in the end quite useful. It stimulated action. For instance, J. M. Richards, then assistant editor of the *Architectural Review*, taken to task for his obstructionist attitude by Burlington House exhibitors and friends, wrote a long, important, thoughtful and of course defensive article, 'Towards a Rational Aesthetic'. This examined the character of modern industrial design, showing how it differed from handicraft design, arguing that it entails a changed vocabulary in conformity with a new unity of values. It insists upon simplicity and it emphasizes the impersonal. But standardization does not mean monotony: J. M. Richards was insistent on this point. He gave some illustrations of the rational aesthetic: a strong-room door showing 'the beauty of mechanical precision', laboratory glass, porcelain vessels by Doulton and Royal Worcester, an Imperial Airways monoplane, a Rolls Royce. He added a catalogue of everyday objects generally available: Anglepoise lamps, sports equipment from Fortnum & Mason, assorted baths

and basins, kitchen cabinets and cookers, stoneware footwarmers, cane carpet-beaters, metal chairs and tools, 'everyday things in which a high standard of design has been unselfconsciously achieved'. Like Semper and Matthew Digby Wyatt, he had listed the ordinary products which do not strive for art.

What was most ironic was the way in which these everyday utilitarian objects became themselves a cult. Royal Doulton's Acid Jars were sold by Gordon Russell as objects of beauty to adorn the house, and Pevsner, in *Industrial Art in England*, published in 1937, states, 'At present they are amongst the best-sellers in most shops dealing in well-designed modern goods.' The same was true of Cornish Ware, which leads one to suspect that the peasant-life fixation was not so deeply buried. It was not wholly banished by the rational aesthetic, and in the post-war years it was to recur again.

Ironically, also, the drive for anonymity was largely the concern of a few dozen individuals who were quite outstanding, even manic, in their efforts. Shipowner Colin Anderson comes straight-away to mind. Though his family, the partners in the Orient Line, were hardly inartistic (Kenneth Anderson, a relative, had been the first Chairman of the DIA), their ideas on the design of the interiors of passenger ships seemed antiquated to him, in 1930. He made up his mind 'to meet the unexpressed need of the travelling public for surroundings that looked more in keeping with the practical achievements of modern engineer-constructors'. He was so persua-sive, or so tiresomely insistent, that his elders handed the whole job on to him. Considering Wells Coates, Hill and Maufe and Serge Chermayeff, all of whom seemed then to him a little disconcerting, he chose as his designer Brian O'Rorke, a good outsider, a New Zealand architect with almost no experience but with great enthusiasm. Architect and client, who were then both twenty-eight, agreed extremely well; they were both of them determined to escape from damask patterns, floral sprigs and sprays, cut velvet, plush and chintz, and brass and bobbles and the vaguely Louis cutlery, traditional paraphernalia of ship decor. The 'Orion', delivered in 1935, and the 'Orcades', completed in 1937, set a startlingly new standard, both of overall design and of fixtures and fittings meticulously chosen. Colin Anderson wrote later :

'It would be hard to exaggerate the difficulties we met in persuad-ing proud and successful industries that not a single object in

their entire output was acceptable for a modern ship interior. We found ourselves having to discover designers capable of producing new designs for a wide range of products, from carpets to cutlery, the makers of which had no staff designers who understood what we were after.'

He employed, among others, E. McKnight Kauffer, Marion Dorn, Alastair Morton of Edinburgh Weavers; Brian O'Rorke designed the furniture and chairs, which were heavily tested by the Orient directors. Such courage and such competence, two Empire-building qualities diverted to the modern movement, stood it in good stead. The 'Orion' and 'Orcades'—like the BBC interiors of 1932 by McGrath, Coates and Chermayeff—altered the outlook of industry a little, just perceptibly enlightening its taste.

Such as it was, the British modern movement in industrial design was wholly individual enterprise, involving a handful of impresarios, like Anderson and Pick (by then with London Transport); a few designers, a few manufacturers and, increasingly important, a few forward-looking shopkeepers. The sheer smallness of the scale of movements for improvement was made obvious in Pevsner's *Industrial Art in England*, a study carried out at Birmingham University, under Professor Sargent Florence. A conscientious survey of 149 manufacturers, 15 shops, 14 art schools, and 17 designers, artists and architects proved that things in general were extremely bad. 'When I say,' said Pevsner, 'that 90 per cent of British industrial art is devoid of any aesthetic merit I am not exaggerating . . . the aim of any campaign for better design can only be to reduce the percentage of objectionable goods, from 90 to 80 or perhaps 75 per cent.'

It might have been a losing battle. All the same, and in spite of Pevsner's words of warning, people thought it worth a try. Wherever there was progress, this progress could be traced back to just one person fighting the great tide, or as Gordon Russell put it, pushing a tank fanatically uphill. The leading designers of this period were the Russells, Robert Goodden, Alfred Read, Keith Murray, Enid Marx, Marian Pepler (later Mrs R. D. Russell), Marion Dorn, Marianne Straub (designing for 70 Welsh textile mills), Chermayeff, Coates, McGrath. It should be noted that these were mostly architects : as yet, there was no training for industrial design.

The progressive manufacturers were, once again, the Russells;

Jack Pritchard (Isokon); Gerald Summers (The Makers of Simple Furniture of Charlotte Street); Thomas Barlow of Barlow & Jones; Allan Walton Textiles; Sir James Morton of Edinburgh Weavers; the potter Susie Cooper; on the whole, Josiah Wedgwood (then, as later, Wedgwood's design policy was never stable); and three leading makers of light fittings, the Boissevains of Merchant Adventurers, Robert Best of Best & Lloyd and H. T. Young of Troughton & Young, who employed the designer A. B. Read.

The shopkeepers included, first of all, the Heals : Ambrose Heal had by now been joined by his two sons, Anthony and Christopher, and in 1936 Christopher was showing his designs, alongside Breuer, Fry, McGrath, Nicholson, O'Rorke and Jack Howe, in an exhibition entitled 'Seven Architects'. In Bristol, Crofton Gane, that very enterprising retailer, commissioned a pavilion for the Bristol Royal Show from Yorke and Marcel Breuer, who by then had left the Bauhaus and was practising in Britain. Gordon Russell's shop in Wigmore Street was, to all intents and purposes, an embryo Design Centre, and famous in its day. In Hitchin, Frank Austin and, in London, Ian Henderson and Alister Maynard were selling hand-made furniture of their own design. Peter Jones had an exclusive range of modern craftsman's furniture designed and made by R. Gordon Stark. George Breeze at Lewis's and Victor Sawtell at Bowman's, Camden Town, ran furniture departments of a popular modernity and a very reasonable standard of design. It was Sawtell who promoted the first unit furniture developed in Britain by Alpe Brothers of Banbury.

In Grosvenor Street, Cecilia Dunbar-Kilburn (later Lady Sempill) opened an exclusive shop with Athole Hay, Royal College of Art registrar. He sent her his students, and she placed their designs for china, glass, textiles and even carpets with co-operative firms. Four-fifths of the stock at Dunbar-Hay was specially made; in those days even Wedgwood would take on special orders. Eric Ravilious, who was retained by Dunbar-Hay, decorated Wedgwood urns and mugs with great inventiveness, and also designed glass, a dining-table and some chairs which were bought by the Victoria and Albert Museum.

In Bromley, Geoffrey Dunn, with the same enthusiasm but less rarified ambitions, joined his father's firm at the age of 23 and spent £10, illicitly, on Susie Cooper pottery which he then displayed, among the reproduction furniture, on hessian-covered

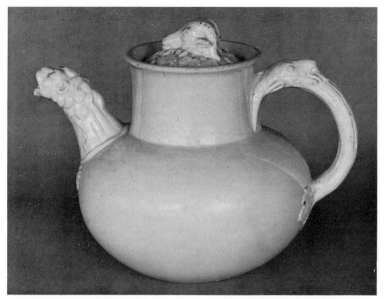

*Henry Cole* Teapot made by Summerly's Art Manufactures, 1846

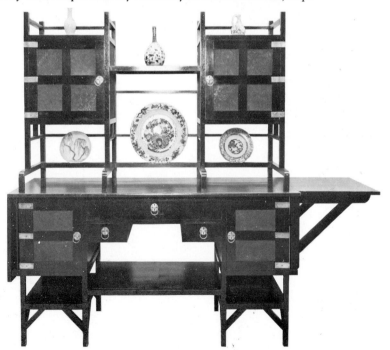

*Edward William Godwin* Ebonized wood sideboard made by
William Watt, 1867

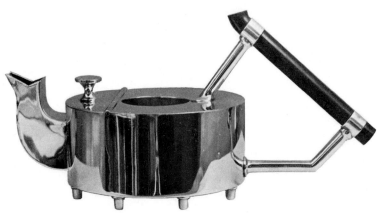

*Christopher Dresser* Silver-plated teapot made by James Dixon, about 1880

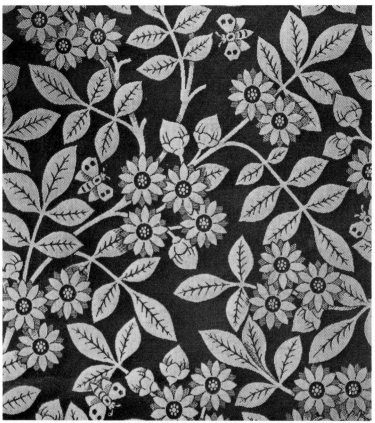

*Bruce J. Talbert* 'Hatton' silk damask made by Warner, about 1880

*C. R. Ashbee* Silver dish made by Guild of Handicraft, 1900

*Ambrose Heal* Unpolished oak sideboard with
plate-rack above, 1906

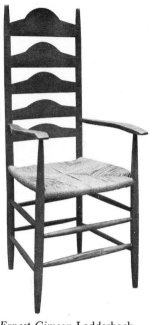

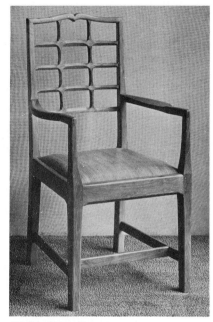

*Ernest Gimson* Ladderback
chair in ash, about 1888

*Gordon Russell*
Chair in English walnut, 1925

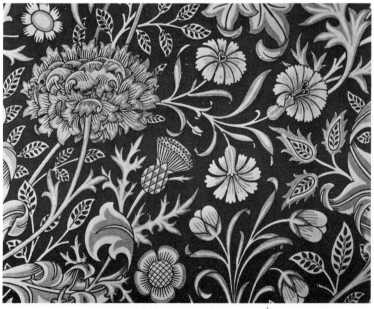

*William Morris* 'Cherwell' hand-block printed velveteen, about 1885

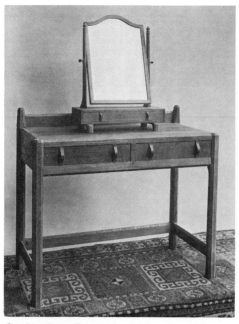

*Gordon Russell*
Dressing-table and mirror in English oak, 1914

*Ambrose Heal* Dresser in elm with black margin, 1914

*Claud Lovat Fraser*
Printed fabric made by Foxton,
about 1920

*Gregory Brown*
Printed fabric made by Foxton,
about 1920

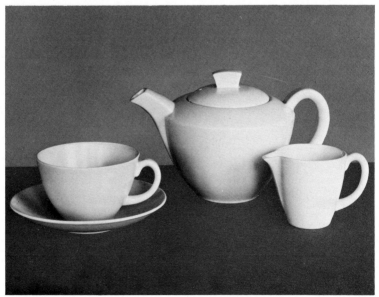

*John Adams* Early-morning tea-set made by Carter Stabler Adams,
about 1925

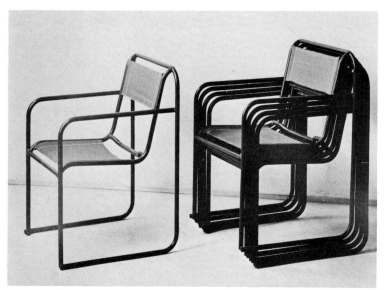

*Serge Chermayeff* Stacking chair for Broadcasting House, 1932

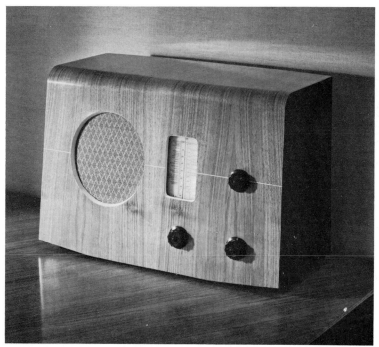

*R. D. Russell* Radio-cabinet made by **Murphy** in light walnut with dark stained sides, 1937

*R. Y. Goodden* Small pressed-glass bowl made by Chance Brothers, 1934

*Keith Murray* Earthenware beer-mugs and jug made by Wedgwood, 1935

*Best and Lloyd*
'Bestlite' reading-lamp, 1930

*Marion Dorn*
Upholstery fabric for London
Transport, 1939

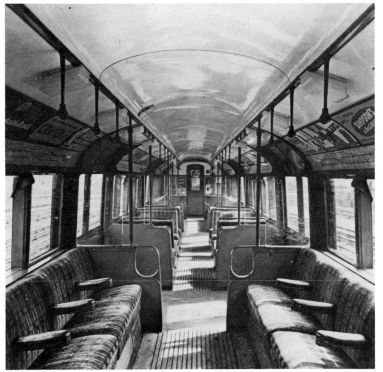

*London Transport* Tube train interior, 1938

*Enid Marx*
Woven fabric, designed for
Utility Furniture Committee, 1946

*Enid Marx*
'Ring' cotton tapestry, designed for
Utility Furniture Committee, 1945

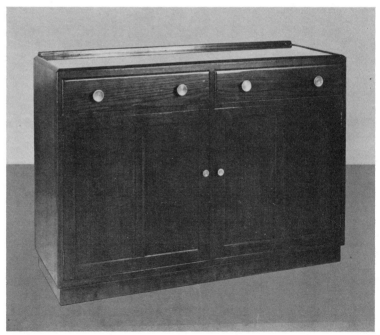

*Utility Furniture Committee* 'Chiltern' oak sideboard, 1945

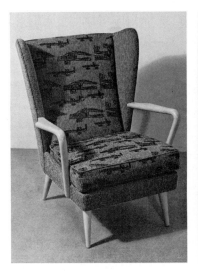

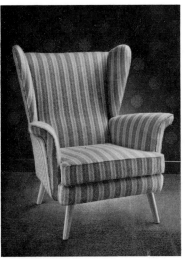

*Howard Keith*
'Intruder' chair made by
H. K. Furniture, 1949

*Howard Keith*
'Cavalier' chair made by
H. K. Furniture, 1949

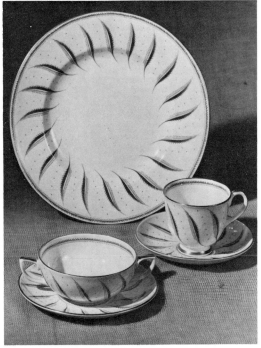

*Susie Cooper* 'Spiral Fern' earthenware plate and
soup-cup, 1940–1; china tea-cup, late 1950s

*Ernest Race*
'Antelope' chair made by Race
Furniture, 1950

*Lucienne Day*
'Calyx' printed cotton made by
Heal Fabrics, 1951

*David Mellor* 'Pride' silver-plated cutlery made by Walker and Hall, 1954

*Hulme Chadwick*
Pruner made by Wilkinson Sword,
1956

*C. W. P. Longman*
'Packaway' refrigerator made by
Prestcold Division of Pressed Steel,
1959

*Jack Howe* Transport-shelter in timber designed for London Transport, 1954

*Robin Day*
Polypropylene stacking chair made
by Hille, 1961

*Shirley Craven*
'Five' printed linen and cotton made
by Hull Traders, 1966

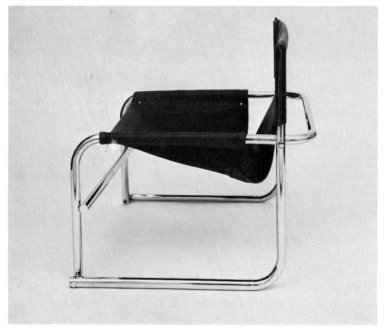

*O M K Design* Chair in chrome-plated tubular steel and leather, 1966

*Robert Heritage* 'Quartet Major' light-fittings made by Rotaflex, 1964

*Kenneth Grange*
'Classic' electric iron made by
Morphy Richards, 1966

*Noel London and Howard Upjohn*
'Patholux' microscope for Vickers
Instruments, 1964

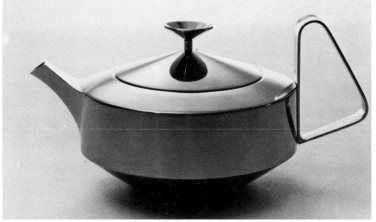

*Robert Welch* 'Alveston' stainless-steel teapot made by Old Hall, 1963

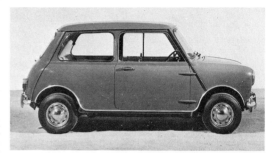

*Alec Issigonis*
Mini Minor made by British Motor Corporation,
1959

*David Mellor*
Traffic-signal system
designed with
Ministry of Trans-
port, 1969

*Mather and Platt Industrial Design Dept with
Electrical Engineering Designers*, Flameproof
motors, 1966

*Misha Black and J. Beresford Evans of Design Research Unit*
25kv. 3,200 h.p. AC/electric locomotive designed for British Railways, 1956

cubes. It was all sold in three weeks. The Bromley modern move-
ment went from strength to strength : by 1938, the shop was
almost wholly modern. In 1938, Geoffrey Dunn and Crofton Gane
and Gordon Russell, with the fine old British mixture of high
ideals and *bonhomie*, had formed the Good Furniture Group. This
was an association of retailers which collectively commissioned
designs, had them manufactured and stocked them simultaneously:
the simple aim, wrote Dunn, was 'to get some nice furniture
designed and made and sold by a few real believers'. The most
successful project was a dining suite : good furniture from Gordon
Russell Limited.

Pleasant and straightforward, civilized and sensible, a reasonably
idealistic, gentlemanly clique : the Good Furniture Group was a
very true reflection of the British modern movement by 1938. In
fact, the modern movement had come and almost gone again; the
rational aesthetic had not really made much headway. Industrial
design was still quite homespun in its attitudes, not so very far
from the British Arts and Crafts : tolerant and gentle, unpretentious
and careful, in friendly and predictable agreement with Frank Pick
that national design should be 'modest and not too grandiose in
scale . . . not too logical in form . . . a reasonable compromise
between beauty and utility, neither overstressing beauty till it
degenerates into ornament, nor overstressing utility until it becomes
bare and hard'.

This is why Great Britain could not really stand the Bauhaus.
Gropius' arrival, sponsored by Jack Pritchard, escaping from the
Nazis in 1934, brought the British face-to-face with what had been
a far-off theory. And on the whole they realized that it was not
for them. It was too unnerving; it was too uncompromising;
Gropius' belief that crafts and industry were opposites and handi-
crafts' sole function was industrial research, that handicrafts
belonged in the factory laboratory, was a good deal too dogmatic
for the British DIA. And the British DIA, in its turn, unnerved
Gropius with its slowness and its politeness and extreme naivety.
In Birmingham a member asked to see the Bauhaus timetable,
thinking that it might be applied to the teaching at the Birmingham
College of Arts and Crafts. Gropius was horrified : 'It would not
tell you much,' he replied with deepest scorn, 'it was the *atmos-
phere.*' The difference of opinion, and simple lack of work, drove
Gropius out of England : in partnership with Fry, he had only

E

been commissioned to design one house, one college, and a few small oddments, a fire for Best & Lloyd and an aluminium waste-bin. Like Breuer and Moholy-Nagy, Erich Mendelsohn, Serge Chermayeff and Naum Gabo, Walter Gropius left Britain for America. He had been appointed Harvard Professor of Architecture. People said how sad they were, and even how surprised. Herbert Read and other mourners wrote a letter to *The Times* in a rather aggrieved tone :

'Professor Gropius has been resident in this country for the last three years, and it was the confident hope of many people that we were to have the benefit of his outstanding talents for many years to come. In this we have been disappointed.'

However, they gave Gropius a Trocadero dinner (25s a head, including wine) and settled back quite equably into the old routine.

Almost as a send-off to Gropius, with a sigh of relief that the old order was unchanged, the British created a Faculty of Royal Designers for Industry. In the aftermath of the 1935 Exhibition of 'British Art in Industry' at Burlington House, the Royal Society of Arts had decided to give recognition to designers who consistently produced work of a high aesthetic standard, and set them on a level with the Royal Acadamicians. In 1936, ten Designers for Industry were formally appointed, and in 1937 the Home Office decreed that these Designers should be designated Royal. They were an odd collection : poster artists and typographers, decorators, old-time craftsmen, Eric Gill who hated factories, Keith Murray, Harold Stabler, aged Voysey—although Voysey loathed the modern movement, which he found unchristian.

The Faculty of Royal Designers for Industry—which still goes on, enlarged and a bit more level-headed—includes a little section for Honorary Members, distinguished industrial designers from abroad. Through the years, these foreign appointments have shown neatly the current allegiances of design in Britain. In 1939, for instance, before Alvar Aalto or Gropius was honoured, Raymond Loewy (usa) was received into the Faculty. This was an event of some significance. For it meant the recognition of the 'stylists' of America, the large expansive prophets of commercial design, Bel Geddes and van Doren, Dorwin Teague and Henry Dreyfuss who, like Loewy, had been spending the past decade in league with the great advertising agencies, promoting the idea that design is businesslike. An rdi for Loewy meant acceptance of the fact

that design in Britain, too, was increasingly commercial : in Loewy's British office (with J. Beresford-Evans, Douglas Scott and F. C. Ashford), in Richard Lonsdale-Hands' thrusting new Design Unit, and the group which Norbert Dutton, Ronald Armstrong and Ronald Ingles had founded very recently, all leaving Metal Box. This regime meant rejection, or at least ruthless dilution of the DIA virtues and the old crusading zeal. As Milner Grey, in a later speech, expressed it :

'From the cosy gatherings of the converted and the high ideals of the highbrows of the 1920s, industrial design had come down to earth.'

But this was not for long. With the war, a time of fantasy, the businesslike designers, architects and art directors were hurried into uniform and set to work to hide the defences of the country as soon as they were built. The *Architectural Review* gave fine descriptions of the work of Her Majesty's Camouflage Corps in disguising the ubiquitous hexagonal pillboxes as tea-kiosks, bus stops, petrol stations, fair booths and public lavatories, as haystacks, road-menders' huts and even wood-piles. Wartime, for designers, was a kind of golden age in which almost unlimited money and labour were forthcoming to pursue the wildest fancies, masterpieces of inventiveness, from ivy-clad ruins to gypsy caravans, from cosy thatched toll-houses to resplendent Gothic lodge-gates. All this was perfect practice for the Festival of Britain, and helps greatly to explain the light fantastic atmosphere.

BOOK LIST

Battersby, Martin  *The Decorative Thirties* (Studio Vista, 1971)
Bertram, Anthony  *Design in Daily Life* (Penguin, 1938)
Blake, John and Avril  *The Practical Idealists: A History of Design Research Unit* (Lund Humphries, 1969)
Carrington, Noel  *Design and a Changing Civilisation* (John Lane, Bodley Head, 1935)
  *Design in the Home* (London, 1933)
  *Industrial Design in Britain* (George Allen & Unwin, 1976)
Dowling, H. G.  *A Survey of British Industrial Arts* (F. Lewis & Co., 1935)
Gloag, John  *Design in Modern Life* (George Allen & Unwin, 1934)
  *Industrial Art Explained* (George Allen & Unwin, 1934)
Gould, Jeremy  *Modern Houses in Britain, 1919–1939* (Society of Architectural Historians, 1977)

Holme, Geoffrey  *Industrial Design and the Future* (Studio, 1934)
Joel, David  *The Adventure of British Furniture* (Ernest Benn, 1953)
McGrath, Raymond  *Twentieth Century Houses* (Faber, 1934)
Martin, J. L. and Speight, S.  *The Flat Book* (Heinemann, 1939)
Meynell, Francis  *My Lives* (Bodley Head, 1971)
Morton, Jocelyn  *Three Generations in a Family Textile Firm* (Routledge & Kegan Paul, 1971)
Pevsner, Nikolaus  *An Enquiry into Industrial Art in England* (Cambridge University Press, 1937)
  *The Sources of Modern Architecture and Design* (Thames & Hudson, 1968)
  *Studies in Art, Architecture and Design*, vol. 2 (Thames & Hudson, 1968)
Read, Herbert  *Art and Industry* (Faber, 1934)
Rowland, Kurt  *A History of the Modern Movement* (Van Nostrand Reinhold, 1973)
Russell, Gordon  *Designer's Trade* (George Allen & Unwin, 1968)
  *Looking at Furniture* (Lund Humphries, 1964)
Simon, Herbert  *Song and Words: A History of the Curwen Press* (George Allen & Unwin, 1973)
Teague, Walter Dorwin  *Design This Day: The Techniques of Order in the Machine Age* (American edition, 1940; British edition, Studio Publications, 1947)

EXHIBITION CATALOGUES

*Bauhaus: 50 Years* (London, Royal Academy, 1968)
*British Art in Industry* (London, Royal Academy, 1935)
*Classics of Modern Design* (London, Camden Arts Centre, 1977)
*PEL and Tubular Steel Furniture of the Thirties* (London, Architectural Association, 1977)
*Susie Cooper: Elegance and Utility* (Barlaston, Josiah Wedgwood & Sons, 1978)

PERIODICALS

*Architectural Review*
*Commercial Art and Industry*, later *Art and Industry*
*Design and Industries Association Journal and News Sheet*
*Design in Industry*, published by DIA, 1932; replaced by *Design for Today*, 1933; later superseded by *Trend in Design of Everyday Things*, 1936
*Society of Industrial Artists Newsletter and Journal*, from 1930
*The Studio*

# The Council of
# Industrial Design
# 1940–1951

It was 1942 when Gordon Russell's country war-work, stone-carving, looking after bees and keeping pigs, was for ever interrupted: Hugh Dalton wrote requesting him to sit on a Utility furniture committee. Although he did not realize it, this sudden translation from the Cotswolds to an office at the Board of Trade would have long repercussions, both for him and for the progress of industrial design. Under Gordon Russell a new reform began, related to the earlier attempts, yet very different in its scope, organization and its government support. Government furniture was more or less a godsend. 'I felt,' wrote Gordon Russell, 'that to raise the whole standard of furniture for the mass of the people was not a bad war-job . . . Wartime conditions had given us a unique opportunity of making an advance.'

There had been an ultimatum: from November 1942 the only furniture to be manufactured in Britain was Utility. Hundreds of small firms throughout the country, with all kinds of methods of production, would then make a single range of furniture under the control of a central small committee. Dalton had selected this committee with finesse. Counteracting Russell there was Lebus, mass-producer; balancing John Gloag and Elizabeth Denby there was Mrs Wimborne and the Reverend Jenkinson, the voice of the consumer and presumably the church; there was trade and there was public, there were housing men and retailers, a beautiful cross-section of the national state of taste. Gordon Russell travelled up to London for the first of the meetings; with the deadline in November, it was by then July.

The President of the Board of Trade, Hugh Dalton, came in to his committee with some rules and regulations: Utility furniture must be soundly made of the best possible materials; it must be pleasant in design; and it must also be produced extremely quickly, to prevent a national famine. He departed very briskly, leaving the committee with a long list of materials; everything they needed, from plywood and blockboard to steel and paint and textiles, was either unobtainable or else extremely scarce. He also left them puzzling over what he meant by pleasant: in common usage, 'pleasant' furniture was Jacobean. But Gordon Russell's view of 'pleasant' was accepted; as he later wrote, 'the basic rightness of contemporary design won the day'. In any case—fortunately, as it happened—there was not enough timber for bulbous legs or labour for even the most rudimentary carving. Mr. Clinch and Mr Cutler, good basic trade designers from High Wycombe seconded to the wartime furniture committee, evolved for new Utility a modern Gimson style, which the *Architectural Review* attacked as retrograde (too true to the old DIA aesthetic), and the trade on the whole condemned as too advanced. Gordon Russell was contented to see shots from both directions: 'it looked', he recollected 'as if we were about right. I am never for forcing the pace, a limited advance and then consolidation is a sound principle, both in war and peace'. This calm, most British, attitude proved usefully disarming in peacetime at the Council of Industrial Design.

Meanwhile, Gordon Russell wrote a report—as Cole would have done—to his chairman, Charles Tennyson, whose work for the FBI Industrial Art Committee and the wartime Central Institute had proved him sympathetic. Gordon Russell suggested a programme of research into furniture design, for wartime use and for the future; he recommended a panel of not more than six designers with a knowledgeable chairman, probably an architect, who would be given a seat on the Utility Furniture Committee to speak for the designers. To Gordon Russell's surprise, the President asked him to take on the Chairman's job himself and set about appointing the members of the Panel. This, in fact, was none too easy for the best of the designers were abroad or inaccessible. Eden Minns, who had agreed to join, was without warning called up into the Navy and sent out to the Pacific; Dick Russell was in Admiralty camouflage and rapidly transported off to India and Burma; Ian

Henderson, who thought the Foreign Office might have loaned him, found the scheme impracticable. But Jacques Groag, a Czech refugee, an architect and former pupil and assistant of Adolf Loos, was a most imaginative, vociferous addition to the Panel, counteracting the prosaic, though most worthy, Clinch and Cutler. Utility Furniture was ready to progress.

Installed at the Board of Trade, without a desk and carpet (for no one knew their status), working in a room furnished mainly with their own discarded prototypes, regarded with tender solicitude by permanent officials, even pointed out by the most venerable members as proof of what the country will resort to in a war, Gordon Russell and his Furniture Design Panel embarked on a two-fold programme of research : into temporary furniture to cope with devastation if the bombing should intensify; and into long-term planning for furniture for peacetime, when supplies of plywood, blockboard, cellulose and steel would be once again at hand.

There were worries. Plain Utility shapes were sometimes appearing illegally decorated with appalling carving. The Committee, trying to meet the public need for a bit of wartime gaiety, discussed the possibility of a patterned range, taking up their problem with the sculptor Henry Moore whose interest in abstract patterns was well known. But Moore, though very willing, had nothing to contribute. Utility furniture remained uncompromisingly unadorned and solid until the war was ending, and the mass-production woodworking firms employed on aircraft could return to furniture. The Panel then developed a range of smaller, lighter, more sophisticated and more graceful furniture. To a chorus of approval from even the *Architectural Review*, the latest Utility range was unveiled on VE Day at a CEMA exhibition in the National Gallery : 'Some pieces such as a mahogany sideboard and some easy chairs are very attractive indeed.'

Gordon Russell's war-work had substantial influence, after an initial frenzied contrary reaction to Utility design, on the general run of furniture : within another fifteen years, plain Gimson-style was fashion. Gordon Russell set the scene for the general reformation of design in post-war Britain soberly, humanely, subtly, with a good use of committees, with a constant view to 'solid, not spectacular, progress'. From now on, and for many years, this was the general aim of the leaders of the movement. Designers emerged,

like Gordon Russell, from their war-work with a new determination and realistic aims.

In the Ministry of Information, Exhibitions Division, Milner Grey and Misha Black and Kenneth Bayes, for instance, had together made good use of their time. In the intervals of planning patriotic exhibitions, they evolved a new design group the size and scope of which had not been known in Britain, or this side of the Atlantic. As early as 1942, the aims and organization of Design Research Unit had been formulated by Milner Gray : in general, 'The purpose of the formation of a group such as is envisaged is to make available immediately a design service equipped to advise on all problems of design and to form a nucleus group which through contacts established during the war period with specialist designers and experts in all appropriate fields, would be in a position at the end of the war to expand to undertake the wider services which may then be demanded of it.

'The final aim is to present a service so complete that it could undertake any design case which might confront the State, Municipal Authorities, Industry or Commerce.

'The scope of such a service would be so wide, within its sphere, that any description may seem to imply a limitation. But it is perhaps useful to remind ourselves of some of the fields of operation open to such an organization. All productions of industry necessary to the home life of the community and to the public services come properly within the purview of such a group. Every garment which we wear, every utensil that we use, every notice that we read, every service in transport and in our daily round of which we make use. Design for the banks, breweries, petrol, shipping and co-operative companies : design for Government printing, publicity and exhibitions : design for office, shop and warehouse: design for the lamp standard, the fire alarm, the letterbox, street name plates, traffic signs and traffic control box : design for the packing of products : design for kitchen, household and hotel equipment. Everything that is made is first designed.'

Although it seems perhaps impossible, an even vaster scheme for design was then afoot within the Board of Trade, involving Laurence Watkinson and Alan Hoskin, involving Francis Meynell (temporary adviser on Civilian Needs), involving Thomas Barlow (Director-General of Civilian Clothing) and, from time to time, involving Gordon Russell, at work among his prototypes along the

corridor. The idea was a Council. Not a Council like Frank Pick's understaffed and undersubsidized and rather unconvincing, but a Central Design Council big enough and strong enough to raise the design standards in industry at large, with the ultimate purpose of improving British exports. The details were decided long before the war had ended. In 1943 Cecil Weir's Sub-Committee on Industrial Design and Art in Industry (set up by the Post-War Export Trade Committee of the Department of Overseas Trade) reported that since there *is* such a thing as recognizably good design, and since there *is not* a fundamental conflict between 'giving the public what it wants' and good design, then a Central Design Council, not directly responsible to a government department, should start work. In 1944, the Meynell-Hoskin Report (submitted to the Presidents of the Boards of Trade and Education) discussed ways and means of making art training more practical and useful for the 'post-war push', and recommended that the Central Design Council should be a grant-aided body, financed on the Board of Trade vote. This should all be discussed with the Ministry of Reconstruction, they said : and it was. And just as the FBI Industrial Art Committee was completing its own 'Proposals for a Central Design Council and Industrial Design Centre', the Coalition Government had moved ahead.

'Has the President of the Board of Trade,' asked John Dugdale in Parliament on 19 December 1944, 'taken steps to encourage good design in British industry?'

'Yes sir,' said Dr Hugh Dalton. 'I have appointed a Council of Industrial Design to promote by all practical means the improvement of design in the products of British industry.'

With that assurance, the Government went on to consider British Engines (Spare Parts) and Discharged Service Men (Badge) : the Prime Minister maintaining that no man's patriotism could be challenged because he wore civilian clothes.

One has to remember the emotions of the period, the surging hopefulness, the urge for great renewal, the feeling that the man and the woman in the street deserved a better life, deserved improved design. All this comes pounding through the speech which Dr Hugh Dalton made to his new Council in 1944 :

'We must, therefore, make a sustained effort to improve design, and to bring industry to recognize the importance of this task. You have to arouse the interest of ordinary men and women . . . If you

succeed in your task, in a few years' time every side of our daily life will be better for your work. Every kitchen will be an easier place to work in; every home a pleasanter place to live in. Men and women in millions will be in your debt, though they may not know it; and not in Britain alone but all over the world . . . Industry itself will have much cause to thank you. Our export trade, and our volume of business at home, will both be the greater if our goods are planned and made, with skill and imagination, to meet the user's real need, to give pleasure in the using.'

Listening, and taking note were the two dozen first members of the Council, including Francis Meynell, Ernest Goodale, Charles Tennyson, Josiah Wedgwood, Allan Walton, Gordon Russell (who had all been long involved in the fight for good design). The Chairman was Sir Thomas Barlow. The Director was S. C. Leslie, who came to the CoID from the Home Office, where he was Principal Assistant Secretary. Though hardly a DIA tub-thumper in his outlook, he was not inartistic. He soon learned about design.

The Government had changed, as governments will change, often spelling doom to small grant-aided bodies. But the Council of Industrial Design, which was the offshoot of a coalition government, was blessedly immune, and in 1945, the election of Labour brought an extra supporter for reformers of design. It brought Sir Stafford Cripps, an eager weekend-carpenter, to replace Dr Hugh Dalton at the Board of Trade. This was good for the Council of Industrial Design, for Cripps (and Cripps' wife) had still more heart in it than Dalton. Within twenty-four hours of his appointment, he was over at the CoID offices in Petty France telling the Director to stage an exhibition : never mind about the money, there would be a special grant.

With an extra £234,757; with much talk of turning swords into ploughshares and producing 'goods as suitable for peace time as were the weapons the country produced for the war', 'Britain Can Make It', a great exhibition—great for post-wartime—was rapidly planned. There had already been two excellent post-war design displays : the CEMA Exhibition 'Design in the Home' (by Milner Gray) and the substantial Exhibition of Wallpapers (displayed on Eric Brown and Stefan Buzas). But this new exhibition was to be much more ambitious. 'Britain Can Make It' was planned for 90,000 square feet of the Victoria and Albert Museum, which

at the time was empty (it was also without windows: a minor difficulty which Cripps soon overcame by diverting London's next two months' entire supply of glass). It was meant 'to intensify the interest of manufacturers and distributors in industrial design, and their awareness of the desirability of rapid progress; to arouse greater interest in design in the minds of the general public, as consumers; and to stage a prestige advertisement, before the world, for British industry, industrial design and standards of display'. Cripps saw it as the first blossoming of British industry after the devastating effects of war.

This was all very well. But what was there to show? The *Architectural Review* was very nervous, suggesting that Cripps was rather overdoing things, pointing out:

'It is he who conceived the idea of the exhibition and insists on its early date. Council and manufacturers will have a tough job, with no materials yet to make new things, and no skilled labour, with plenty of designers still in the forces, with an understandable dislike to show the old 1938 things again, and an equally understandable dislike to show new designs not yet in production. What will be exhibited then? Prototypes, models, products available for export only? One feels unable even to guess, and yet one ardently wishes this test show the greatest possible international success.'

It was indeed a great success—more than anyone imagined. Although most of the exhibits were in fact still unobtainable, although the exhibition was renamed by the public 'Britain Can't Have It', Cripps' wildest schemes were justified. It pleased a lot of people in many different ways. It was ideal for the *Architectural Review*, showing British products deprived of frills and furbelows by wartime stress and shortages, as close as they had ever been to rational aesthetics. (This was rationality perforce: it did not last.) 'Britain Can Make It' pleased the King and Queen, who made a special journey from Balmoral for the opening. It very much pleased *Punch*, which joked about the imitation farmer's bedroom designed by David Medd with a Kenneth Rowntree picture of a tractor on the wall. Most of all, and in great numbers, the Exhibition pleased the people: a million and a half formed patient queues (which they were used to) down the road as far as the Brompton Oratory, and wandered round the Exhibition with amazement, a third of a mile of it, almost in a dream.

They wandered through the Foyer designed by Basil Spence

75

(assistant to James Gardner, Exhibition Designer). They moved into a section called 'From War to Peace' which showed 'side by side with their warlike origins' some 20 domestic articles evolved from the new processes, new materials and new techniques developed during the war : a new type of saucepan was shown beside the exhaust stub of a wrecked Spitfire, inflatable reclining chairs lined up with dummy weapons, and in case the swords-to-ploughshares theme escaped the public, the products were exhibited against a dim background of bomb-shattered London, picked out by shafts of light. On and on to the Textiles, Metal, Rubber, Glass and Timber, Plastics and Paper; to the Shop Window Street, with its hosiery display and its fanciful Glove Tree :

'On entering this section the visitor obtains his plastic coins at the QUIZ BANK on the left of a large entrance platform, paved with rubber, from which he surveys the brightly-lit displays set under a dark blue sky, charged with a faint afterglow of sunset . . . Each visitor is presented with 10 coins for QUIZ BOXES placed in various parts of the hall. Each box contains 3 photographs of comparable articles, and 3 coin slots. The visitor can thus register a "vote" for the design he favours.'

The public was also, very gently, introduced to the idea of the industrial designer. Designers' work was credited throughout the exhibition; at the end, beyond the Rest Lounge (designed by Robert Goodden), Misha Black told the public 'What Industrial Design Means', using simple examples to explain the way an industrial designer works and the way in which different materials and processes influence design : 'This theme is vividly illustrated in a section called "The Birth of an Eggcup". "Who designs the eggcup? Not the machine, which cannot think. The hen is partly responsible; she lays the egg to which all bowls to all eggcups must conform." ' But the hero of the piece was the industrial designer. This was something which the public had, bit by bit, to learn.

'Design At Work', a follow-up, a smaller exhibition of products by Royal Designers for Industry, was held in 1948. It was jointly sponsored by the Royal Society of Arts and CoID. It had two quite important results, one very positive : Prince Philip came to it, encouraged by the painter who was working on his portrait, and from then on was a vigorous promoter of design. The other was more negative : the exhibition showed that designers for industry had very far to go. The exhibition was not bad, but it was

rather unconvincing. The national limitations, cleverly glossed over at 'Britain Can Make It', were all too obvious now.

The position was this: there were not enough designers trained specifically for industrial design. The nucleus of staff designers in the country—in the Potteries for instance, in the carpet industry, in textiles and in silver—were obviously unlikely to raise standards on their own, both by reason of their skimpy, narrow-minded type of training and by reason of their fairly menial status in the trade. But how should they be supplemented? The National Register of Industrial Art Designers (founded in 1936 and resurrected as the Record of Designers by the CoID) showed on investigation that professional standards of practice left much to be desired. The Society of Industrial Artists' publication *Designers in Britain*, with examples of their work, proved all too plainly that in 1947 competent designers were in fact in short supply; though the spirit of the enterprise was businesslike and workmanlike, the same old names came round with disconcerting frequency. Though the influx of designers from abroad before the war and through it (Jacques Groag, for instance, George Fejer, Stefan Buzas, Margaret Leischner, Tibor Reich, Marianne Straub, Natasha Kroll, Hans Schleger, Willi de Majo, Lewis Woudhuysen and F. H. K. Henrion) enlivened the profession, there were virtually no national sources of supply for designers in the future. Although it was agreed the days for amateurs were over—an opinion reinforced by John Gloag's *Missing Technician*, published in 1944—and although by then it seemed obvious to the experts an architect's training was not ideal for design, it was difficult to know what to do about designers. Where could they be found, and how should they be taught?

For many, many years, back to Cole and even earlier, the British had been conscious of the lack of proper training for artists for industry (as they liked to call them). The Schools of Design, set up with best intentions, provided quite impractical art training, for a century. All through the 1930s the complaints accumulated: from the FBI, the DIA, Gorell and Pick, the Nugent Committee on Industrial Art Education, the Hambledon Committee on Industrial Art Education in London. They all said much the same. The system was not efficient: it did not produce designers of any use to industry, immediate or potential. The whole basis of the training must be changed. There were new laments in wartime;

complaints from Meynell-Hoskin and the interdepartmental Committee on art training; a positive cry of despair from Herbert Read in the *Architectural Review* : 'The present educational system being not aesthetic, only a minority who have managed by luck or illness to escape its deadening influences show any natural desire to become artists or designers.' This was very true.

The most violent abuse, through the years, had been hurled at the Royal College of Art. It was useless : a waste of public money and a national disgrace. So said the innumerable committees of enquiry set up to consider its maladministration from the 1830s onwards; so, more or less, said Hambledon in 1936; so said Meynell-Hoskin; and so said Herbert Read. They all urged the College to return to its original function : the training of *industrial* designers. In 1946, the report *The Visual Arts*, sponsored by the Dartington Hall Trustees, still spoke extremely gloomily of amateurishness, unsuitable premises, inadequate equipment, hindering development at every turn :

'Throughout its chequered history it has never been adequately supported by the Ministry of Education . . . the College has yet to fulfil adequately its original purpose of training designers for industry.'

All these inadequacies at the RCA were more obvious because of the developments at other art schools : courses in design for machine production had begun, before the war, at Leicester and the Central, and immediately afterwards in Glasgow, although these courses at that date were still in embryo.

The state of education naturally worried the Council of Industrial Design. For how could it promote design in British industry when British designers were so few and far between? A Training Committee was appointed very quickly, and by 1946 their verdict was prepared. Robin Darwin, the Council's Education Officer, acted as Secretary and wrote the report. This report, though never published, was a most impressive document; with logic and proper common sense, it deprecated the traditional division in British education between the arts and sciences, the art schools and the technical schools, and schools of commerce and the universities. It argued the need for much broader and more realistic training for designers than there ever was before. The functions of the Royal College of Art were deeply considered, and Robin Darwin commented that 'Much would, course, depend upon the Principal,

and the initial appointment would be a factor of pivotal importance for the ultimate development of the school.'

Two years later, when Darwin took office—for Robin Darwin was himself appointed Principal—conditions in the College were depressing. The buildings had in 1911 been thoroughly condemned as 'unworthy of a national establishment'; in 1948 the College was still kept in a series of shacks scattered round South Kensington, without a lecture theatre, and almost without studios. A ramshackle tin drill hall, a Boer War relic, still served as the students' all-purpose common room. The drawing desks were stamped 1870; the looms for students of weaving were even more historic; the printed textiles students were reduced to using Morrison shelters for tables; and worse, there was only one sewing-machine to be shared between all unfortunate students of Dress. Conditions were so frightful that William Rothenstein, Principal in 1920, had decided, rather than embark on an ever-losing battle, to concentrate on painting and forget about design.

The staff was just as primitive. Jowett, Darwin's predecessor, asked him to tea to meet them in a body. According to Darwin, in *The Dodo and the Phoenix*, some had never met before and many of them did not know their colleagues' names at all. The Council of the College had no set terms of reference, and seemed to be discouragingly ignorant of finance. The pupils, up to then, had all been pre-selected not by the professors, but by the outside visitor. All this must be changed. As luck would have it, Robin Darwin was related to John Maud—later Lord Redcliffe-Maud, and at that time in a powerful position at the Ministry of Education —and began negotiations for reforms with great determination and a fair degree of confidence.

Darwin insisted on a whole new regime for the RCA. He wanted (and received) full academic freedom, with the right for the College to choose its own students, devise its own teaching methods, frame its own examinations, grant its own awards; in addition, the right for teaching members to select their own colleagues without outside interference; in addition, the sharing of financial responsibility (consistent with the use of public funds) between the Council and Principal and staff. The Principal himself should decide broad lines of policy in conjunction with the Council and should provide general and if possible equal inspiration to departments in his care. Beyond this his job was mainly 'to support his staff and act as a

79

guardian and a watchdog of their freedom'.

One of Darwin's innovations was this dependence on, and great faith in, his staff : he said, 'Herein must lie the real power and vitality—and if the power is not real, the vitality will not spark.' A bit like Cole in theory, but more pertinent in practice, he appointed as Professors active practising designers. He equipped the design schools for actual production : again like Henry Cole, who had had a scheme for students making government furnishings, and like Cole's friend William Dyce who, attempting to be practical, had brought in a loom and a Jacquard machine. But where Cole's and Dyce's training schemes, so admirable in principle, collapsed or were diluted, Darwin pushed his through. And in point of fact the Cole group was never in the minds of reformers of the College in 1948. In those days it was the Bauhaus, with its emphasis on knowledge of materials in training for industrial design, and its well-established principle of working on professional commissions in the classroom, which influenced them most.

In a way, the Bauhaus principles seemed to them ideal. But these of course were tempered, as they always have been tempered, by a very British, civilized and gentlemanly attitude. Darwin, who himself came from a famous Cambridge family, had immense respect for traditional university ideals of education. It was his idea to send out from his college people with broad interests and deep sophistication, people whose minds were 'amused and well-tempered', literate, articulate and generally cultured.

Concurrent with the new regime at the RCA, and just as important for the future of design, changes were taking place at the Council of Industrial Design. On the very day that Darwin's new post as Principal was announced in *The Times*, Gordon Russell's new appointment as Director of the CoID, in succession to F. C. Leslie, was publicly announced. The announcements in *The Times* were printed side-by-side, with a great sense of occasion : for this was the beginning of strong and, on the whole, affectionate ties between the CoID and the College. To start with, Gordon Russell's brother Dick was now Professor of Wood, Metal and Plastics (a temporary School which was later divided into Furniture Design, still under R. D. Russell, and design for Engineering). Robert Gooden, a great friend and ally of the Russells, was Professor of Silversmithing, Jewellery and Glass, and later the Vice-Principal. Gordon Russell recollected how, in times of trouble at the Council of Industrial

Design, he could easily be comforted by the arrival of the regular pink list, beautifully illustrated and composed by Edward Ardizzone, of wines just purchased for the College Senior Common Room. Despite the fact that Gatti's, haunt of Morris and his confreres, had now been designated a club for H.M. forces, a little of the Arts and Crafts delight in proper living, good food and wine and fellowship, still lingered on.

Gordon Russell needed comforts : at the time when he took over at the CoID, the situation was not promising. As he said, he got the backwash from Utility furniture and from 'Britain Can Make It'. The trade—all the trades put together—disliked the idea of outside selection, as of course they always had : their order books were full, in the spate of post-war buying, and they argued irritably that what sold was well-designed. The retailers were angry at aspersions being cast on their own ability to choose the finest products. Designers were annoyed because they felt the Council's standards were too lenient; the trade thought them ridiculously high. There was trouble from the people who were not Council-members, and insisted that they ought to be; and there was yet more trouble from people on the Council who felt that it should work at simple sales promotion, never mind about design. The trade press fought the Council, and Russell was alarmed in case the export trades united to denounce the Council's work to the Board of Trade, maintaining that the Council was jeopardizing exports by criticizing products which were bringing income in. On top of this the Chairman, Thomas Barlow, wrote resigning because of overwork.

'My army experience stood me in good stead,' wrote Gordon Russell, reminiscing on this unsettling period. He drafted a new plan for CoID development, a good efficient plan by means of which the Council managed in the end to effect a kind of truce. In the Annual Report 1948–1949, he explained how and why he had now regrouped his staff (which for Britain Can Make It had worked in one big body) into two divisions :

'Without an effective demand for better design there can be no adequate supply of it and without examples of good design being put before the public there can be no standard of comparison on which to base the demand. The twin drive for better design must therefore be pursued at the same time—the Industrial Division, to encourage a supply of well-designed products from, and the flow

of trained talent to, industry, and the Information Division to stimulate public demand for higher standards.'

Chief Industrial Officer was Mark Hartland Thomas; Chief Information Officer was Paul Reilly, son of Sir Charles Reilly, the pre-war Professor of Architecture at Liverpool University.

Convincing by showing, reforming by exhibiting, encouraging industry to alter its aesthetics; this was nothing new. It was just what Henry Cole, Gottfried Semper and Prince Albert had been setting out to do. It was one of the main principles of the DIA and of Pick's sadly ineffective Council. And nothing much had altered; very little had improved. Gordon Russell, undeterred, with the added great advantage of a grant of £164,000 and a staff of 165, started off again to end the ever-lasting circle of apathetic manufacturers and shopkeepers and ignorant consumers. He was systematic. While industrial officers went round the manufacturers, examining, entreating and, where they could, encouraging the Information Division was travelling the country, enlightening the people, in a kind of caravan : taking its Design Fair, a mobile exhibition, to join in such civic displays as 'Sheffield on Its Mettle'; creating whole Design Weeks in Newcastle and Nottingham, Southampton, Bristol, Bradford and other hopeful towns, drawing in the civic dignitaries, retailers and housewives, Rotarians, Soroptomists and children from the schools to special exhibitions, often in museums, to lectures and discussions. They laid on Housewives Forums to which women came demanding squarer saucepans, larger castors and higher three-piece suites. They indoctrinated sales staff with residential conferences, speeches on 'What We Mean by Good Design', and Brains Trusts. They distributed small booklets called 'Four Ways of Living' (dress designer, doctor, chain-store keeper, clerk). They brought out little leaflets saying to the public :

'Design is what makes a thing
    easy to make,
    easy to use,
    easy to look at.'

They sent around their newsheets and analyses of dishracks and pamphlets on 'How to Furnish Your Home', and in 1949 they started to publish *Design* magazine—an act of such confidence, just then, that Francis Meynell, calling it megalomania, resigned.

*Design* began most tactfully. With just the same soft-pedalling as *Journal of Design* a century before, the first editorial announced

that 'This journal begins publication with one purpose, and one purpose only: to help industry in its task of raising standards of design.' With this aim, the first issue included a feature entitled 'Neater Meter' (a before-and-after story), and an article by Gordon Russell asking patiently, for about the hundredth time, 'What is good design?' The answer—a product which is true to its materials, good in appearance and, above all, fit for use—shows how very close the Council's thinking was in those days to the basic pre-war doctrine of the DIA. But the illustrations emphasize a most important difference, something which the DIA had never really tackled. The Beetle plastics sugar dredger shown by Gordon Russell, the strainer and potato masher, prove how hard the Council tried to reach the general public. This was design within the people's ken.

One way and another, by roughly 1950, partly through the Council's efforts, partly independently, design in British industry was visibly improving. Besides the pre-war devotees there were some newer converts. Besides Gordon Russell, there was HK, Race and Hille and Morris of Glasgow. Besides Edinburgh Weavers, there was now Whitehead and Tibor. The pre-war Good Furniture Group had been revived, and a counterpart in Scotland, Scottish Furniture Manufacturers, by then had commissioned new designs. Alongside Heal's and Dunn's, there were many other shops showing sudden post-war interest in modern merchandise: Liberty's in London, Bainbridge's of Newcastle, Hopewells of Nottingham, David Morgan, Cardiff, Hammonds of Hull, Brown's of Newcastle, John Bowler of Brighton. Said *Design* magazine obviously encouraged, 'The list will grow, for the tide is turning.' And indeed perhaps it was.

In 1946, the *Architectural Review* had been complaining that the daily press, which publicized authors, never mentioned industrial designers. By 1950, *Design* was saying:

'Note the increasing frequency of constructive references to design in the home; see how the women's pages examine the design of household goods; watch the rising demand by editors for hand-picked photographs from the Council of Industrial Design and consider that full page in the Daily Mirror given up to a serious review of *Designers in Britain* under the four-column headline: DESIGN HAS COME INTO YOUR LIFE.'

Surely this deserved a celebration. And in fact, a celebration

83

was already underway : a heyday to be known as The Festival of Britain, a landmark in the history of industrial design.

## BOOK LIST

Blake, John and Avril  *The Practical Idealists: A History of Design Research Unit* (Lund Humphries, 1969)
Carrington, Noel and Harris, Muriel (eds)  *Achievement in British Design* (Pilot Press, 1946)
Gloag, John  *The English Tradition in Design* (Penguin, 1947; revised edition, A. & C. Black, 1959)
    *The Missing Technician in Industrial Production* (London, 1944)
    *Self-Training for Industrial Designers* (London, 1947)
Jarvis, A.  *Things We See – Indoors and Out* (London, 1946)
Joel, David  *The Adventure of British Furniture* (Ernest Benn, 1953)
Meynell, Francis  *My Lives* (Bodley Head, 1971)
Morton, Jocelyn  *Three Generations in a Family Textile Firm* (Routledge & Kegan Paul, 1971)
Read, Sir Herbert (intr.)  *The Practice of Design* (London, 1946)
Russell, Gordon  *Designer's Trade* (George Allen & Unwin, 1968)
    *Looking at Furniture* (Lund Humphries, 1964)

## EXHIBITION CATALOGUES

*Britain Can Make It* (London, Victoria & Albert Museum, 1946)
*Utility Furniture* (London, Geffrye Museum, 1975)

## PERIODICALS

*Architectural Review*
*Art and Design*, monthly bulletin of Central Institute of Art and Design, 1942–8
*Art and Industry*, to 1958
*Council of Industrial Design Annual Report*, from 1944
*Design*, published by Council of Industrial Design, from 1949
*Design and Industries Association News Sheet and Year Book*
*Designers in Britain*, review of SIA members' work, Society of Industrial Artists, 1947–9

# The Industrial Designers
## 1951–1960

HUDDLED in a cubby hole, a former footman's bedroom, in one of those imperious red houses behind Harrods, Hugh Casson and his Festival Design Group apprehensively sat hour after hour sipping Bisodol and wondering how ever they could make an exhibition on their badly-blitzed and desolate, depressing South Bank site.

The idea of the Festival was mooted some years earlier: incongrously enough, in the middle of the War, the Royal Society of Arts had proposed a 1951 exhibition to commemorate the Great Exhibition held a hundred years before. This private suggestion was reinforced more publicly in 1945 when John Gloag, voice of the DIA resurgent, wrote to *The Times*, and almost simultaneously Gerald Barry, then editor of the *News Chronicle*, published an Open Letter to Sir Stafford Cripps. What they both wanted was an international exhibition, and as it turned out, the suggestion was timely. For Cripps, an exhibition enthusiast who had built 'Britain Can Make It' almost singlehanded, was already making plans for a festival in Britain. He sent one of his urgent red-ink letters back to Barry, expressing his enthusiasm; within another fortnight, the Ramsden Committee was set up, which recommended 'a first category international exhibition,' held at the earliest practicable date, 'to demonstrate to the world the recovery of the United Kingdom from the effects of the war in the moral, cultural, spiritual and material fields'.

This was 1946. By the time it reached Hugh Casson, three years later, the Festival of Britain was not so grandiose. By then it was not international, just British; the country's economics, lack of housing, loss of factories, had cut down the plans to a more

manageable size, reducing the theme from universal showmanship to national reassessment. The Festival would now be a national morale-booster, a time for fun and fantasy; after a decade of war, deprivation and darkness, it was to be a moment of remembrance of things past and incentive to things future. In this heady atmosphere, the organizers were directed to display 'the British contribution to civilization, past, present and future, in the arts, in science and technology, and in industrial design'. Stafford Cripps, the President of the Board of Trade, had by then handed on the Festival responsibility to the Lord President of the Council, Herbert Morrison. The Festival Council had been appointed. Under Gerald Barry, by then himself installed as Director-General of all festivities, the Festival Executive Committee was at work; and under the Committee was the Presentation Panel, and then beneath the Panel was Hugh Casson's Design Unit, appointed to give shape to the patriotic concept, to bring the fun and fantasy alive beside the Thames.

'They enjoyed it,' said Hugh Casson on the BBC, talking to the Schools in 1951, 'they laughed a lot and from the very beginning they made up their minds that it shoudn't be pompous or boring.' He and James Holland, James Gardner, Ralph Tubbs and Misha Black sat shivering in overcoats for hours, day after day, in the attic room in Knightsbridge with drawing boards on their knees and tracing paper piling up around them, determined that the Festival should be bright, gay and popular and totally inspiring on its awkward tiny site. No long palatial vistas, but small ones, interlocking; no ponderous pavilions, but buildings grouped informally: Hugh Casson described it to the Schools (and Olive Shapley) as a very large house with the roof taken off and the pavilions laid out like outdoor rooms.

Who was to design the various Pavilions and Restaurants and showpieces? Hugh Casson and his Unit needed men of genius, but as time was short, they could not afford men of temperament. They settled, very wisely, for themselves and many friends: Black and Holland on the Upstream Circuit, 'The Land'; James Gardner on the Downstream Circuit, 'The People'; Ralph Tubbs on the Dome of Discovery—provided that the Dome could in fact be fitted in. ('It seemed doubtful,' said Casson, 'because in a fit of exhibitionism we had decided it must be 365 feet across and we clung to that dimension with pathetic assurance.') The Lion and

the Unicorn Pavilion was assigned to Robert Goodden and Dick Russell; Homes and Gardens to Katz Vaughan; the Tele-cinema to Wells Coates; the Shot Tower to Casson and Gardner. The teamwork was quite breathtaking for Britain—a country where up to then team spirit in design was non-existent—extending to the litter bins (Jack Howe) and chairs (by Race) and signposts (by Milner Gray and Robin Day.) A hundred or more designers were employed. There was somebody responsible for every little detail, the ice-cream stalls and flower-pots, the sculpture and the murals, the knives and forks and pottery, the bird boxes and even the breed of ducks selected for the ornamental lake.

The Council of Industrial Design was much involved; the Council and the Festival seemed made for one another. The Council was the source of all the manufactured objects; the Festival the carrot (or the stick) for manufacturers, urging them to try a little harder with design. The original scheme had been for a special separate pavilion of industrial design, but Gordon Russell who argued—much like Morris—that design is all around us, resisted the idea of a Good Design Pavilion. Fearing clumsy WCs and basins in the public lavatories, unco-ordinated lettering, badly-chosen chairs and a general lack of function throughout the Festival, he suggested that his Council, far from being confined to one exemplary pavilion, should oversee the total design standards. The rule was made that nothing in industrial production should be included without CoID approval, thus forestalling free-for-all Halls of Textiles, Pavilions of Confectionery, Palaces of Gas : there were to be no Winston Churchills in Swiss roll, no effigies of royalty in edible fats; a paper manufacturers' proposal to exhibit a model of the South Bank in lavatory paper was regretfully declined. 'No stunts,' said Gordon Russell to his industrial officers before he sent them out to gather British products : 'They will be real goods to go into real shops and so be available for real people. This may not be an earth-shattering statement, but it is British common sense.'

Sensibly, the Council thought up and implemented the 1951 Stock List, a card-index of all the well-designed articles the officers could search out in a systematic survey of the industries, from locomotives to henhouses, from tableware to sailing boats, all organised so neatly in 70 categories that finally the Stock List was

itself exhibited, renamed (more festively perhaps) 'Design Review'. Doggedly, the Council persuaded twenty-eight British manufacturers to work for eighteen months in the Festival Pattern Group, decorating products with patterns derived from crystal structure diagrams, taking advice from a scientist at Girton, triumphantly producing dress-prints based on haemoglobin, crystal-structure curtain fabrics, plastic sheets and ties, crystal-structure lighting fittings, dinner plates and wine-glasses, a crystal-structure foyer for the Science Exhibition. Sir Lawrence Bragg politely wrote to say how pleased he was. The *Architectural Review* was not so keen. It is certain that the project, mingling art and science and industry, would have been dear to the heart of Henry Cole.

Cole would have approved of the whole conduct of the Council at the Festival of Britain: its calmness and efficiency; the way (against all odds) it organized the loan of a large locomotive from Glasgow; the way in which it collected, stored and catalogued and finally returned 10,000 objects from 3,500 firms—an operation managed by Benoy, a retired major-general, whose experience with moving troops for the African invasion in World War II stood him in good stead. Best of all, the Council had succeeded in not ruffling, and not being ruffled by, industry too greatly. The standards of selection were deliberately moderate. Wrote Gordon Russell in the *Architectural Review* (which had complained, as usual, about the Council's leniency):

'Our aim was to find something worth showing from the greatest number of firms possible, otherwise we should run the risk of all the exhibits in certain trades coming from three or four firms, which could hardly be tolerated in an operation financed by public funds on this scale.'

Perhaps it was this moderation, the discovery that modern design was, after all, approachable; perhaps it was the fact that the Festival was billed as 'the people's show, not organized arbitrarily for them to enjoy, but put on largely by them, by us all, as an expression of a way of life in which we believe'; perhaps it was the intoxication of the time when Churchill, in medals, rode up the escalator in the Dome of Discovery and everybody cheered and danced in the open-air along the Fairway and set off in balloons for unknown destinations; perhaps it was the brilliance of Casson's small piazzas and pretty outdoor cafés and the catwalk and the Skylon; perhaps it was the crystals which the purists so despised:

whatever the reason, or accumulated reasons, modern design seemed suddenly acceptable. The public, which had for a century resisted all benevolent attempts to bring them good design—from Prince Albert's workmen's cottages of 1851, the 1905 Cheap Cottages at Letchworth, the display of 'Industrial Art for the Slender Purse' in 1929 at the Victoria and Albert, the DIA pre-war working-class showhouses, 'Homes for the People' in Manchester in wartime, Pick's well-intentioned survey of 'The Working-Class Home' (about which they cared nothing)—overnight came round. They went off in their thousands to the showhouse at Lansbury furnished entirely, with CoID approval, for £143 4s 7d; where Bill, a dock-worker, his wife Mary (35) who had been in service and understood good housekeeping, their children, Jack, Jill, Jane and Baby Tom (4–5 months) lived happily with blue distemper walls and dark blue paper, starred and dotted, on the wall above the chimney, an extending dining table, an expanding coffee table, a reversible trolley convertible to cardtable, "Jack and Jill" easy chairs, a brass-stem standard lamp and russet wild-flower curtains (7s 11d a yard).

Gerald Barry had insisted that 1951 must be something more than a year of bigger and better exhibitions and more and merrier festivals; his idea that the Festival should be a sort of springboard for young architects and artists and designers had in fact come beautifully true. Neville Ward, for instance, wrote that 'Ward and Austin were (just) in practice, two of the three of us still in our twenties; so to be invited to take part in the South Bank project was wonderful. It was, in a time of few and small opportunities, a big thing.' The repercussions, both for design and for designers, were to be long-lasting. The Casson-Black contingent went from strength to strength; the Royal College of Art was greatly glorified by the contributions of its practising professors, and the students on the fringe of it absorbed the optimism and understood the discipline and teamwork of it all. The British began paying more attention to detail: to good lettering on captions and on signposts, to interior and exterior furniture, electrical fitments, litter-bins and landscaping, to texture and the colour of paving and to lighting, things which they had hardly bothered with before. Individual objects which were first seen on the South Bank, ranging from Race bright steel-rod chairs to concrete flower bowls, were soon found far and wide. Barry, looking back on it, summed it up quite

89

wisely: 'In this bold use of colour, in the marriage of architecture and sculpture, in scrupulous use of landscaping, in attention to elegance and finish in interior and exterior fittings, new standards and a new style were set up—the 'Festival Style'—which evidently caught the imagination of other designers and also created a public or commercial demand. It was copied all over the country —copied, and gradually debased. In due course the Festival style became a cliché. Probably this was inevitable.'

Gordon Russell and his Council of Industrial Design made the very most of the Festival of Britain. This seemed their great moment to consolidate for ever the movement for reform, to try once and for all to break down the vicious circle which for ages had prevented real progress in design. They kept 'Design Review', the Stock List from the Festival; by then they had accumulated rather more good-will from the manufacturers; contemporary case-histories prove time and time again, unlikely as it seems, that manufacturers whose products were rejected had afterwards come to the Council for advice. In the greatly improved climate of the fifties, a system—simple in outline, elaborate in operation—was developed, and soon became the envy of, and model for, reformers of design in other European countries. (Rather as the British architects and craftsmen had impressed the Continentals fifty years before.)

The system they evolved was this, in briefest outline. The CoID would suggest to a British manufacturer that one (or maybe all) of his designs could be improved on. The manufacturer would then come back to the Council for the names of some designers with the relevant experience. A designer would be chosen to work with the manufacturer (on staff or freelance basis) to produce a new design, which would then be submitted to the Council for approval, which would then be accepted for 'Design Review', exhibited to retailers, shown to the public in the various design centres, ultimately —in the most ideal conditions—winning a Design Centre Award.

This may sound cut-and-dried, but the system evolved slowly. It took years for the Council to make its purpose known, and years to gain enough support for tangible achievement. Through the early fifties, the scale of operations was relatively small. In 1953, the Record of Designers had only 350 requests from manufacturers; and one must remember that the Haymarket Design Centre was not in fact opened until 1956, and Design Centre Awards did

not begin till 1957. But onwards from the Festival, the system was immeasurably strengthened by designers trained to be designers, from the RCA and other colleges of art. This was one large reason for the Council's rush of confidence; the training of designers at long last seemed secure. It was 1951 when the Des. RCA was first awarded to students completing the design course at the Royal College of Art. By 1953, the RCA reported that out of the 59 students who had left, 44 had posts in industry. By 1957, *Designers in Britain* (the catalogue of work of the SIA designers) showed Des. RCA products on every other page : Guille's designs for Kandya, Robert Welch's stainless steel for Wiggin, David Mellor's cutlery for Walker & Hall, Robert Heritage's furniture for Evans. The issue also featured a certain Terence Conran, a designer from the Central School, showing a picture of an unusually long sideboard produced by Conran Furniture.

A new kind of designer was emerging : not architect, not artist and not exactly craftsman, but someone who had actually trained specifically to design for industrial production. The bias was towards the small and individual practice. The scale of operations in America, where offices were sometimes 50-strong, seemed most unsympathetic to students who were trained in knowledge of materials and personal experiment. The Scandinavian system of individual offices seemed rather more ideal, and many of the students who emerged from design courses set up their own small design offices, to act as consultants to British industry. For instance : the RCA-trained furniture designers Ronald Carter and Robert Heritage; the textile designers Audrey Levy, Pat Albeck, Shirley Craven; the jeweller John Donald; the silversmith/ industrial designers Gerald Benney, Robert Welch and David Mellor. Robert Welch, in Chipping Campden, opened his own workshop in Ashbee's old headquarters : in Sheffield, David Mellor set up his own office and metal-working shop. The difference, of course, was that whereas C. R. Ashbee and his craftsmen worked mostly on special commissions, Robert Welch and David Mellor, besides their one-off silver, used their workshops for production of industrial prototypes : alongside special silver for Churchill College, Cambridge, Robert Welch would be working on designs for stainless steel; as well as a cross for Southwell Minster, David Mellor would design a cast-iron heater or a lamp-post or a litter-bin. In Britain in the fifties a new realistic breed of designers was evolving

a new realistic style: or, in point of fact, developing traditional British virtues of common sense and wholesomeness, simplicity and reticence into a good, decent, measured, modest, modern style.

In 1953, the Council of Industrial Design had made the characteristically sensible announcement that

'Though rules of thumb and narrow definitions are neither feasible nor desirable, the general principle can be stated that the object of the Council's selections is to promote good design as comprising good materials and workmanship, fitness for purpose and pleasure in use.'

This was the principle of all its activities: its bulletins and lectures, its photographic library, its visual aids for schools, its travelling exhibitions. It was clearly to be seen in the illustrations chosen for the Annual Reports: the office dictaphone, the pickled beetroot label, the dress-shield display dispenser, all shown in 1953, along with the unit bedroom furniture designed by Frank Austin, 'as a result of the meeting between CoID staff and the firm's managing director'. Goodness and fitness and pleasure were all obvious in the CoID show-flats and show-houses round the country, and the CoID Ideal Home displays of decent living, with Ward & Austin pianos, and shelves by Robert Heritage, Stag wardrobes designed by John and Sylvia Reid, Kandya chairs, Reynolds Woodware sideboards and Conelamps, adjustable and washable and pleated, clean and neat in acetate, by Cooke-Yarborough and Homes.

A pleasant time it was, when standards seemed so certain, and good design meant comeliness and usefulness and sense, and the London Design Centre was opened by the Duke of Edinburgh who wished it the very best of luck. It had taken so long coming—back in 1931 Gorell and his committee had stressed the crying need for a central exhibition, and committees ever after had demanded and demanded a Pavilion of Design—that once the Centre opened in 1956, thanks to Walter Worboys, CoID Chairman, thanks to Gordon Russell's indefatigable spadework, and thanks to £27,000 from industry, it seemed a great occasion. DIA prayers seemed answered. Here at last in London was a showplace for design. What if Buckminster Fuller called it 'Bargain basement stuff; you're designing for today in the idiom of ten years ago'; and what if Charles Eames, visiting the Centre, found it 'very creepy'. Mr Gaitskell and his wife had said that they wished they had seen

the Centre earlier, before they had altered their Hampstead home, and Marghanita Laski had felt that 'any woman who is at all interested in good design will feel an immense debt of gratitude to the CoID for starting the Centre'. The *Daily Telegraph* even predicted it might make us the best-furnished nation in the world.

So on with honest business : selection committees on Tuesdays and on Thursdays to assess the various products submitted to the Council. A group of outside specialists, designers, architects and retailers, backed up by Council members and CoID staff, sat in judgement on up to 200 products, regaled at 3 o'clock by a cup of Council tea, asking, in general, the old DIA questions on fitness for purpose and pleasure in use. Will it pour or cut or hold things? is it man-size, child-size, ship-shape? Is it functional and proper? Is it fair and square and good, performing (when it need to) reasonable ablutions? Provided that the judges, heirs of Ambrose Heal, were satisfied, the product could then (on payment of a fee) be shown in the Design Centre and (if the manufacturers wrote in for special labels) could be emblazoned 'Design Centre Approved'.

Ten years before, such a scheme could never have proved practical : British manufacturers would not have dreamed of paying for space in a selective exhibition of design. Though even now some grumbled and fumed about the Council and its ignorant committees and its high-falutin' principles, the fact that every day 2,000 people came to see the exhibition in the Haymarket bore weight. Bit by bit, by conferences, with a Scottish Design Centre (under Alister Maynard, the furniture designer), with Design Centres attached to Building Centres in the provinces, the cause of good design was patiently argued and precisely illustrated. By tactful, careful conduct, by general efficiency, by constantly opposing the idea of long-haired art, the Council showed the manufacturers that there was nothing so extreme about its policy. The level of selection remained thoroughly Home Service, design for a large public, the aesthetic middlebrow.

What is interesting is that, in spite of all this tolerance, the Council was then, in a sense, quite narrow-minded. This, again, was a great strength : through the early and mid-fifties, Gordon Russell was almost exclusively intent on raising design standards in consumer industries. No dallying, at this stage, with design in engineering; no veering off to contemplate the face of the land,

93

few thoughts about environment and mass-communications. For the moment, the main aim was better teacups, chairs and tables. 'Limited advance and consolidate', his motto, reached its point of glory with Design Centre Awards. In 1957, two RCA Professors (Goodden and Russell), Brian O'Rorke the architect, Milner Gray, Master of the Faculty of Royal Designers for Industry, and Mrs Astrid Sampe, picked out twelve outstandingly simple and practical objects: dinner and teaware, table glasses, wallpaper, cutlery, a curtain fabric, a carpet, plastic tableware, a lamp shade, a TV set, a convertible settee-bed, Pyrex casseroles and a convector open fire.

'Although,' wrote the judges, on a note of some surprise, 'none of the articles selected was chosen for its affinity with another, in the case of the table glass, dinner ware and cutlery it is interesting to see in the result how well the selected examples would combine as a place setting.' Interesting certainly; but surely not surprising. It was thoroughly predictable—might one say inevitable?—given the Council's emphasis on clean appearance, sound workmanship and suitability for purpose, that Design Centre Awards would tend to look alike.

The Design Centre Awards given in 1957 and on each successive year (with the bonus of the Duke of Edinburgh's Prize for Elegant Design) brought extraordinary glory to the partnerships beginning to build up between the freelance designer and his clients. Year after year, design awards were given (or seemed to be given) to Robin Day and Hille, the Reids and Rotaflex, Hulme Chadwick and Wilkinson Sword, Humphrey Spender and Edinburgh Weavers, Audrey Levy and Wall Paper Manufacturers, Edward Pond and Bernard Wardle, Robert Welch and Old Hall, Robert Heritage and Archie Shine, and David Mellor and Walker & Hall. Year after year—and this was no illusion—design awards became an accolade for Royal College of Art training. Robin Darwin wrote a letter to *Design* magazine in 1958 pointing out that 35 per cent of the 20 'Designs of the Year' was the work of designers who had studied at the RCA during the previous seven years. Besides— he added, to be fair—'two other winning designers belong to an earlier generation'.

Design was still in many ways an amiable clique. Identical professors seemed forever giving prizes to their own RCA students, identical designers were forever smiling thanks to the Duke of

Edinburgh. The DIA still talked of 'spreading the gospel', and for that very purpose held house-parties at Ashridge, convivial country gatherings they called 'Design Weekends'. The fact was that the Council of Industrial Design had stolen the DIA's thunder; through the fifties, its activities were altogether cosy and low-key, with lunch meetings at Overseas House (sample topic: *Design Starvation in the Public Schools*); with musical evenings in the Geffrye Museum; with little exhibitions in Charing Cross Station, 'Register Your Choice' and later 'Make or Mar'.

And yet, in spite of the family circle of DIA and RCA and CoID, in spite of the widespread continuing assumption that design was still the gospel to be spread to unbelievers, there was by now a change of some significance. Hamilton Temple Smith, a founding father of the DIA, had perceived it in 1951 : 'The heathen, he wrote, 'no longer stone us out of their cities : they are more likely to offer us a cocktail. And this frightens me.' Marghanita Laski had noticed it, and rather to the horror of the courteous DIA, stated in the *Year Book* 'The day of the design we have fought and struggled for these many years is already over. It is popular, accepted and boring.' In a way, she was right : from the Festival onwards design—or Design as it became—was all around. Design was on the railways : in 1956, British Railways Design Panel was hopefully established. (George Williams, the first Design Director, had been on the staff of the CoID.) Design had reached the Ministry of Works, where Harold Glover, the Controller of Supplies, persistently raised standards. The LCC Architects Department, in particular the Furniture Section directed by Frank Height, designed official furniture for LCC schools, colleges, offices and welfare homes, controlling all the colours for all LCC buildings. The Ministry of Transport offered what amounted to bribes for good design, subsidizing lighting on trunk roads on condition that local authorities selected lighting columns already approved by the CoID. Meanwhile Ernest Marples, the new Postmaster General, announced a design policy which, if it had matured, might have been the most impressive of all the design policies of the middle and late fifties : he would modernize the Post Offices, posters, greetings telegrams; redesign the telephone kiosks and consider new telephones. Mr Marples was even undertaking to test all the prototypes himself.

This was the age in which Design became a factor in public

95

image-building. Successive PMGs promised the public better-designed pillar-boxes; managing directors of forward-looking companies commissioned themselves symbols and new, dynamic letter-headings. Corporate identity programmes began flourishing on airlines, in laundries, in off-licences, in banks. The reformers' age-old plans for uniting art and commerce had at last materialized, not quite as they imagined. Design was advertising; Design was serious commerce; Design was the concern of Boards of Directors, a development acknowledged with characteristic pomp by the Royal Society of Arts which from 1954, the year of its Bicentenary, gave a Bicentenary Design Medal to people who 'in a manner other than as industrial designers have exerted an exceptional influence in promoting art and design in British industry'. The first four medals went to good artistic businessmen : 1954 Sir Colin Anderson, 1955 Sir Charles Tennyson, 1956 Sir Walter Worboys and 1957 Sir Ernest Goodale.

This was the era of management consultants : design consultants fitted neatly in beside them. This was the beginning of consumer-consciousness : Design of course, appealed strongly to readers of 'Which?'. This was the age of 'Outrage' and the Anti-Ugly demonstrations when people shouted 'Hell' and beat drums and carried coffins to appalling modern buildings : Design impinged upon these activities as well. Design was in the shops and Design was in the showrooms, the posters and advertisements. Design was on TV : 'Design Review' became a monthly woman's feature, introducing Moira Hallifax of Peter Jones, Sloane Square. Design was, most of all, in evidence in journalism. A vast factor in dissemination of Design were the magazines and the newspapers of the period. Design, at that time, was considered very newsworthy, and a whole new breed of writers, the Home Editors, were born.

In 1953, at Coronation time, *Ideal Home* made the rousing, very patriotic statement that 'The finest efforts of living designers, encouraged by everyone's desire for the best, will safeguard our heritage.' In fact this was a turning point. The work of living designers—up to then a specialist subject for *Design* magazine, the *Architectural Review* and esoteric foreign publications, like *Mobilia, Graphis, Domus*—was featured in more general, domestic magazines. in 1953, *Ideal Home* was running features on 'Silver in the Home', showing RCA silversmiths; 'At Home with the Days', showing Lucienne and Robin chatting in their studio; a genial

and encouraging lecture by Paul Reilly called 'Don't be Afraid of Contemporary Design'.

*Home* and *Homes and Gardens*, *House Beautiful* and *Housewife*, *Everywoman*, *Woman and Home* and *Woman's Journal*: within the next few years, the design-conscious magazines enlarged and multiplied.

As fervent propagandists for design the journalists were considerably fiercer than the CoID. On factory tours, immaculate small parties of lady journalists in smart imposing hats would tackle manufacturers, who generally seemed dumbfounded, and ask them why their standards of design were mediocre. Why cut that glass decanter when it looks much better plainer? Why paint that cup with roses when it looks so lovely white? Why not treat designers the way they do in Sweden? Why not be like Gustavsberg, Arabia or Orrefors? For this was the time when Scandinavia, to the journalists and other tasteful people, approximated heaven.

To encourage them, Paul Stemann at Finmar was importing Wegner chairs and Gense stainless steel, Arabia pottery and Kaare Klint paper lampshades. The Green Group (the Good Furnishing Group of retailers in a new and more Nordic incarnation) was importing substantial quantities of Scandinavian furniture. Little shops, craft-orientated, Scandinavian in tenor, with a comfortable love of well-made little things, now appeared in Britain : the first was Primavera, Henry Rothschild's shop in Sloane Street in 1945, and by the later fifties they were opening in dozens. In Sheffield, Interior Decorations; in Manchester, Malcolm Bishop; in Doncaster and Retford, York Tenn, Yorkshire design shops apparently directly inspired by Scandinavia, based on the Swedish design shop, Svensk Tenn. And everywhere you went, you were almost sure of finding a Svensk or Norsk or Dansk shop, full of stainless steel and teak.

This love of Scandinavia was at its most fastidious in the upper reaches of the RCA, in the Western Galleries, the long dank College workshops above the Aeronautical Museum, where Professor R. D. Russell and David Pye were teaching their furniture students to respect the plain and simple, to understand construction, to care for natural wood, to appreciate the Swedish understatement of Carl Malmsten, to worship the finesse of the Danish school of Klint : Scandinavian designers who were, in their turn, indebted to the British eighteenth-century fine sturdy craftsman style.

Design had gone full circle; the British avant-garde was in-

fluenced by Denmark which was influenced by Britain. At the same time, more directly, the British craft tradition revived by Webb and Gimson in the later nineteenth century began to be appreciated. Morris and his friends, up to now the rather private preserve of *Architectural Review* readers and Pevsner, came as a revelation to a greatly widened public. In 1951, in honour of the Festival, a special exhibition, 'The Cotswold Tradition', was mounted by Oliver Hill in Cheltenham, showing Ashbee and Gimson and the Barnsleys in their setting of patient Cotswold building and sheep-shearing and hay-making. The next year Peter Floud, Keeper of Circulation at the Victoria and Albert Museum, an addict of the period, put on an exhibition of 'Victorian and Edwardian Decorative Arts', showing the work of Godwin and Dresser and other Victorian designers of importance, and covering the Arts and Crafts movement in great detail. An era which had seemed almost wholly unimportant, of negligible interest if not an outright joke, seemed suddenly quite vital. Voysey was a hero; and people began noticing Charles Rennie Mackintosh.

In 1959, Gordon Russell, a designer with the Cotswold tradition very much at heart, a philosopher in tune with Gimson and with Ashbee, retired from the Council of Industrial Design. By then he had been knighted and the Queen, as she tapped him on the shoulder with her sword, had kindly murmured a few words on the success of the CoID, and—wrote Sir Gordon—'I felt gratified that her reaction, as usual, would be that of a great many of her subjects.' In 1959, the Council was awarded the Gran Premio Internazionale la Rinascente Compasso d'Oro, recognition from Milan 'as the oldest and most efficient government organization for the development and popularization of good design'. Calling himself the Council's scheduled ancient monument, feasted and presented with an English oak staircase by the CoID members, and a tankard from the Arts Club, and an old cut-glass decanter from the Scottish Committee, Gordon Russell went his way, back to Kingcombe in the Cotswolds, and soon the entire character of British design changed.

BOOK LIST

Ashford, F. C.   *Designing for Industry* (Pitman, 1955)
Barry, Sir Gerald   Cantor Lectures on the Festival of Britain (Royal Society of Arts Journal, 1952)

Beresford-Evans, J.  *Form in Engineering Design* (Oxford, 1954)
Carrington, Noel  *Colour and Pattern in the Home* (Batsford, 1954)
  *Design and Decoration in the Home* (Batsford, 1952)
Casson, Hugh  'Dreams and awakenings', chapter 8 in *Spirit of the Age*
  (BBC Publications, 1975)
Farr, Michael  *Design in British Industry − A Mid-Century Survey*
  (Cambridge University Press, 1955)
Hughes, Graham  *Modern Jewellery* (Studio Vista, 1963)
  *Modern Silver* (Studio Vista, 1967)
Larkman, Brian  *Metalwork Designs of Today* (John Murray, 1969)
Pilditch, James and Scott, Douglas  *The Business of Product Design*
  (Business Publications, 1965)
Russell, Gordon  *Designer's Trade* (George Allen & Unwin, 1968)
Sissons, Michael and French, Philip (eds)  *The Age of Austerity* for
  chapter on the Festival of Britain by Michael Frayn (Hodder &
  Stoughton, 1963)
Stafford, M. and Middlemas, R. K.  *British Furniture through the Ages*
  (Arthur Barker, 1966)
Welch, Robert  *Design in a Cotswold Workshop* (Lund Humphries,
  1973)

EXHIBITION CATALOGUES

*Classics of Modern Design* (London, Camden Arts Centre, 1977)
*Festival of Britain*. Illustrated catalogue, 1951; souvenir booklet, *Design
  in the Festival*, 1951; Crystal Design Book by the Festival Pattern
  Group, 1951; *The Story of the Festival of Britain*, official report, 1951
*A Tonic to the Nation: The Festival of Britain, 1951* (London, Victoria
  & Albert Museum, 1977). Souvenir book edited by Mary Banham and
Bevis Hillier (Thames & Hudson, 1977)

PERIODICALS

*ARK,* journal of Royal College of Art
*Council of Industrial Design Annual Report*
*Design,* published by Council of Industrial Design
*Design and Industries Association Year Book*
*Designers in Britan,* review of SIA members' work, Society of Industrial
  Artists, 1951, 1954, 1957
*House and Garden*
*Ideal Home*
*Society of Industrial Artists Journal*

# The Engineers
# 1960–1970

'The Princess Margaret, Countess of Snowdon and
The Earl of Snowdon this evening visited an
Exhibition of Perspex at the Royal College of Art.'

THIS was the announcement from Kensington Palace, published
in *The Times* Court Circular and showing how far the royal spirit
of patronage had moved from Prince Albert's workmen's cottages,
the Duchess of York's poker-work, Prince Edward's functional
reading lamp of 1933, and even the Duke of Edinburgh's Prize for
Elegant Design, first awarded in 1959. For in the 1960s, in Lord
Snowdon, a professional photographer and film-maker, designer of
an aluminium Aviary for London Zoo, reformers of design had
a most practical supporter—more convincing than Prince Edward,
more useful than Prince Albert—with an interest in science and a
wordly sense of fashion : two contrary directions in which design
was shifting. Lord Snowdon joined the Council of Industrial
Design.

When, in 1961, Lord Snowdon was installed in a CoID staff
office in the Piccadilly building, helping with the CoID's endeavours
to promote 'by all practicable means' design in British industry, the
movement for reform in design was nothing new. It was over a
century since Henry Cole was trying to effect the alliance of fine
art and manufacture, and a hundred years exactly since William
Morris opened his art workshops, and was preaching to his friends
and fellow-craftsmen the importance of simplicity, sincerity, good
materials and sound workmanship. It was, by then, more than
forty years since the Design and Industries Association was first
sounding its tucket and striking its colours. It was almost thirty

years since Frank Pick's Council for Art and Industry began its conscientious work. It was even (although at the time it did not seem it), sixteen years since the formation of the Council of Industrial Design. By this time, the Council employed 204 people; the Board of Trade Grant was £240,000. Government support for the reformers was substantial. What exactly, at this stage, could they be said to have achieved?

They had made a certain headway with the manufacturers. The output of decent tea-cups, well-made tables and neat refrigerators was much higher than it used to be. They had also made a certain headway with the retailer. The number of shops *stocking* decent tea-cups, well-made tables, and Council-approved products in general was greater. At the same time, the imagination of the public—and this was most important and extremely interesting—had been seized, much more than ever, by ideas of good design. Design for modern life : it became a kind of craving. So much so, as we shall see, that the Council of Industrial Design, which had encouraged it, was almost left behind.

The thing was that the ideals of the *cognoscenti*, the reverential feeling for the nicely-designed object, largely through the efforts of successions of reformers, had gradually reached a much, much wider public.

The cult of special objects for the house, precisely chosen for their individuality and beauty of design, goes back as far as Morris and art furniture workshops and the days when Morris wallpapers adorned most tasteful houses. The singling out of teapots, chairs and tables, books and cushions as positive examples of the designer's art was, for instance, a Walter Crane obsession : art, he said, should be recognized in the very humblest objects. This intense discrimination, this emphasis upon the designer of the product— *Gimson* chairs, *De Morgan* pottery—essential to the character of the British Arts and Crafts, reached its heights, of course, in Glasgow, with Mackintosh and Walton and Miss Cranston's spotless tea-rooms, in which even the cutlery was specially designed. Wrote Mrs Jessie Newbery, wife of the Director of the Glasgow School of Art, herself a fine embroideress and cushion-cover maker :
'I believe that nothing is common or unclean; that the design and decoration of a pepper pot is as important, in its degree, as the conception of a cathedral.'

This was the principle sophisticated people (the DIA, the

*Architectural Review*) hung on to through the century. They glorified the pepper pot. They carried on the cult of the nicely-chosen object; a pleasant household snobbery for people in the know. In the twenties and the thirties, they cultivated craftsmanship : an Edward Barnsley cupboard, a bowl by Bernard Leach. They also came to worship certain new industrial products : a beer mug by Keith Murray, an Edward Bawden tile. At the same time, and increasingly, they loved an *objet trouvé*, or an object which they found to be much better than it seemed : plain old things like porridge bowls were suddenly invested with an awesome sort of glamour. By 1945, pre-dating Terence Conran by almost twenty years, the *Architectural Review* went into raptures over white enamel ironware, red-rimmed and workmanlike; shiny black earthenware jugs (which 'look particularly well if used for milk') and burnt sienna-colour pint mugs 'discovered in a country ironmonger's store'.

By then the war had ended. The aesthetically painful time of taking what you got was shortly to be over. For even if utility furniture and pottery had been a lot more tolerable than anyone had thought, this did not compensate for lack of choice : and in reaction, the urge towards uniqueness was starting up again. This was one good reason for the magic of the Festival, when every designer in the country had his head. This was why the magazines, especially *House and Garden*, could entice their readers out to search for butchers' blocks in hornbeam, antique leeches' urns and other little curios, individual to the point of obscurity. This also explains well the success of the Council of Industrial Design in promoting the idea of special household products designed by special people. The cult of the designer expanded and expanded; by 1962 a discriminating couple would knowledgeably buy a Robin Day convertible, a David Mellor coffee pot, a Brian Asquith boiler, a Martyn Rowlands baby bath, some David Carter castors, a Lucienne Day glasscloth, a chair by Ernest Race, and a Duke's Prize cordless razor designed with utmost elegance by Kenneth Grange.

People knew about designers and design. For there they were in focus everlastingly at Heal's, where in 1960 they held an exhibition entitled 'Designers of the Future'. At the Cotton Board Design and Style Centre in Manchester, under Donald Tomlinson, young textile designers were publicised effectively : for instance,

Pat Albeck, Robert Dodd, Colleen and Gillian Farr with their delicately twining fashionable florals. At Goldsmiths' Hall in London, Graham Hughes the Art Director, was busily promoting the young jewellers and silversmiths : Andrew Grima and John Donald, Gerald Benney, David Mellor, Robert Welch, Keith Tyssen, Keith Redfern, Gerda Flockinger. Commercial firms were boosting their designers : Viners advertised the expertise of Benney, 'famous goldsmith designer'; Old Hall then went one better and described its stainless steel as 'noble metal shaped to perfection by Robert Welch who is recognized as a leading British designer'.

The immense design palaver (which, of course, infuriated basic engineer-designers, whose praises were unsung) happened at a time when youthfulness in general had taken hold of Britain in a rather startling way. The era of the pop group, the boutique and soon the mini-skirt; the heyday of Bazaar and Woolland's 21 Shop; concentration on the personal, the off-beat and the jolly : this sudden burst of fashion made 'design' more popular. Soon what had begun as a small and earnest movement became unrecognisably extrovert and confident. Art nouveau and William Morris were brought back into favour by a larger populace than they had ever known : 'In Carnaby Street,' said the *Daily Express* in 1965, 'Gear have run out of £80 Chesterfields upholstered in William Morris fabrics'; 'William Morris ties the latest vogue', said the *Mail*; 'William Morris wallpapers for bathrooms', said the *Sun*. In *Industrial Design and the Community* Ken Baynes, with, it seems in retrospect, inordinate approval, commented on the way that ordinary people and the designer were moving towards one another: 'It is,' he found, 'a *rapprochement* based on a reawakening delight in gaiety, vulgarity, and humour.' It was in this atmosphere of vulgarity and gaiety, the decade of the design-conscious consumer, that Terence Conran's Habitat shops originated. They were to have great influence upon design in Britain. The first Habitat, a household shop, 'a shop for switched-on people', opened in South Kensington in 1964. It offered, quite blatantly, 'instant good taste': 'We hope we have taken the foot slogging out of shopping by assembling a wide selection of unusual and top quality goods under our roof. It has taken us a year to complete this pre-digested shopping programme and we are confident that many women will take to this new style of buying with enthusiasm.'

Here, pre-assembled and impeccably displayed, were all the things

the design pundits had hunted for and gloated over all these many years : workmen's mugs and rustic cooking pots and sturdy peasant furniture, baskets, cheap pub glasses, butchers' aprons, wooden toys, an overall good humour and indomitable Britishness. The debt to Arts and Crafts was altogether obvious. But where Arts and Crafts were genuine (or almost), this was phoney : a brilliant and timely commercial pastiche.

'I am not,' wrote Terence Conran, 'interested in "pure" design, which designers sell to other designers, and architects to other architects. I am interested in selling good design to the masses.' The idea of pre-selection—the principle at Heal's and shops like Dunn's of Bromley—was now carried to extremes. Hand-picked by Terence Conran, Habitat was selling a whole fashionable, jovial, pseudo-rural way of life. And all around the country, in small shops called Trend or Scope, Shape or Gear or Spectrum (instead of Svensk and Dansk), pre-selected furnishings and modern bric-à-brac were sold with vast conviction and informal, personal service. At Design Design in Lancaster the owners concentrated on things which they themselves had either bought or admired in the past, or things handmade by friends. A firm called Goods & Chattels had a pre-selected stock of storage jars and bentwood, dried dyed flowers and cut-out guardsmen and suchlike for the shopkeepers too ignorant or lazy to pre-select themselves.

In the face of the supermarkets, individual shopkeepers, usually with very little capital, began. None were perhaps braver, more Christian, harder-working than the people who elected to sell proper children's toys : not the mass-produced monstrosities which quickly fell to bits, but strong good toys with play-value, substantial in design. Perhaps they did not know it, but they shared the purist outlook of the parents of John Ruskin, who expected him to play with just a wooden cart and bricks. They certainly acknowledged the influence of Abbatts, who opened shop in Wimpole Street in 1933, stocking good stout trucks and jigsaws and the bricks which H. G. Wells designed when he wrote *Floor Games* : all toys of lasting worth. By 1967, there were probably a dozen shops with Abbatt's outlook—Galts, John Dobbie, John for Toys, The Owl and the Pussycat, the Boy and Girl Shop, Play and Learn and so on—addicts for sound workmanship, immaculate and bright.

It was with the instinct that anything is possible Doc Hudson

began candle-making, Nigel Quiney started decorating paper-bags and wrapping-paper, Ian Logan put the first of his bold swirling patterns on to plain tin trays. This was the attitude that led to little firms like JRM and OMK and Osborne-Little wallpapers, Impetus and Genesis and all the new purveyors of paper chairs and blow-up, knock-down, stack-flat coloured furniture; the dozens of small jewellers; the individual clockmakers.

What is interesting is the way in which a number of these individual enterprises reached a wider market: the way in which Clendenning's experimental furniture was taken up by Race; the way in which the toys designed and made painstakingly by Kristin Baybars and her friends were later mass-produced. What is interesting too is the way designer-craftsmen—designers and/or craftsmen —had become so interchangeable. Apart from the few dedicated potters or craft silversmiths, the students leaving college had developed a new attitude: designers were beginning to be far less interested in designing for industrial production. Instead of being dependent on the whims of manufacturers, designers were beginning to see the possibilities of making and marketing their own designs themselves.

All this was quite a change: a rather disconcerting change for the Council of Industrial Design which, through the sixties, had been working on respectably, with Centre and with Index, with Awards and Conferences. In the times of OMK and JRM and swinging London, the CoID was still plodding round the industries explaining the virtues of a modern design policy, and it had to be admitted it seemed almost out of date. The dilemma was perceptively explained by Paul Reilly who succeeded Sir Gordon Russell as Director of the CoID, in a leader for the *Architectural Review* in 1967, 'The Challenge of Pop'. Ten years earlier, he said, it had all been so much easier: the reformers of design were confident of their criteria; Design Centre selectors with firm standards of functional efficiency and fitness for purpose, truth to materials, economy of means, had easily picked out sound design from meretricious; there was then a 'concensus of informed professional opinion in favour of direct, simple, unostentatious, almost neutral solutions'. So much so that the Council, without quite intending it, had seemed to establish its own sober, neutral style.

'London,' wrote Paul Reilly, 'was not yet actually swinging, but she was on the move and rediscovering the excitements of *fin de*

*siecle* colours and patterns. At this point the Design Centre, which until then had spearheaded the campaign against feeble imitations in favour of modern common sense, came into real danger of being hoist with its own petard.' In other words, the Council, so upright and so sensible, was looking rather dowdy, not to say irrelevant. In an SIA Oration, Stephen Spender had cruelly summed up a situation which was to become increasingly obvious through the early 1960s, when the standards of design which the Council propagated were appearing too inflexible, too boring, too austere. He complained of the simple furniture, the unobtrusive yet tasteful hangings, clean-limbed flat irons, innocuous cups and saucers, limpid glass, governessy electric clocks, glacial refrigerators, flat-chested cupboards, disinfected panels of linoleum, all suggesting the young married couple wearing plastic overalls and washing up together after a wholesome and simple meal of foods which are a harmony of oatmeal and pastel shades, at the end of a day in separate offices equipped with electric typewriters. Was this what the DIA ideals had come to? And, if so, what did the Council plan to do?

'Writing in retrospect,' continued Paul Reilly, 'it is easy to give a false impression of deliberate policy decisions being taken by subtle, pliable men sitting round a Council table and recognizing the danger signals and trimming their sails accordingly.' This, he assured readers, was not at all what happened. But one way or another, policy was altered: 'We are shifting, perhaps,' he explained, 'from attachment to permanent universal values to acceptance that a design may be valid at a given time for a given purpose to a given group of people in a given set of circumstances, but that outside those limits it may not be valid at all; and conversely there may be contemporaneous but quite dissimilar solutions that can still be equally defensible for different groups— mini-skirt for the teenager, something less divulging for the matron; painted paper furniture for the young, teak or rosewood for the ageing—and all equally of their times and all equally susceptible to evaluation by a selection committee. All this means is that a product must be good of its kind for the set of circumstances for which it has been designed.'

That attitude was, of course, a very different thing from the other older theories of absolute correctness: the precise, dogmatic principles of Henry Cole; the Arts and Crafts' great love for solid,

lasting values; the DIA insistence on interminable worth; Gordon Russell's gentle urge for 'making rich the daily round'. But Paul Reilly was of course a very different kind of person, son of Sir Charles Reilly, the famous Professor of Architecture at Liverpool University. He was educated as more of an international modernist than British country craftsman, more cerebral than practical, astute more than romantic, ambitiously benevolent, an opportunist, rather than a steady slow advancer, articulate and sociable, quick and diplomatic. His background in the British modern movement of the thirties, with its optimistic principles of taking the broad view, no doubt encouraged Paul Reilly to develop a workable and tolerant philosophy as Director of the Council of Industrial Design : a theory that stretched from paper chairs to machine tools, from Union Jack dishcloths to, say, cranes or AC motors. From 1960, when he became Director, Paul Reilly seized all possible chances to enlarge.

So it was that the Council of Industrial Design, not content with promoting decent teacups, well-made tables, and neat refrigerators, moved on to bigger things as well : to machine tools and computers, to heavy engineering. It seemed clear that the British engineers' exceptional talent, a century before, for producing a design which was technically and aesthetically admirable, somehow, somewhere, through the years, had gone astray. Since Brunel and Stephenson, Fowler and Baker (with his statement that 'honesty is the guiding light of the designer'), engineers appeared to have lost their sensitivity. It was the old, old story; the Feilden Committee put it bluntly in the report on engineering design submitted in 1963 to the Department of Scientific and Industrial Research, 'British machines are being compared with foreign machines whose designers had understood better the refinements of design and the requirements of the user.'

This was the problem which W. H. Mayall, the new officer for Capital Goods at the Council, had to think about. An inaugural conference in Birmingham convinced him that it was necessary to strengthen the concept of industrial design in engineering and in particular to define its relationship with engineering design. In other words, no one—not design engineers, not industrial designers —knew quite what they were aiming at. Bill Mayall formulated a basic design doctrine, which he carried around like a banner from then on. This doctrine was, briefly, that the design objective con-

tains within it two related aims : the achievement of a functional purpose and the marrying of this purpose to human needs and desires. The former is primarily the engineering design objective, the latter the industrial design objective. Good design is the symbiosis of the two.

This particular movement for reform was very gradual. Bill Mayall's strategy was to give lectures and write articles for the engineering press and so awaken interest, then cultivate the people who seemed hopeful and persuade them to take on a professional industrial designer to work with the firm's design engineers. Odd pockets of improvement in different industries affected the converted firm's competitors : for instance, one microscope maker modernized his products and soon the other microscope makers followed suit; a machine-tool manufacturer worked with a designer, and gradually other manufacturers came asking the Record of Designers for a list of possibilities. The five or six companies employing an industrial designer in 1958, through soundly-reasoned argument and sensible persistence, had ten years later multiplied to 200 or more.

As it was in the thirties, it is interesting still, beyond the official propaganda and persuasion, to find in every firm making progress in design, one particular enthusiast behind it. Individuals still counted. Rupert Kay, at AEI since 1933, had fought for and achieved, in the end, his own design centre, a fully-equipped model shop, a professional design staff, a series of inter-departmental design conferences : this was, in its day a considerable victory. J. H. Hilton at Mather & Platt, with consistent encouragement from William Mather, then Director of the General Machinery Division, built up an industrial design unit, establishing a new company design philosophy based on three fundamental notions of SIMPLICITY, STANDARDIZATION and MODERN CONFIGURATION. British design, with emphasis on ergonomics, cybernetics and scientific concepts, had entered a new phase.

Now, more than ever, the industrial designer steered clear of frills and fripperies, avoided the word 'art'. The SIA renamed itself, as hastily as possible, Society of Industrial Artists and Designers, and serious Colleges of Art (and sometimes Craft) were transformed into Colleges of Art and Design. They were businessmen, not artists, Douglas Scott and F. C. Ashford, Alan Kirkbride, Wilkes & Ashmore and Jack Howe who, insisting that industrial design is

a serious activity and designers are sincere and capable individuals, most sanely explained in a *Financial Times* article, the industrial designer's role as a member of a whole industrial team.

This was indeed an age of designing by committee : a commercial committee or a government committee, a British Rail or London Transport Design Panel, a committee set up by the Ministry of Public Building and Works to commission design for British embassies, committees convened by the Ministry of Transport to consider new road signs and design new traffic signals. Standard Telephones & Cables appointed Richard Stevens as Industrial Design Manager; Michael Farr set up as management consultant in design; the Royal Society of Arts gave out more medals to encourage 'consistently distinguished design policies'. Industrial design manuals, reports and regulations, directories of house styles, official memoranda on corporate identity, proposals and amendments and paper-work, piled up. And with them the offices of the design consultants, led by Design Research Unit, expanded : as Milner Gray had stated back in 1955 'In my view, a design consultant's services can be best employed through a design committee . . . is it not part of the industrial designer's responsibility to accustom himself to the techniques of inter-departmental administration? I believe it is.'

This was the period of large all-purpose offices, the advent of the general consultant designer : designer of products and packaging and graphics, house styles, exhibitions, offices and shops, space planner and environmental architect, market researcher almost ad infinitum. 'We can,' maintained Hulme Chadwick, 'do almost anything; the scope is unlimited.' Others said the same : Gaby Schreiber, Lewis Woudhuysen, F. H. K. Henrion, Willi de Majo, Ogle Design, Richard Lonsdale-Hands, Tandy Holford Mills (employing 45), Allied Industrial Designers (employing 51, with offices in Brussels, Oslo and Stockholm, with clients in the Netherlands and Germany and Switzerland, with design teams operating in French, German, Swedish, English). Eric Marshall, whose large office, American in outlook, was as far from William Morris as the British had yet gone, summed up his philosophy :
'The company believes that industrial product design, by definition, is engineering orientated design and that industrial graphic design is market orientated. Aesthetics alone are of no value.'

Large-scale designers, through the sixties, had been holding large-

scale conferences on huge and complex subjects, like 'The Frontiers of Perception'. Professor Misha Black, an untiring conference-speaker, had addressed the world's designers at ICSID and UNESCO. Designers were mingling with psychologists, ergonomists, statisticians, sociologists and anthropologists, founding Design Research Societies, Ergonomics Research Societies and so on; holding symposiums on the computer; discussing the designer in industrialized building; embarking with great earnestness, and systematic method, on programmes of research which might well last them for ten years.

By the end of the sixties, the whole mood of the movement for reform of design had altered greatly. For all this sudden emphasis on systematic method, this insistence on rationalizing design processes, was a bid for intellectual respectability : something which designers before now had done without. In the sixties, the whole set-up for the training of designers had become much more ambitious, broader-based, more literate. The Diploma in Art and Design, an equivalent of a university degree, was introduced in 40 colleges in England and Wales. Five of them also offered post-diploma studies. Half of these big colleges by now had been absorbed into centrally-administered, large polytechnic schemes. Besides, with trumpets blowing and specially-embroidered ceremonial robes, the Royal College of Art had now been granted university status, and gave master's degrees to its students of design.

With the news at the end of the sixties that the Council of Industrial Design was soon to be incorporated in a National Design Council, a larger, richer, and more influential body, covering the whole range of industry, from light to heavy and from craft-based to scientific, a new phase for reform of design appeared to be beginning. An age of anonymity for the designer. An age of teamwork and systematic method and industrial design manuals. A time for talk of total-activity-patterns and the designer's contribution to the expanding technological universe. A period in which a new subject, Design History, entered the curricula of the polytechnics, and in which a new Chair, the first Chair in Design Management (which Cole would have approved of), was inaugurated.

But also, in full contrast, with the kind of volte-face which has recurred all through the history of design in Britain, there was

soon to be new emphasis on individuality, a new sense of designers' personal responsibility. Influenced by the Small-is-Beautiful philosophy, encouraged by the new government-financed Crafts Advisory Committee, the spirit of individual enterprise was to flourish, and designer-manufacturers, designer-distributors and designer-shopkeepers were to multiply. The early 1970s were to be a period of re-awakened moral fervour, in which the designer asserted the right to design according to the dictates of his conscience and in which the designer asserted the right to design according to the dictates of his conscience and in which, as a result, some of the very best practitioners were less interested in adding art to British industry than in improving the conditions of such people as the handicapped at home and underprivileged abroad.

In the seventies, a period of economic stringency, the old commercial arguments for good design, the theory that better design meant better business, appeared to lose their relevance. Amongst design reformers (for by this time, more than ever, people realised the need to get our country clean and our people beautiful), a new, idealistic attitude was surfacing, a fresh and hopeful era in the history of design.

## BOOK LIST

Archer, L. Bruce  *Systematic Methods for designers* (London, 1965)

Baynes, Ken  *Industrial Design and the Community* (Lund Humphries, 1967)

Baynes, Ken (ed)  *Attitudes in Design Education* (Lund Humphries, 1969)

Beard, Geoffrey  *Modern Glass* (Studio Vista, 1968)

Black, Professor Misha Cantor Lectures on Training of Industrial Designers for the Engineering Industries (Royal Society of Arts Journal, 1965)

Caplan, David and Stewart, G.  *British Trademarks and Symbols* (London, 1966)

*Design Centre Books I and II* (Council of Industrial Design, 1961 and 1962)

Dixon, John R.  *Design Engineering* (London, 1966)

Farr, Michael  *Design Management* (London, 1966)

Goslett, Dorothy  *Professional Practice for Designers* (Batsford, 1961)

Henrion, F. H. K. and Parkin, Alan  *Design Co-ordination and the Corporate Image* (Studio Vista, 1967)

Jones, J. Christopher  *Design Methods* (London, 1970)

Mayall, W. H. *Industrial Design for Engineers* (London, 1967)
  *Machines and Perception in Industrial Design* (Studio Vista, 1968)
Middleton, Michael *Group Practice in Design* (Architectural Press, 1967)
Moody, Ella *Modern Furniture* (Studio Vista, 1966)
Stanton, Corin Hughes *Transport Design* (Studio Vista, 1968)
Young, Dennis and Barbara *Furniture in Britain Today* (Tiranti, 1964)

EXHIBITION CATALOGUES

*Classics of Modern Design* (London, Camden Arts Centre, 1977)

PERIODICALS

*ARK*, Journal of Royal College of Art
*Council of Industrial Design Annual Report*
*Design*, published by Council of Industrial Design
*Design and Industries Association Year Book*
*Designers in Britain*, review of SIA members' work, Society of Industrial Artists, 1964
*House and Garden*
*Ideal Home*
*Royal College of Art Year Book*
*Society of Industrial Artists Journal*, later *The Designer*

# Chronological Table

1836    Mr Ewart's Select Committee reported to the Government on 'the best means of extending a knowledge of the arts and the principles of design among the people (especially the manufacturing population) of the country'.

1837    Normal School of Design established at Somerset House (later to develop into Royal College of Art).

1841    *True Principles of Pointed or Christian Architecture* by Augustus Welby Northmore Pugin published.

1844    Society for the Encouragement of Arts, Manufactures and Commerce held first Exhibition of the Products of National Industry.

1846    Felix Summerly (alias Henry Cole) won silver medal for design for tea-set in Society of Arts Competition.
       Society of Arts began to give annual prizes to students of design in art schools.

1847    Summerly's Art Manufactures founded.
       Society of Arts granted Royal Charter.

1849    *Journal of Design and Manufactures* first published.
       *Seven Lamps of Architecture* by John Ruskin published.

1851    Great Exhibition held in Hyde Park.

1851–3    *Report on Industrial Arts of the Nineteenth Century*, at the Great Exhibition, by M. D. Wyatt, published.
       *Stones of Venice* by John Ruskin published.

1852    Ornamental Art Collection opened at Marlborough House (later to form basis for Victoria and Albert Museum).

1856    Department of Practical Art created (later to become Department of Science and Art) at South Kensington under Henry Cole.
       *Grammar of Ornament* by Owen Jones published.

1857    *Report on the Present State of Design as Applied to Manufactures* by Richard Redgrave published.

1861    Morris, Marshall and Faulkner, Fine Art Workmen, issued first prospectus.

1862    International Exhibition held in South Kensington.

1868    *Hints on Household Taste* by Charles Eastlake published.

1875    Arthur Lasenby Liberty opened shop in Regent Street, specializing in Oriental merchandise.

1877    Society for the Protection of Ancient Buildings (Anti-Scrape) formed.

1880   Art Furniture Alliance opened by Christopher Dresser in Bond Street
1881   George Edmund Street died.
1882   Century Guild formed by A. H. Mackmurdo.
      Sir Henry Cole died.
1884   Art Workers' Guild founded.
      Home Art and Industries Association formed.
1888   Arts and Crafts Exhibition Society founded, holding successful exhibitions in 1888, 1889, 1890, 1893 and 1896.
      National Association for Advancement of Art and its Application to Industry founded.
      C. R. Ashbee formed Guild and School of Handicraft in Whitechapel.
1890   Kenton & Co., furniture workshops, opened by Lethaby, Gimson and Sidney Barnsley.
      William Morris founded Kelmscott Press.
1893   *The Studio* first published.
1895   Bing's shop, L'Art Nouveau, opened in Paris, selling a large number of Arts and Crafts from England.
1896   Society of Designers established 'To advance the arts of design and the status of designers; and for friendly intercourse' (but little appears to have been heard of it again).
      Central School opened 'to encourage the industrial application of decorative art' and Lethaby appointed joint Principal.
      Hermann Muthesius attached to German Embassy in London for research into British architecture and crafts.
      William Morris died.
1897–99   Glasgow School of Art, first phase, built to design by Charles Rennie Mackintosh.
1898   Heal's first catalogue of Plain Oak Furniture produced.
      Northern Art Workers' Guild held first exhibition.
      Walter Crane appointed Principal of the Royal College of Art but resigned the same year.
1899   Grand Duke of Hesse's artistic colony at Darmstadt established with designs for the Palace by Baillie Scott and Mackintosh.
1900   Paris Exhibition: British designers represented (Heal's winning two silver medals).
      Ernest Gimson and the Barnsley brothers settled in the Cotswolds.
      Lethaby became first Professor at the Royal College of Art (retiring as Principal of the Central School in 1911).
1901   Glasgow International Exhibition.
      *Die Englische Baukunst der Gegenwart* by Hermann Muthesius published in Germany.
1902   Turin International Exhibition.
      Ashbee's Guild of Handicraft moved to Chipping Campden, Gloucestershire.
1904   Christopher Dresser died.
1904–5   *Das Englische Haus*, 3 illustrated volumes by Hermann Muthesius, published in Germany.

1905   Exhibition of Cheap Cottages at Letchworth, sponsored by *The Spectator*.

1910   Lewis Day died.

1911   Report of the Departmental Committee on the Royal College of Art recommended closure of the College.

1914   Harold Stabler, Ambrose Heal, Harry Peach and others visited the Werkbund Exhibition in Cologne and returned convinced of the importance of designing for machine production.

1915   Government-sponsored wartime exhibition of German industrial design held at Goldsmiths Hall.
Design and Industries Association founded with 199 members.
DIA held first exhibition 'Design and Workmanship in Printing' at Whitechapel Gallery.
Walter Crane died.

1916   DIA exhibited at Arts and Crafts Exhibition at Burlington House.
New typeface commissioned by Frank Pick from Edward Johnston for London Underground Railway.

1918   Cecil Brewer died.

1919   *Art and Industry* pamphlet issued by Ministry of Reconstruction.

1920   British Institute of Industrial Art founded and gallery opened in Knightsbridge but official grant withdrawn the next year.
Federation of British Industry formed Industrial Art Committee, with Charles Tennyson as Chairman, 'to consider the question of industrial art in this country'.
DIA 'Exhibition of Household Things' held at Whitechapel Gallery.
Ernest Gimson died.

1923   Exhibition of 'Industrial Art Today'.
Francis Meynell founded Nonesuch Press.

1924   Designers' Register and Employment Bureau opened by Industrial Art Committee of FBI.
Royal Society of Arts, encouraged by Sir Frank Warner, began series of annual competitions for design open to all British subjects.
W. A. S. Benson died.

1925   Paris Exhibition.
Sidney Barnsley died.

1927   DIA exhibited at Leipzig Fair.

1928   Chermayeff exhibition held at Waring & Gillow.
Gordon Russell exhibited furniture at Powell's London showroom.
Charles Rennie Mackintosh died.

1929   'Industrial Art for the Slender Purse', British Institute of Industrial Art exhibition, held at Victoria and Albert Museum.
Gordon Russell opened shop in Wigmore Street.
Jack Pritchard commissioned stand from Le Corbusier for Venesta at Building Trades Exhibition.
*The Face of the Land,* DIA Year Book, published.

1930   Society of Industrial Artists founded.
Memorandum on State-aided Art Education published by Industrial Art Committee of FBI, recommending that regional colleges

should be established and the Royal College of Art reorganized. Report on Handicrafts in Elementary Schools published by LCC. Report on Design in the Cotton Industry published by H.M. Inspectors.

1931　Board of Trade appointed Committee on Art and Industry, under Lord Gorell.

Exhibition of Swedish Art held in London.

William Richard Lethaby died.

1932　Association of Artists in Commerce founded (but never came to much).

Raymond McGrath, Wells Coates and Serge Chermayeff designed interiors for new BBC building.

Report on Art and Education, in particular industrial art exhibitions, published by Gorell committee.

1933　Dorland Hall exhibiton held, in collaboration with DIA.

DIA exhibitions of model houses held in Manchester and Welwyn.

BBC held series of talks, 'Design in Modern Life'.

Paul and Marjorie Abbatt opened toyshop in Wimpole Street.

*Ghastly Good Taste*, by John Betjeman, published.

1934　Council for Art and Industry set up by Board of Trade, with Frank Pick as Chairman, to encourage good design, 'especially in relation to manufacturers'.

Pick Council held small exhibition of Silverware at Victoria and Albert Museum.

Second, less successful, Dorland Hall exhibition held.

DIA exhibition held in Birmingham.

'Exhibition of Modern Living' held at Whiteley's.

Walter Gropius arrived in England, and left again two years later.

*Art and Industry* by Herbert Read published.

Memorandum on Art Education, with particular reference to the Royal College of Art, sent by the DIA to the Board of Education.

1935　'British Art in Industry' exhibition held at Burlington House.

Pick Council held pottery exhibition at Victoria and Albert Museum.

*Orion*, architect Brian O'Rorke, launched by Orient Line.

Industrial Design Partnership founded by Milner Gray, Misha Black and others.

Report on Industrial Art submitted by Nugent Committee to Minister of Education.

Memorandum on industrial art training for management and staff of firms (full-time and part-time) and for foremen, travellers and salesmen, published by Industrial Art Committee of FBI.

Report on Education for the Consumer, particularly training in design in elementary and secondary schools, published by Pick Council.

1936　First 10 Designers for Industry appointed by Royal Society of Arts (from 1937, *Royal* Designers for Industry): Douglas Cockerell,

Eric Gill, James Hogan, J. H. Mason, H. G. Murphy, Keith Murray, Tom Purvis, George Sheringham, Harold Stabler, Fred Taylor, C. F. A. Voysey.

National Register of Industrial Art Designers formed by Board of Trade on recommendation of Pick Council.

Committee on Advanced Education in London, under Viscount Hambledon, appointed by Board of Education.

Pick Council held exhibition of domestic metalwork.

'Exhibition of Everyday Things' at Royal Institute of British Architects.

'Seven Architects' Exhibition at Heal's.

Dunbar-Hay furnishing shop opened in Albemarle Street.

Crofton Gane commissioned pavilion for Royal Show, Bristol, from Marcel Breuer and F. R. S. Yorke.

Report on The Working-Class Home: its Furnishing and Equipment by Mrs C. G. Tomrley, published by Pick Council.

Harry Peach died.

1937    Paris Exhibition included British Pavilion by Pick Council.

Working-Class Home exhibition, based on Pick Council report, held at Building Centre.

BBC Talks on Design by Anthony Bertram held with concurrent travelling exhibitions by DIA.

*Industrial Art in England* by Nickolaus Pevsner published.

Report on Design and the Designer in Industry published by Pick Council.

Report on Advanced Art Education in London published by Hambledon Committee recommending that 'a new orientation should be given to the Royal College'.

Proposal for an Industrial Art Centre completed by Pick Council but never published.

1938    Glasgow Exhibition.

Royal Designers for Industry appointed: Reco Capey, E. Gordon Craig, Milner Gray, Percy Metcalfe, Ethel Mairet.

Royal Society of Arts Industrial Bursaries Competition began.

Good Furnishing Group formed by Geoffrey Dunn, Crofton Gane, Gordon Russell and others.

1939    Central Institute of Art and Design formed, to safeguard artists' and designers' interests in wartime.

Royal Designers for Industry appointed: Laurence Irving, Sir Ambrose Heal, Brian O'Rorke.

1940    Cotton Board Fashion Design & Style Centre opened in Manchester.

Royal Designers for Industry appointed: Susie Cooper, E. W. Grieve, A. B. Read, Gordon Russell, Percy Delf Smith, Allan Walton, Anna Zinkeisen.

1941    Royal Designer for Industry appointed: Duncan Grant.

C. F. A. Voysey died.

Frank Pick died.

1942    Utility Furniture Committee and subsequently Design Panel,

Chairman Gordon Russell, set up by Board of Trade.

DIA, with Army Bureau of Current Affairs, began to send mobile design exhibitions round army camps, art galleries and schools.

A. H. Mackmurdo died.

C. R. Ashbee died.

Eric Ravilious died.

1943 Report on 'Industrial Design and Art in Industry' completed, but not published, by sub-committee under Cecil Weir (set up by Post-War Export Trade Committee of Department of Overseas Trade), recommending the establishment of a Central Design Council.

Design Research Unit set up by Marcus Brumwell, Misha Black, Milner Gray and others, with Herbert Read as first manager.

Royal Designers for Industry appointed: Charles Holden, Barnes Wallis.

1944 Report on Art Training by Meynell-Hoskin Committee, submitted to Board of Trade and Education, supported the idea of a Central Design Council, recommending that it should be a grant-aided body.

Proposals for a Central Design Council and Industrial Design Centre published by Industrial Art Committee of FBI.

Council of Industrial Design (with separate Scottish Committee) formed 'to promote by all practicable means the improvement of design in the products of British industry': first Chairman was Sir Thomas Barlow; first Director, S. C. Leslie.

Rayon Industry Design Centre established.

*The Missing Technician in Industrial Production* by John Gloag published.

Edward Johnston died.

Royal Designers for Industry appointed: Wells Coates, Sir Geoffrey de Havilland, Enid Marx, Charles Nicholson, R. D. Russell.

1945 'Design for the Home' exhibition, designed by Milner Gray, held by Council for the Encouragement of Music and the Arts.

'Historical and British Wallpapers' exhibition, designed by Eric Brown and Stefan Buzas, held at National Gallery.

CoID Record of Designers developed from National Register of Industrial Art Designers.

Primavera opened by Henry Rothschild in Sloane Street.

Royal Designer for Industry appointed: Francis Meynell.

1946 'Britain Can Make It' exhibition held by CoID at Victoria and Albert Museum, designer James Gardner.

Design and Research Centre for the Gold, Silver and Jewellery Industries established.

National Diploma in Design introduced in art schools, with emphasis on specialization.

Report on the Training of the Industrial Designer completed by CoID but never published.

Report *The Visual Arts* sponsored by Dartington Hall trustees,

published in collaboration with PEP.

1947　Gordon Russell succeeded S. C. Leslie as Director of the Council of Industrial Design; Dr Ralph Edwards succeeded Sir Thomas Barlow as Chairman.

'Enterprise Scotland' exhibition held by CoID in Edinburgh.

Royal Designers for Industry appointed: James Gardner, Robert Goodden, Ashley Havinden.

1948　Robin Darwin appointed Principal of Royal College of Art.

'Design at Work' exhibition of products by Royal Designers for Industry sponsored by RSA and CoID.

Robin Day and Clive Latimer won prize in International Low-cost Furniture Competition, Museum of Modern Art, New York.

Central Institute for Art and Design disbanded.

Royal Designer for Industry appointed: Christian Barman.

1949　CoID exhibited abroad for first time, in 'International Exhibition of Industrial Design' in Amsterdam.

BBC series of programmes, 'Looking At Things', for school-children began.

Royal Designers for Industry appointed: Edward Bawden, Barnett Freedman, Roger Furse, Eric Ottaway.

1950　Royal Designers for Industry appointed: Edward Molyneux, Sir James McNeill, Alastair Morton.

1951　Festival of Britain: South Bank Exhibition Design Group, Hugh Casson, James Holland, James Gardner, Ralph Tubbs, Misha Black.

'Living Traditions of Scotland' exhibition held in Edinburgh.

Exhibition of Industrial Power held in Glasgow.

Des. RCA first given to students awarded design diplomas at Royal College of Art.

Royal Designers for Industry appointed: Hugh Casson, J. Laurent Giles.

1952　Exhibition of Victorian and Edwardian Decorative Arts at Victoria and Albert Museum.

CoID Street Furniture design competition.

Time-Life building in Bond Street completed, with interiors co-ordinated by Hugh Casson and Misha Black.

1953　Walter J. Worboys succeeded Dr Ralph Edwards as Chairman of the CoID.

'Register Your Choice' DIA exhibition, at Charing Cross.

Royal Designers for Industry appointed: John Waterer, Ernest Race.

1954　Government approved establishment of The Design Centre for British Industries.

First Royal Society of Arts Bicentenary Medal, for people who 'in a manner other than as industrial designers have exerted an exceptional influence in promoting art and design in British industry', awarded to Sir Colin Anderson.

Royal Designer for Industry appointed: William Lyons.

1955    *Design in British Industry* by Michael Farr published.
Royal Designer for Industry appointed: Uffa Fox.
RSA Bicentenary Medal awarded to Sir Charles Tennyson.

1956    Design Centre, Haymarket, opened by Duke of Edinburgh.
'Management of Design' conference organized by CoID.
British Railways Design Panel set up; George Williams Director of Design.
Royal Designer for Industry appointed: Reynolds Stone.
RSA Bicentenary Medal awarded to Sir Walter Worboys.
SIA Design Medal awarded to Milner Gray.
Gordon Russell knighted.
*Design* magazine began to include regular reviews of engineering products.

1957    Scottish Design Centre opened by Scottish Committee of CoID.
'Make or Mar', DIA exhibition, held at Charing Cross.
Report on Art Examinations submitted to Minister of Education by Freeman Committee on Art Examinations, recommending greater administrative freedom for individual colleges.
Royal Designer for Industry appointed: Misha Black.
RSA Bicentenary Medal awarded to Sir Ernest Goodale.
SIA Design Medal awarded to Jan van Krimpen.
First Design Centre Awards selected by Milner Gray, Professor R. Y. Goodden, Brian O'Rorke, Professor R. D. Russell, Astrid Sampe:
  Pyrex ovenware—designers, John D. Cochrane in conjunction with Milner Gray and Kenneth Lamble of Design Research Unit; maker, James A. Jobling.
  Convertible bed settee—designer, Robin Day; maker, Hille.
  Rotaflex lampshade—designers, John and Sylvia Reid; maker, Rotaflex.
  Rayburn convector fire—designer, David Ogle; maker, Allied Ironfounders.
  Television set—designer, Robin Day; maker, Pye.
  Midwinter Melmex plastics ware—designers, A. H. Woodfull and John Vale; maker, Streetly, for W. R. Midwinter.
  Impasto wallpaper—designer, Audrey Levy; maker, The Wall Paper Manufacturers.
  Strawberry Hill tableware—designers, Victor Swellern and Millicent Taplin; maker, Wedgwood.
  Pride cutlery and flatware—designer, David Mellor; maker, Walker & Hall.
  Connoisseur wine glasses—designer, S. Fogelberg; maker, Thomas Webb.
  Flamingo furnishing cotton—designer, Tibor Reich; maker, Tibor.
  Imperial Axminster carpet—designer, Lucienne Day; maker, Tomkinsons.

1958    'The Design Centre Comes to Newcastle' exhibition: first in series of promotions in provincial stores.

'Industrial Design and the Engineering Industries' conference organized by the CoID in Birmingham.

Wells Coates died.

RSA Bicentenary Medal awarded to John Gloag.

SIA Design Medal awarded to Robin Day.

Design Centre Awards selected by Sir Walter Worboys, Noel Carrington, Geoffrey Dunn, Wyndham Goodden, Jack Howe:

Carlton lavatory basin—designers, staff; maker, Shanks.

Satina pendant lighting fitting—designer, Nigel Chapman; maker, Hailwood and Ackroyd Ltd for AEI.

Hiflo bibcock tap—designers, staff; maker, Barking Brassware.

Knifecut pruner—designers, staff with Hulme Chadwick; maker, Wilkinson Sword.

Occasional chair—designer, J. N. Stafford; maker, Stafford Furniture.

Tallent paraffin oil convector heater—designers, staff; maker, Tallent Enginering.

Prestwick range of suitcases—designer, K. H. Paterson; maker, S. E. Norris.

Phantom Rose handscreen printed wallpaper—designer, Audrey Levy; maker, The Wall Paper Manufacturers.

Old Hall stainless steel toast rack—designer, Robert Welch; maker, Old Hall.

Conference tableware—designers, Tom Arnold (shape), Pat Albeck (pattern); maker, Ridgway.

Hamilton sideboard—designer, Robert Heritage; maker, Archie Shine.

Adam woven textile—designer, Keith Vaughan; maker, Edinburgh Weavers.

Vision Net lace curtaining—designer, F. G. Hobden and staff; maker, Clyde Manufacturing.

Royal Gobelin Axminster body carpet—designers, Neville and Mary Ward; maker, Tomkinsons.

Queensberry enamelled cast iron ovenware—designer, David Queensberry; maker, Enamelled Iron & Steel Products.

Artkurl Wilton broadloom carpets—designers, staff; maker, William C. Gray.

Riviera tablecloths and napkins—designer, Arthur Ingham; maker, James Finlay.

Gold Seal baby bath—designer, Martyn Rowlands; maker, Ekco Plastics.

Minster printed textile—designer, Humphrey Spender; maker, Edinburgh Weavers.

Vistavu slide viewer—designers, Harld R. Stapleton assisted by Howard Upjohn; maker, Rank Precision Industries.

1959 National Advisory Council on Art Education, under Sir William Coldstream, formed.

CoID awarded Gran Premio Internazionale la Rinascente Compasso

d'Oro in Milan.

Design Centre labelling scheme began.

*Oriana* launched by Orient Line.

Sir Gordon Russell retired as Director of CoID.

Sir Ambrose Heal died.

Royal Designers for Industry appointed: Robin Day, Abram Games, F. H. K. Henrion, Hans Schleger, Berthold Wolpe.

RSA Bicentenary Medal awarded to Frank Mercer.

SIA Design Medal awarded to Tapio Wirkkala.

Duke of Edinburgh's first Prize for Elegant Design awarded by Lady Casson, Sir Basil Spence, John Summerson and Audrey Withers to C. W. F. Longman, designer (in association with Edward G. Wilkes) of Packaway refrigerator made by Prestcold Division of Pressed Steel Company.

Design Centre Awards selected by Sir Colin Anderson, Geoffrey Dunn, F. H. K. Henrion, Jack Howe and Monica Pidgeon:

Swoe garden tool—designers, staff, with Hulme Chadwick; maker, Wilkinson Sword.

Ilford K1 professional tripod—designer, Walter Kennedy; maker, Ilford.

Ellipse series lighting fittings—designer, Paul Boissevain; maker, The Merchant Adventurers.

Pride EPNS teaset—designer, David Mellor; maker, Walker & Hall.

Aristocrat socket chisels—designer, staff; maker, Ward & Payne.

Planit system: ceramic glazed tiles—designer, Derek Hodgkinson; maker, H. & R. Johnson.

Flamingo easy chair—designer, Ernest Race; maker, Race Furniture.

Fluorescent kitchen light—designers, John and Sylvia Reid; maker, Atlas.

Lever handle—designer, Roger Peach; maker, Dryad Metal.

Mandala Wilton body carpet—designer, Audrey Tanner; maker, Carpet Manufacturing.

Queen-heater solid fuel room heater—designer, David Mellor; maker, Grahamston Iron Co.

Malindi printed furnishing fabric—designer, Gwenfred Jarvis; maker, Liberty.

Piazza plastics coated fabric—designer, Edward Pond; maker, Bernard Wardle.

Inglewood woven furnishing fabric—designer, Humphrey Spender; maker, Edinburgh Weavers.

Circular dining table—designer, Hassan El-Hayani; maker, Design Furniture for the New Furniture Design Group.

1960    Paul Reilly succeeded Sir Gordon Russell as Director of CoID; Sir Duncan Oppenheim succeeded Sir Walter Worboys as Chairman.

'Designers of the Future' exhibition held at Heal's.

Competition for better litter bins sponsored by CoID.

First Report on Art Education by Coldstream Committee submitted to Minister of Education, recommending new courses of a higher standard to replace the National Diploma in Design.

Industrial Design (Engineering) Research Unit set up at Royal College of Art, under Bruce Archer.

Royal Designers for Industry appointed: Stanley Morison, Basil Spence.

RSA Bicentenary medal awarded to J. Cleveland Belle.

Duke's Price for Elegant Design awarded by Lady Casson, Robin Darwin, Gaby Schreiber and Basil Spence to Neal French and David White for Spode Apollo tableware made by W. T. Copeland.

Design Centre Awards selected by Professor Misha Black, J. Beresford-Evans, F. H. K. Henrion and Jo Pattrick:

Street lighting columns and lanterns—designer, Richard Stevens; maker, Abacus.

Irish linen glass towels—designer, Lucienne Day; maker, Thomas Somerset.

Chelsea lighting fittings—designers, Richard Stevens and P. Rodd; maker, Atlas Lighting.

Le Bosquet printed cotton satin—designer, Shirley Craven; maker, Hull Traders.

Brownie camera—designers, staff with Kenneth Grange; maker, Kodak.

Low voltage display fitting—designer, Richard Stevens; maker, Atlas Lighting.

Queensberry Ware nursery china—designers, David Queensberry (shape), Bernard Blatch (pattern); maker, Crown Staffordshire.

Pannus wallpaper—designer, Humphrey Spender; maker, The Wall Paper Manufacturers.

Lemington glass vases—designer, R. Stennett-Wilson; maker, Osram.

Fiesta melamine plates—designer, Ronald E. Brookes; maker, Brookes and Adams.

Vynide coated fabric—designers, staff; maker, ICI.

Formation Furniture office desk units—designers, Yorke, Rosenberg and Mardall; maker, Bath Cabinet Makers.

Ely Stripe woven furnishing—designers, staff; maker, Donald Brothers.

Anniversary Ware oval casseroles—designers, John and Sylvia Reid; maker, Izons.

Judge stainless steel stewpans—designers, Misha Black and Ronald Armstrong of DRU; maker, Ernest Stevens.

Denison Vision Net drip-dry furnishing lace—designer, F. G. Hobden; maker, Clyde.

Royal Gobelin Axminster carpet—designer, Graham Tutton; maker, Tomkinsons.

1961  National Council for Diplomas in Art and Design, under Sir John

Summerson, set up on Coldstream Council's recommendation as an independent self-governing body to administer the award of diplomas.

Antony Armstrong-Jones (later the Earl of Snowdon) joined staff of CoID.

'Design Policy for Corporate Buying', international design congress organized in London by CoID.

Modern Jewellery Exhibition held at Goldsmiths' Hall.

CoID Street Furniture exhibition installed on South Bank.

Royal Designers for Industry appointed: Stefan Buzas, Jack Howe.

RSA Bicentenary medal awarded to Audrey Withers.

SIA Design Medal awarded to Abram Games.

Duke's Prize for Elegant Design awarded by Sir Kenneth Clark, Robin Darwin, Jane Drew and Gaby Schreiber to Eric Marshall for Rio transistor radio made by Ultra.

Design Centre Awards selected by Whitney W. Straight, Neville Condor, Jo Pattrick, J. M. Richards, and Gary Schreiber:

Kodaslide 40 slide projector—designers, staff with Kenneth Grange; maker, Kodak.

Cormorant folding outdoor chair—designer, Ernest Race; maker, Race Furniture.

Table mirror—designer, Colin Beales; maker, Peter Cuddon.

Towel rail—designer and maker, Peter Cuddon.

Town Number One litter bin—designers, Derek Goad and John Ricks; maker, G. A. Harvey.

Adjustable spotlights—designers, John and Sylvia Reid; maker, Rotaflex.

Monte Carlo carving set—designer, G. G. Bellamy; maker, George Wostenholm.

Chef Royal saucepans—designers, Berkeley Associates; maker, Curran.

Orbit furniture castors—designers, staff with R. David Carter; maker, Joseph Gillott.

Redfyre Centramatic 35 oil fired boiler—designers, staff with Brian Asquith; maker, Redfyre.

Form unit furniture—designer, Robin Day; maker, Hille.

Paragon chemical closet—designer, Martyn Rowlands; maker, Racasan.

1962 First conference on systematic design methods held at Imperial College, London.

Second report of Coldstream Council, on vocational courses in Colleges and Schools of Art, published.

Royal Designers for Industry appointed: Lucienne Day, David Mellor.

RSA Bicentenary medal awarded to Robin Darwin.

SIA Design Medal awarded to Pier Luigi Lervi.

Duke's Prize for Elegant Design awarded by Sir Kenneth Clark, Sir Trenchard Cox, Lucienne Day and Jane Drew to Nicholas

Sekers for furnishing fabrics made by West Cumberland Silk Mills.
Design Centre Awards selected by Martin Moss, Stefan Buzas,
Elsbeth Juda, David Queensberry, Brian Shackel and Nigel
Walters:

BR heavy duty settee—designer, Robin Day; maker, Hille.

Stainless steel dishes—designer, Robert Welch; maker, Old Hall.

Pick-up arm—designers, A. Robertson-Aikman and W. J.
Watkinson; maker, SME.

Hoe and rake—designer, Brian Asquith; maker, Spear and
Jackson.

Dimex ceramic tiles—designer, Michael Caddy; maker, Wade.

Trifoliate wallpaper—designer, Cliff Holden; maker, The Wall
Paper Manufacturers.

Sunflower printed cotton—designer, Howard Carter; maker, Heal
Fabrics.

Symbol cutlery and flatware—designer, David Mellor; maker,
Walker & Hall.

Vacco de luxe vacuum flask—designer, L. Leslie-Smith; maker,
Vacco.

Cawdor woven linen fabric—designers, staff and Peter M.
Simpson; maker, Donald Brothers.

1963 Report on Engineering Design produced by committee appointed
by Department of Scientific and Industrial Research, Chairman
G. B. R. Feilden, to consider the present standing of mechanical
engineering design.

London Transport Design Panel formed.

*Systematic method for designers* by L. Bruce Archer published.

Marion Dorn died.

Royal Designers for Industry appointed: Tom Eckersley, Robert
Heritage.

RSA Bicentenary Medal awarded to Paul Reilly.

SIA Design Medal awarded to Ernest Race.

Duke's Prize for Elegant Design awarded by Sir Trenchard Cox,
Lucienne Day, The Viscountess Eccles and David Hicks to Kenneth
Grange for the Milward Courier Cordless electric shaver made
by Henry Milward.

Design Centre Awards selected by O. B. Miller, Elgin Anderson,
Trevor Dannatt, Natasha Kroll, David Mellor and Eirlys Roberts.

Pay-on-answer coin box—designers (engineering), Associated
Automation with GPO, (case) Douglas Scott; maker, Associated
Automation.

Harrington screen-printed cotton—designer, Humphrey Spender;
maker, Cepea.

Heritage range of wall storage units—designer, Robert Heritage;
maker, Archie Shine.

Trays and sectional hors d'oeuvre dishes (in grey translucent
plastics)—designer, Noel Lefebvre; maker, Xlon.

Linking/stacking chair—designer, Clive Bacon; maker, Design

Furnishing Contracts.

Lightweight slide storage box—designer, Albert Cragg; maker, Boots.

Cruachan screen printed cotton—designer, Peter McCulloch; maker, Hull Traders.

Corinthian inset fire unit—designer, David Brunton; maker, Belling.

Sheppey settees and chair—designer, Ernest Race; maker, Race.

Sola wash basin—designer, E. Stanley Ellis; maker, Twyfords.

Oregon dining chair—designer, Robert Heritage; maker, Archie Shine.

1964 House of Lords debate on industrial design: Lord Peddie rose to draw attention to the Annual Report of the CoID and 'to stress the importance of encouraging original design as a factor in the stimulation of exports and the improvement of home standards'.

First report of Summerson Council for Diplomas in Art and Design published.

Third report of Coldstream Council, on Post-Diploma Studies in Art and Design, published.

Terence Conran opened first Habitat household shop in Fulham Road.

Hornsey Mobile Caravan, designed by staff/student team under Clive Latimer, won Grand Prix at Milan Triennale.

Ernest Race died.

Royal Designers for Industry appointed: Hardy Amies, Alan Irvine, Alec Issigonis.

RSA Bicentenary Medal awarded to Anthony Heal.

SIA Design Medal awarded to Edward Bawden.

First Royal Society of Arts Presidential Awards for Design Management made to Heal's, Conran, Hille, London Transport, Gilbey, Jaeger.

Duke's Prize for Elegant Design awarded by The Viscountess Eccles, Lucienne Day, Sir Trenchard Cox and David Hicks to David Queensberry for cut crystal glassware made by Webb Corbett.

Design Centre Awards selected by A. E. Everett Jones, Audrey Levy, Neville Ward, Katharine Whitehorn and George Williams:

Friedland 972 bell kit—designers, staff with Norman Stevenson; makers, V. & E. Friedland.

Moulton bicycle—designer, Alex Moulton; maker, Moulton Bicycles.

Brompton Chair—designer, Ronald Carter; maker Dancer & Hearne.

Nubian laminate—designer, Helen Dalby; maker, Formica.

Glendale woven fabric—designers, William Robertson and Peter Simpson; maker, Donald Bros.

Memory master clock—designer, staff and Robert Heritage; maker, English Clock Systems.

Brownie Vecta camera—designer, Kodak in consultation with

Kenneth Grange; maker, Kodak.

Palladio Lamina wallpaper—designer, Deryck Healey; maker, The Wall Paper Manufacturers.

Insulated tumbler—designer, H. D. F. Creighton; maker, Insulex.

Garden shears—designers, staff and Hulme Chadwick; maker, Wilkinson Sword.

Printed fabrics, Shape Sixty-three and Division—designer, Shirley Craven; maker, Hull Traders.

Merlin electric clock—designers, staff and Robert Welch; maker, Westclox.

1965 Society of Industrial Artists renamed Society of Industrial Artists and Designers.

Report on Industrial and Engineering Design produced by working party of Federation of British Industries under G. B. R. Feilden.

Royal designers for Industry appointed: Herbert Spencer, Robert Welch.

RSA Bicentenary Medal awarded to Hans Juda.

SIA Design Medal awarded to Misha Black.

Duke's Prize for Elegant Design awarded by The Viscountess Eccles, David Hicks, Ernestine Carter and Milner Gray to Peter Dickinson for auditorium seating by Race.

Design Centre awards selected by Anthony Heal, Helen Challen, Shirley Conran, Robert Gutmann, Richard Stevens:

'Meridian One' Sanitary Suite—designers, Knud Holscher and Alan Tye with Alan H. Adams; maker, Adamsez.

'Arrowslim' fluorescent light fittings—designers, Peter Rodd and John Barnes; maker, Atlas.

'Gaylec' convector heater—designer, Bernard Burns; maker, Carnscot.

Cotton Satin 'Legend' 0700—designer, Alan Reynolds; maker, Edinburgh Weavers.

Yard Arm Pick-up Stick—designer, D. A. Morton; maker, Mabar.

'Embassy' Sterling Silver—designer and maker, David Mellor.

'Alveston' cutlery—designer, Robert Welch; maker, Old Hall.

Hille Wall Storage System—designers, Alan Turville and John Lewak; maker, Hille.

Rag Dolls—designers, Joy and Malcolm Wilcox; maker, Sari.

Plastics Handled Saw—designer, Brian Asquith; maker, Spear & Jackson.

Thornton Pic Slide Rules—designer, Norman Stevenson with staff; maker, Thornton.

'Kristna' furnishing fabric—designer, Sir Nicholas Sekers; maker, West Cumberland Silk Mills.

Hille Polypropylene Stacking Chair—designer, Robin Day; maker, Hille.

Ceiling Roses and Switches—designer, London & Upjohn; maker, GEC.

Hospital Wall Light—designer, Roger Brockbank; maker, Atlas.

Students' Striped Bedspreads—designers, H. W. Rothschild and Primavera Design Group; maker, Primavera.

1966 Plans first announced for combined London headquarters of Institute of Contemporary Arts, The Society of Industrial Artists, the Institute of Landscape Architects and the Designers and Art Directors' Association in Nash House Terrace, London.

Diplomas in Art and Design, equivalent to a first degree, first awarded to students completing courses at Colleges of Art.

Report 'A Plan for Polytechnics and Other Colleges', published by Department of Education and Science, proposing that many of the largest British Art Schools should be incorporated in local Polytechnics.

Engineering Design Centre established at Loughborough University.

Leverhulme Trust gave first travelling scholarships in industrial design.

George Williams, Director of Design, British Railways, died.

Royal Designer for Industry appointed: Natasha Kroll.

RSA Bicentenary medal awarded to Graham Hughes.

SIAD Design Medal awarded to Mary Quant.

Duke's Prize for Elegant Design awarded by Ernestine Carter, Mary Ward, Sir Colin Anderson and Milner Gray to Andrew Grima for jewellery.

Design Centre Awards selected by Sir Duncan Oppenheim, The Hon. G. C. H. Chubb, Elsbeth Juda, Leslie Julius, Michael Laird, Leonard Manasseh:

'Automatic 1501' washing machine— designer, staff with Industrial Design Unit; maker, AEI–Hotpoint.

'Modric' architectural ironmongery—designers, Knud Holscher and Alan Tye; maker, G. & S. Allgood.

Desk Lamp 'Cantilever 41555'—designer, Gerald Abramovitz; maker, Best and Lloyd.

Hamilton stoneware—designers, Tarquin Cole and John Minshaw; maker, Govancroft.

Thrift Cutlery—designer, David Mellor; commissioned by Ministry of Public Building and Works.

1108 and 1111 Radios—designer, Robin Day with Douglas Jones; maker, Pye.

Flexible Chair—designer, Nicholas Frewing; maker, Race.

Quartet Major Lighting—designer, Robert Heritage; maker, Rotaflex.

Credaplan Individual Quick-Discs hotplates—designer, staff; maker, Simplex Electric.

STC Deltaphone and Deltaline Telephones—designer, Martyn Rowlands; maker, Standard Telephones and Cables.

Barbican hand rinse basin—designer, Chamberlin, Powell and Bon with staff; maker, Twyfords.

1967 Royal College of Art given University status (as a result of Robbins report on Higher Education, 1963).

Design Centre Awards renamed Council of Industrial Design Awards and scope broadened to include engineering design.

Crofton Gane died.

RSA Bicentenary Medal awarded to Harold Glover.

SIAD Design Medal awarded to Charles Eames.

RSA Presidential Awards for Design Management made to BTR Industries, Sainsbury, Clydesdale Bank, A. G. Thornton.

Duke's Prize for Elegant Design awarded by Sir Colin Anderson, Ernestine Carter, Milner Gray and Mary Ward to R. David Carter for 'Gas-Flo' system of points and fittings developed by Wales Gas Board.

CoID Design Awards—Consumer Goods Section—selected by Jasper Grinling, Brian Asquith, Rosamind Julius, Alan Irvine, Fiona MacCarthy:

'Iced Diamond' Refrigerators by Hotpoint

Ilfoprint Processors by Ilford

'PU Work Station' Office Furniture by Interiors International

Graphic System for Directional Road Signs commissioned by Ministry of Transport

'International' Range of Electric Convector Radiators by Morphy-Richards

'Tempest' Yacht by Richardson Boats and Plastics.

CoID Design Awards—Capital Goods Section—selected by W. L. Mather, Professor Misha Black, H. G. Conway, Professor W. F. Floyd, C. H. Flurscheim, H. R. Heap, Jack Howe, D. B. Welbourn:

Mascot 1600 Centre Lathe by Colchester Lathe Company

Co-ordinate Inspection Machine by Ferranti

Thompson-Watts Map Plotter by Hilger & Watts

1900 Series Computer by International Computers and Tabulators

Power Rammer by Pegson

Gas Cylinder by Reynolds Tube Company

Hy-Mac Excavator by Rhymney Engineering for Peter Hamilton Equipment.

1968 Working party set up by Institute of Mechanical Engineers, at the request of the Council of Engineering Institutions, submitted report to Ministry of Technology advocating a single design council to promote design across the whole span of British industry.

Joint Coldstream/Summerson Committee of Inquiry into structure of art and design education prompted by student disturbances at Hornsey, Guildford and other colleges of art.

Stedjelich Museum, Amsterdam, held international exhibition of industrial design: Britain represented by Robin Day, Kenneth Grange, David Mellor and Robert Welch.

Bauhaus Exhibition at Royal Academy.

Paul Reilly knighted.

RSA Bicentenary medal awarded to Marcus Brumwell.

SIAD Design Medal awarded to Thomas Maldonado.

Duke's Prize for Elegant Design awarded by Sir Colin Anderson, The Marchioness of Anglesey, Robert Heritage and Mary Ward to David H. Powell for 'Nova' plastics tableware by Ecko.

CoID Awards—Consumer Goods—selected by Peter Tennant, Kathleen Darby, Althea McNeish, Geoffrey Salmon, Alan Tye:

'Clamcleat' rope cleats by Clamcleats

Furnishing fabrics 'Chevron', 'Complex' and 'Extension' by Heal Fabrics

Kompas 1 table by Hille

Furnishing fabrics 'Simple Solar' and 'Five' by Hull Traders

'Trilateral' poster display unit by London and Provincial Poster Group

'Trimline' light by Merchant Adventurers

'Those Things' children's furniture by Perspective Designs

'Reigate' rocking chair by William Plunkett

'Coulsdon' coffee table by William Plunkett

'Silverspan' flourescent light fittings by Rotaflex

'Sealmaster' door and window seals by Sealmaster

'International' kitchen units by Wrighton.

CoID Awards—Capital Goods—selected by A. R. Miller, F. C. Ashford, J. Atherton, Professor D. H. Chaddock, H. R. Heap, C. C. Mitchell, Professor W. T. Singleton, E. G. M. Wilkes:

'Hainsworth' worm gear reducer by J. H. Fenner

Flameproof motors by Mather and Platt

Colour television camera Mark VII by Marconi

'Sentinel' diesel hydraulic shunting locomotive by Rolls-Royce

'Crimpspin' CS12-600 false twist crimping machine by Ernest Scragg

'DD2' dockside crane by Stothert and Pitt.

1969   Proposals pressed forward for National Design Council, incorporating Council of Industrial Design, to cover engineering design as well as industrial design.

International Council for Societies of Industrial Design (ICSID) held conference in London.

SIA and DIA (with Institute of Contemporary Arts, Institute of Landscape Architects and Designers and Art Directors' Association) moved into headquarters in Nash House Terrace.

QE2 launched by Cunard, joint design co-ordinators James Gardner and Dennis Lennon.

Walter Gropius died.

Royal Designers for Industry appointed: Kenneth Grange, Mary Quant, Margaret Leischner, Ian Proctor.

RSA Bicentenary Medal awarded to Sir Duncan Oppenheim.

SIAD Design Medal awarded to Willy de Majo.

Duke's Prize for Elegant Design awarded by the Marchioness of Anglesey, Robin Day, Robert Heritage and Mary Quant to Jack Howe for cash dispenser MD2 by Chubb.

CoID Design Awards—Consumer Goods—selected by F. E.

Shrosbree, Inette Austin-Smith, Gontran Goulden, Martin Grierson, Gilian Packard:

Audio equipment by The Acoustical Manufacturing Company,
'Superjet' 4448 reading light by Concord Lighting
'Ease-e-load' trolleys by Deavin-Irvine
Bollard light by Frederick Thomas
Furnishing fabrics 'Polychrome', 'Concentric' and 'Mitre' by Heal Fabrics.
'Vinyl' wall coverings 'Gemini', 'Solitaire' and 'Tempo' by ICI
'Kangol Reflex' car safety belt by Kangol
Upholstery fabrics 'Spruce', 'Larch', 'Rowan' and 'Aspen' made by Margo
'Big Screen' exhibition and display units by Marler Haley
'QE2' chair by Race
'Roanrail 2' curtain track by Roanoid
'Mercury 33' automatic deadlock by Yale.

CoID Design Awards—Capital Goods—selected by Matthew Wylie, Professor D. H. Chaddock, Dr. R. Conrad, Ewen M'Ewen, Frank Height, B. G. L. Jackman, Noel London, C. C. Mitchell:
Ceramic collar insulator by British Insulated Callenders & Cables
'Monobox' overhead travelling crane by J. H. Carruthers
'Kaldo' steel furnace made by Ashmore, Benson, Pease
'K Major' diesel engine by Mirrlees National
'Vision Comparascope' by Vision Engineering
Knitting machine by Wildt Mellor Bromley.

1970 Joint Coldstream/Summerson Committee of Inquiry into structure of art and design education recommended replacement of vocational courses by new design technician's course.

Government decision 'not to proceed to set up the new Design Council in present circumstances' interpreted by optimists as a postponement, not a cancellation.

Association for Design Education formed to promote design in general education.

Experimental G.C.E. 'A' Level design syllabus introduced in Leicestershire schools.

Institute for Consumer Ergonomics jointly sponsored by Consumers Association and Loughborough University of Technology.

100 millionth Design Centre label produced for display on product selected for Design Index.

Exhibition of Modern Chairs at Whitechapel Gallery.

Royal Designers for Industry appointed: David Gentleman, G. Allan Hutt.

RSA Bicentenary Medal awarded to T. C. H. Worthington.

Duke's Prize for Elegant Design awarded by the Marchioness of Anglesey, Mary Quant, Robert Heritage and Robin Day to Patrick Rylands for Trendon Toys.

CoID Design Awards—Consumer Goods—selected by Terence Conran, Alex Gordon, John Vaughan, Juliet Glynn Smith, Kenneth

Grange:

   'Opella 500' bath tap by I.M.I. Developments

   'Star' mobile radiophone by Standard Telephones and Cables

   'Apollo' lamp by J.R.M. Design

   Knockdown storage unit by Kewlox

   Disposable plastic cutlery by Ecko

   Dining table and chair by Plush Kicker

   'Savannah' heating unit by Redfyre

   'Hedway' sign by Syncronol

   'Muraweave' jute wallcoverings by Boyle

   Range of hand-printed wallpapers by Osborne & Little

   'Hebridean' upholstery fabrics by Donald Brothers

   'Spiral' and 'Automation' furnishing fabrics by Heal Fabrics

   'Hexagon' Brussels carpets by John Crossley.

CoID Design Awards—Capital Goods—selected by G. B. R. Feilden, Frank Height, Sir Arnold Lindley, Richard Stevens, S. H. Grylls, Dr. R. Conrad:

   'Boss Mark III' range of forklift trucks by Lancer Boss

   Weighing machine TP30 by L. Oertling

   'Autotest' system by Marconi Instruments

   'Dualform Model 4E' press by Press & Shear Machinery Co.

   The McArthur microscope made for Dr. John McArthur

   'Wee Chieftain Mark 3' boiler by John Thompson Cochran

   Additions to '1900' range of computers by International Computers

   Container transporter crane by Stothert & Pitt.

# Sources of Illustration

ge 1 Henry Cole teapot, *Victoria and Albert Museum*
Edward Godwin sideboard, *Victoria and Albert Museum*
2 Christopher Dresser teapot, *James Dixon, Sheffield*
Bruce J. Talbot fabric, *Victoria and Albert Museum*
3 C. R. Ashbee silver dish, *Victoria and Albert Museum*
Ambrose Heal sideboard, *Heal and Son*
4 Ernest Gimson chair, *Victria and Albert Museum*
Gordon Russell chair, *Gordon Russell*
William Morris fabric, *Victoria and Albert Museum*
5 Gordon Russell dressing table, *Gordon Russell*
Ambrose Heal dresser, *Heal and Son*
6 Claud Lovat Fraser fabric, *Design and Industries Association*
Gregory Brown fabric, *Design and Industries Association*
John Adams tea set, *Victoria and Albert Museum*
7 Serge Chermayeff chair, *B.B.C.*
R. D. Russell radio cabinet, *Russell*
8 R. Y. Goodden glass bowl, *Goodden*
Keith Murray beer mugs, *Wedgwood*
9 Marion Dorn fabric, *London Transport Board*
London Transport Underground coach, *London Transport Board*
10 Enid Marx woven fabric, *Marx*
Enid Marx cotton tapestry, *Marx*
Utility sideboard, *Council of Industrial Design*
11 Howard Keith chair, *H. K. Furniture*
Howard Keith chair, *photograph John Gay; H. K. Furniture*
Susie Cooper pottery, *Wedgwood*
12 Ernest Race chair, *photograph, Dennis Hooker; Race*
Lucienne Day fabric, *Day*
David Mellor cutlery, *photograph, Dennis Hooker; Mellor*
13 Hulme Chadwick pruner, *Design Council*
G. W. F. Longman refrigerator, *Design Council*
Jack Howe transport shelter, *photograph Colin Tait; London Transport Board*
14 Robin Day chair, *Hille*
Shirley Craven fabric, *Design Council*
O.M.K. chair, *O.M.K. Design*
15 Robert Heritage light fittings, *Design Council*
Kenneth Grange iron, *Grange*
Noel London and Howard Upjohn microscope, *London and Upjohn*
Robert Welch teapot, *Welch*
16 David Mellor traffic signals, *photograph, Dennis Hooker; Mellor*
Alec Issigonis car, *British Motor Corporation*
Mather and Platt flameproof motors, *Design Council*
Miska Black and J. Beresford-Evans electric locomotive, *photograph, Sam Lambert, Design Research Unit*

# Index

Advancement of Art, National Association for the 36
Albert, Prince Consort 12–16, 82, 89, 100
Anderson, Sir Colin 62–3, 96
*Architectural Review* 15, 53, 56, 58, 60, 61–2, 67, 70, 71, 75, 78, 83, 88, 101–2
*Art Union Journal* (later *Art Journal*) 12, 17
Art Workers Guild 27–8, 32
Arts and Crafts Exhibition Society 28, 35, 39, 45
Ashbee, C. R. 24, 26–7, 28, 29, 33, 34, 91, 98

Baillie Scott, M. H. 26, 33, 34
Barlow, Sir Thomas 64, 72, 74, 81
Barnsley, Sidney and Ernest 26, 27, 28, 54, 98
Barry, Sir Gerald 85, 86, 89–90
Bauhaus 15, 50, 57, 65, 80
Benson, W. A. S. 28, 35, 39, 41
Black, Professor Sir Misha 59, 72, 76, 86, 109–10
Board of Trade 9, 41, 46, 49, 57, 69, 71, 73, 81
Brewer, Cecil 40, 41, 42, 47
'Britain Can Make It' Exhibition 74–6, 81
'British Art in Industry' Exhibition 60–1, 66
British Institute of Industrial Art 46–7
British Railways Design Panel 95, 109

Carrington, Noel 49, 59

Carter, Stabler, Adams 48, 58
Casson, Sir Hugh 85–90
Central Design Council 73
Central Institute of Art and Design 70
Central School of Arts and Crafts 31, 42, 78, 91
Chermayeff, Serge 51, 53–4, 57, 58, 59, 62, 63, 66
Coates, Wells 57, 58, 59, 60, 62, 63, 87
Cole Group 10–12, 15–16, 47, 49
Cole, Sir Henry 7–19, 22, 25, 55, 80, 82, 88, 110
Conran, Terence 91, 102, 103–4
Cooper, Susie 64, 65
Council for Art and Industry (Pick Council) 60, 73, 77, 82
Council for the Encouragement of Music and the Arts (CEMA) 71, 74
Council of Industrial Design (CoID) 10, 22, 70, 73–83, 87, 90–4, 98, 100–1, 105–8, 110
Crafts Advisory Committee 110–11
Crane, Walter 23, 28, 29, 30, 31–3, 35–6, 101
Cripps, Sir Stafford 74–5, 85–6

Dalton, Dr. Hugh 69, 70, 73–4
Darwin, Sir Robin 78–80, 94
Day, Robin and Lucienne 87, 94, 96, 102
Design and Industries Association (DIA) 22, 27, 39–51, 53–4, 60, 61, 77, 82, 83, 95
Design Centre 90, 92–3, 105–6
Design Centre Awards 90–1, 94

Design Council, *see* Council of Industrial Design
*Design* magazine 12, 82–3, 94
Design Research Unit 72, 109
Deutscher Werkbund 34, 40–1
Dorland Hall Exhibitions 57–8, 59
Dorn, Marion 51, 63
Dresser, Christopher 18, 55, 98
Dunn, Geoffrey 64–5, 83
Dyce, William 10, 11, 80

Edinburgh, H.R.H. Prince Philip, Duke of 76, 92, 94, 100
Edinburgh Weavers 63, 64, 83, 94
Ewart Committee 9

Federation of British Industries (FBI) 46, 60, 70, 73, 77
Feilden Committee 107
Festival of Britain 67, 84, 85–91
Fifteen, The 28
Foxton, William 48, 50, 58

Gane, Crofton 48, 64, 65
Gardner, James 86, 87
General Post Office (GPO) 95–6
Gimson, Ernest 22, 26, 27, 48, 51, 54, 98, 101
Gloag, John 49, 59, 69, 77, 85
Goodale, Sir Ernest 74, 96
Goodden, Professor Robert 55, 63, 76, 80, 87, 94
Good Furniture Group 65, 83, 97
Gorell Committee 57, 58, 60, 77, 92
Gray, Milner 59, 67, 72, 74, 87, 94, 109
Great Exhibition of 1851 10, 11, 13–16, 85
Green Group 97
Groag, Jacques 71, 77
Gropius, Walter 41, 50, 57, 65–6

Hambledon Committee 77, 78
Heal and Son 26, 40, 43–4, 48, 50, 58, 59, 61, 64, 83, 102
Heritage, Robert 91, 92, 94
Hill, Oliver 58, 62, 98
Hille 83, 94
HK Furniture 83
Howe, Jack 64, 87, 108
Hughes, Graham 102–3
Hunt, William Holman 21
Industrial Design Partnership 59

Isokon 64

Jackson, Ernest 39, 41, 43, 48
Johnston, Edward 48
Jones, Owen 11, 12, 14–15, 16, 48
*Journal of Design and Manufactures* 11–12, 13, 14, 15, 82

Kandya 91, 92
Katz and Vaughan 87

Laski, Marghanita 93, 95
Latimer, Clive 57
Leslie, S. C. 74, 80
Lethaby, William Richard 22, 26, 27, 28, 29, 31, 32, 40, 42–3, 44
Liberty's 25, 83
Loewy, Raymond 66–7
London County Council 31, 54, 95
London Transport 43, 63, 109
London Underground Railway 48

Mackintosh, Charles Rennie 33, 34, 35, 49, 98, 101
Mackmurdo, Arthur Heygate 25, 26, 35
McGrath, Raymond 58, 63, 64
McKnight, Kauffer, E. 63
McLeish, Minnie 51
Marples, Ernest 95
Marx, Enid 63
Maud, John (later Lord Redcliffe-Maud) 79
Mayall, W. H. 107–8
Mellor, David 91, 94, 102, 103
Meynell, Sir Francis 48, 58, 72, 74, 82
Meynell-Hoskin Committee 73, 78
Ministry of Transport 95, 109
Ministry of Works 95, 109
Morris, William 11, 21–25, 26, 27, 28, 29, 33, 35, 39, 41, 47, 49, 98, 101, 103
Morrison, Herbert 86
Morton, Alastair 63
Morton, Sir James 48, 64
Murphy Radio 56
Murray, Keith 55, 63, 66, 102
Museum of Manufactures (later Museum of Ornamental Art) 11, 16, 25
Muthesius, Hermann 33–4, 40

National Register of Industrial Art Designers 77

Nugent Committee  77

Old Hall  94, 103
Omega Workshops  50
O'Rorke, Brian  62, 63, 64, 94

Peach, H. H.  40, 41, 43, 47, 48, 50–1, 54
Pevsner, Sir Nikolaus  61, 62, 63, 98
Pick, Frank  10, 48–9, 58, 60, 63, 65, 73, 89
Prince of Wales, H.R.H. Edward  58
Pritchard, Jack  56–7, 59, 64
Pugin, A. W. N.  11, 12, 16, 26

Race Furniture  83, 87, 89, 102, 105
Ramsden Committee  85
Read, A. B.  49, 51, 58, 63, 64
Read, Sir Herbert  55, 59, 61, 66, 78
Redgrave, Richard  7, 10, 11, 15, 16, 17
Reich, Tibor  77, 83
Reid, John and Sylvia  92, 94
Reilly, Paul (later Lord Reilly)  82, 97, 105–7
Richards, J. M.  61–2
Rossetti, Dante Gabriel  21–2, 23
Royal College of Art  32, 46, 78–81, 89, 91, 94, 97, 110
Royal Designers for Industry  66, 76–7, 94
Royal Society of Arts  7, 12, 13, 60, 66, 76, 85, 96, 109
Ruskin, John  18–19, 23–4, 25, 26, 55
Russell, Sir Gordon  10, 48, 50, 51, 54, 56, 58, 62, 63, 64, 65, 69–72, 74, 80–3, 87–8, 90–4, 98
Russell, Prof. R. D.  56, 63, 70, 80, 87, 94, 97

Schools of Design  10, 11, 12, 16, 17–18, 77

Scott, Douglas  67, 108
Scottish Furniture Manufacturers  83
Semper, Gottfried  11, 12, 15, 16, 62, 82
Snowdon, Earl of  100
Society of Industrial Artists (SIA, later SIAD)  59, 77, 91, 108
St. George's Art Society  27–8
Stabler, Harold  39, 40, 41, 43, 48, 50, 66
Stevens, Alfred George  18
Straub, Marianne  63, 77
Street, George Edmund  24, 41
Studio, The  28, 30, 31, 35, 39–40
Summerley's Art Manufactures  9, 10, 12, 13, 18

Temple Smith, Hamilton  42–4, 95
Tennyson, Sir Charles  46, 49, 70, 74, 96
Tubbs, Ralph  86

Unwin, Raymond  49
Utility Furniture  69–71, 81

Victoria and Albert Museum  16, 46, 64, 74–7, 98
Voysey, C. F. A.  26, 28, 33, 35, 66, 98

Walker and Hall  91, 94
Walton, Allan  64, 74
Ward and Austin  89, 92
Warner, Sir Frank  48, 49
Waterer, John  49–50
Weaver, Sir Lawrence  49
Webb, Philip  22–3, 24, 25, 27, 41, 98
Wedgwood  10, 50, 55, 58, 64, 74
Weir Committee  73
Welch, Robert  91, 94, 103
Williams-Ellis, Clough  46–7, 49
Worboys, Sir Walter  92, 96
Wyatt, Sir Matthew Digby  11, 12, 14, 15, 16, 62